Melissa Leapman

mastering
color knitting

Simple Instructions for Stranded,
Intarsia, and Double Knitting

POTTER
CRAFT

NEW YORK

Published in the United States by Potter Craft,
an imprint of the Crown Publishing Group, a division of Random House, Inc., New York.
www.crownpublishing.com
www.pottercraft.com

POTTER CRAFT and colophon is a registered trademark of Random House, Inc.

Library of Congress Cataloging-in-Publication Data
Leapman, Melissa.
Mastering color knitting : simple instructions for stranded, intarsia, and double knitting / Melissa Leapman. -- 1st ed.
p. cm.
Includes index.
ISBN 978-0-307-58650-6
1. Knitting. I. Title.
TT820.L388 2010
746.43'2--dc22
2010006097
Printed in China

Cover and interior design by Kathleen Phelps
Fashion and author photography by Alexandra Grablewski
Flat fabric photography by Jacob Hand, copyright © Jacob Hand
Technical illustrations by Joni Coniglio
Charts and schematic illustrations by Melissa Leapman
Technical editing by Charlotte Quiggle

Thanks to the Craft Yarn Council of America (www.yarnstandards.com)
for its Standard Yarn Weight System chart, which appears on page 171.

10 9 8 7 6 5 4 3 2 1

First Edition

to CDB
just because

Contents

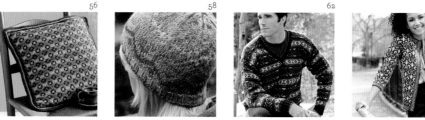

Projects

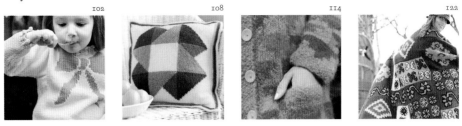

CHAPTER **Reversible Two-Color Double Knitting** 131

Projects

Introduction

Yarn is the medium with which we knitters

perform our craft, but if you ask any knitter what makes one project more interesting to make than another, the response will probably center around color. By combining **colors** together you can create projects that showcase graphic motifs, geometric patterns, and other designs. To me, it's one of the most exciting, fun things you can do while knitting.

In my recent book, *Color Knitting the Easy Way* (Potter Craft, 2010), I explored the fundamentals of **color** knitting and showed you how simple and, yes, how easy **color** knitting can be. We used stripe patterns and slip stitches to highlight the infinite fabric possibilities available using just one color of yarn per row. It's a perfect introduction to, refresher for, and resource on **color** knitting, and this earlier book is chock-full of original stitch patterns and projects, as well as **color** wheels to help you choose **colors** for your projects.

As knitters, we often yearn for the added complexity—and interesting challenge—of knitting with multiple **colors** in a row. In fact, the desire to learn stranded Fair Isle knitting is what drove me to learn how to knit as a teenager! Knitting with more than one **color** at a time may be more advanced, but it doesn't have to be complicated or difficult. In *Mastering Color Knitting* you'll find everything you need to take this next step in **color** knitting, using as many **color** yarns as you like. You'll quickly master three of the most popular types of **multicolor** knitting: stranded **colorwork**, used to create geometric patterns such as those used in traditional Fair Isle patterns; intarsia knitting, used to knit pictorial images as though the knitted fabric were a canvas upon which to "draw" stitches; and double knitting,

used to create a reversible fabric that miraculously appears to be stockinette stitch on both sides!

Once you learn the basics for each technique, practice your new skills by creating projects for yourself, your friends, and everyone on your gift list. Each chapter includes four sample projects to get your started. With the simple instructions and beautiful patterns in this book, you will be able to create seemingly difficult colorwork that won't scream "I'm a newbie!" Throughout, I've shown not only the how-to's for each technique but also their wondrous—and endless—possibilities. Designer's Workshops in each chapter explore topics from how to choose and combine **colors** based on scientific **color** theory to ways to design and incorporate graphic images in your knits. And treasuries of unique stitch patterns allow you to pick a pattern, apply it to a project, and knit away! You can even use knitter's graph paper (included) or common computer software to design—and masterfully knit—your own motifs. Tips and tricks entitled **ColorPlay** are scattered through the pages to guide you every step of the way.

If you are completely new to **color** knitting or need a quick refresher on the fundamentals, don't be intimidated. Complete instructions for basics such as reading charts, starting a new yarn, and carrying yarn are covered in Chapter 1, as well as fail-safe shortcuts for choosing and combining **colors** for any project. A comprehensive section on general techniques, abbreviations, and other resources can be found at the back of the book. So gather the yarns you most enjoy working with in all your favorite **colors** and let's get started. There's so much to explore!

1

Getting Started:
The Basics of Colorful Knitting

Knitters have had a long love affair with color knitting, from traditional Shetland Fair Isles to fun, graphic intarsia knits to cool, contemporary double-knit fabrics first made popular by the mod fashions of the 1970s. Today these techniques are more popular than ever: Friendly local guilds, huge national consumer events, and the proliferation of crafting sites on the Internet have made it easy—and fun—for knitters to share their enthusiasm and learn new skills.

Luckily, no matter how intricate the patterns appear, multicolor knitting is much easier to do than it looks. (And don't let your friends know that a seven-million-color project is no more difficult to create than a two-color one!) Of course, any color knitting requires a basic skill set. These essentials are fully explored in my previous book, *Color Knitting the Easy Way*, and a quick refresher course is included in this chapter as well (page 14). Refer to this chapter any time you'd like a quick reference for using charts, attaching new colors, dealing with yarn tails—even choosing the perfect color palette! Later chapters will cover techniques that are specific to stranded, instarsia, and double knitting.

- -

Reading Color Charts
A chart is a graphic representation of knitted fabric; and since color knitting is, by definition, visual in nature, a chart is a useful way to depict the pattern. Most knitters are already familiar with charts and know how easy they are to use. If you're new to charts, here's my version of Chart Reading 101.

Each square of the grid in the chart represents one stitch on your knitting needle, and each horizontal row of squares represents one row of stitches. Charts are always read from the bottom to the top, with the bottom row of squares representing the first row of knitting and each successive row corresponding to a later row of knitting. When working back and forth in rows for regular flat knitting, right-side rows are read from right to left. Then, since the first stitch of the wrong-side row is the same stitch on the needle as the last stitch of the previous row, wrong-side rows are read in the opposite direction: from left to right.

When working in the round, as when knitting the Fleur de Lis Jacket on page 68, the right side of the fabric is always facing you, so all rows—or rounds, in these cases—are read from right to left.

Knitting charts make it easy to see how many stitches are involved in a pattern repeat. In some charts bold vertical lines indicate the stitch repeat, and if extra stitches are required on each side to center the pattern, they are shown to the left and/or right of the repeat.

color PLAY
Charts for double-knitted, reversible fabrics are read slightly differently from other color knitting charts. For more information about how to use them, see page 140 in Chapter 4.

INTARSIA PATTERN 6

Right: The chart for Intarsia Pattern 6 uses a 16-stitch repeat, as indicated by the vertical lines, to achieve a brightly colored "mountains and valleys" effect.

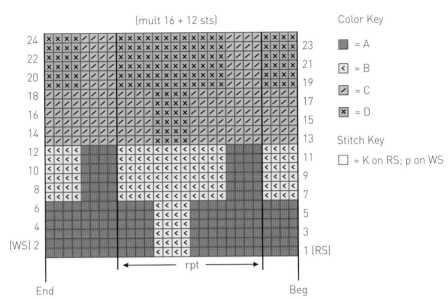

(mult 16 + 12 sts)

Color Key

= A

[<] = B

[/] = C

[X] = D

Stitch Key

□ = K on RS; p on WS

rpt

End Beg

To read the chart below, for example, you'd start at the lower right-hand corner and read from right to left, working the four stitches between the two bold lines as many times as is necessary across the width of your fabric. Then end the row, finally, with the stitch represented in this sample chart by the star. This stitch sits *outside* the stitch repeat and so is worked once per row. It is the *last* stitch of every right-side row; since wrong-side rows are read from left to right, it is the *first* stitch of these rows.

In another example, Intarsia Pattern 6 (above and on page 94) shows a multiple of sixteen plus twelve stitches; it is a sixteen-stitch repeat *plus* eight extra stitches on the left-hand side and four

extra stitches on the right-hand side. These extra stitches on each side are necessary to center the pattern properly. When knitting this chart, the stitches on the outsides of those two bold lines are worked only once; the sixteen stitches in the middle may be repeated several times.

When making knitting projects, sometimes individual pieces or sizes of the same garment may have different beginning and ending places within the stitch pattern. In David's Favorite Fair Isle V-Neck on page 62, for example, each size begins at a different spot in the chart. But don't worry! The taglines underneath the chart tell you exactly what to do: When knitting the body for this garment, cast on a multiple of twenty-four stitches plus one for the size Extra-Small; for the Small, Large, and Extra-Extra Large sizes, however, use a multiple of twenty-four stitches plus eleven. When reading the chart, begin and end where indicated for that particular piece of the garment.

Chart Symbols

The symbols within the chart represent knitting maneuvers—knit or purl or what-have-you—and the arrangement of these symbols creates the pattern. Different colored squares in the grid indicate different colors of yarn. If the yarns are rather close in hue, symbols in addition to colors help you differentiate between them. This also makes the charts easier to read when photocopied. Plus, in multicolor pictorial charts, you can clearly see the motif you're about to knit.

The best part of the knitting charts used in this book is that the symbols actually look like the stitches when knitted. The symbol for a knit stitch, for example, is a blank box, mimicking the flat appearance of the knit stitch itself; the dot symbol for a purl stitch depicts the bumpy appearance of a purled stitch. These symbols are shown *as they appear on the public (or outward-facing) side of the fabric.* So the same symbol means different things on right-side and wrong-side rows. The blank box, for instance, represents a knit stitch on a right-side row; but if you're on a wrong-side row and want the stitch to appear as a knit stitch on the reverse side of the fabric (the public side), you must purl it.

The stitch key tells you what each symbol represents on right- and wrong-side rows. Of course, every designer and editor uses a different set of symbols to represent the same few knitting maneuvers, but don't let that deter you. The key shows you what each symbol means in that particular chart. Once you understand how to read charts, the keys unlock the meaning of any chart you might encounter—no memorization required!

NOTE: *For a complete list of the symbols used in this book, turn to page 171.*

TIPS FOR SUCCESSFUL CHART READING

Following are my suggestions for chart reading that participants in my workshops have found most useful:

· Draw little arrows at the beginning of every line of a chart, on the right- or left-hand side, to show in which direction that particular row will be worked. This will help you remember that right-side rows are read from right to left and wrong-side ones are read in the opposite direction!

· Use a highlighter as a visual cue for wrong-side rows. It will help remind you that the symbols on those particular rows must be reversed: knit for purl and vice versa.

· Use a copy machine to enlarge your charts and make them easier to read.

· Make a note in the key of which yarn colors A, B, C, etc. represent, especially if the yarns—and squares of the grid—are close in hue.

· Place stitch markers on your knitting needles to separate each pattern repeat or panel. That way, if you lose your place in a row (or if the phone rings while you're knitting), you'll find it easier—and faster—to figure out where you are.

· Use sticky notes or a row counter to keep track of your row number.

Using the Pattern Treasuries

I've included three pattern treasuries in this book: graphic patterns for stranded knitting on pages 40–55, pictorial and other patterns suitable for intarsia technique on pages 90–101, and two-color double-knit patterns on pages 142–153. Incorporate these original patterns into your own creations. And since they are already charted out, you can easily visualize the finished fabric.

To use one of these stitch patterns, use the chart to make a swatch at least 6"/[15cm] square (or for an intarsia motif, center the chart in the middle of a large swatch with several stitches on each side). If you plan to wash and block your project pieces, it's important to take the time to treat your gauge swatch in the same manner *before* measuring your stitch gauge. Yarn often behaves differently after washing. Some fibers become limp while others bloom; some will contract lengthwise or widthwise. Consider your gauge swatch the perfect opportunity to preview a tiny piece of your completed project.

When you are ready to measure the gauge, lay your swatch flat and count the number of stitches over 4"/[10cm]. For example, if you count 20 stitches over 4"/[10cm], then your stitch gauge is 20 stitches divided by 4"/[10cm], resulting in a gauge of 5 stitches to the inch [2.5cm]. But, if you knit that same swatch with thicker yarn, you might count 18 stitches over 4"/[10cm]. You would then divide 18 stitches by 4"/[10cm], resulting in a gauge of 4½ stitches to the inch [2.5cm]. *Do not round this number; fractional inches add up when factored over an entire piece of fabric!*

The final step to using a stitch pattern in your own designs is to multiply your stitch gauge by the desired width of your fabric. Of course, you might have to change your final width measurement a little in order to accommodate the stitch multiple for your particular stitch pattern. For example, if you'd like to knit the Stripes 'n' Dots Throw Pillow on page 56 using Intarsia Pattern 3 from page 92, you'd have to cast on 154 stitches instead of 152 stitches to accommodate the stitch repeat of 14 stitches. After all, knitwear design and pattern drafting are more an art form than an exact science.

Right: The Stripes 'n' Dots Throw Pillow (page 56) uses the stranded technique, but you can easily substitute other stitch patterns using the pattern treasuries.

Color Knitting Fundamentals
Here is a mini refresher course on essential color-knitting skills. Refer to this section to learn—or to relearn—basic techniques such as starting a new color, carrying yarn, and weaving in yarn tails.

Starting a New Color

The first technique you need to know in color knitting is how to add a new color. Whenever possible, try to add a new color of yarn at the beginning of a row. This way you don't distort your fabric when weaving in your yarn tails; and if your project is pieced, it is easy to hide the tails in the seams. Of course, depending on the knitting pattern, you may need to use a more specific technique to start a color within a row, as you'll see in the chapters that follow. However, for many simple color patterns, you just begin to knit.

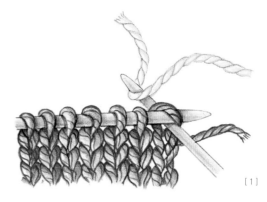

[1]

Below: Don't let the intricate detail in this geometric pattern frighten you (Traveling Triangles Jacket, page 114). Any kind of colorwork is in your grasp once you learn some basic techniques.

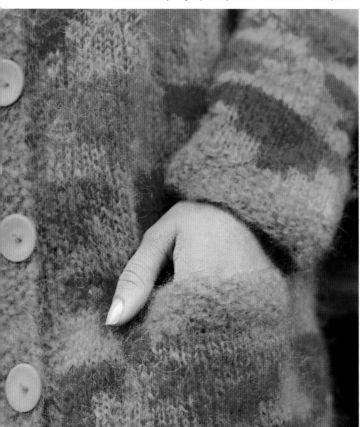

To start a new color of yarn at the beginning of a knit row: Drop the old color, insert your right-hand needle into the first stitch of the row as if you are about to knit, grab the new yarn, and use it to knit the first stitch (illustration 1). Always begin and end every yarn with at least a 6"/[15cm] tail. Otherwise, the piece of yarn won't be long enough to weave in sufficiently.

To start a new color at the beginning of a purl row: Drop the old color, insert your right-hand needle into the first stitch of the row as if you're about to purl, and purl the stitch.

NOTE: *To start a new yarn in stranded knitting, see page 23.*

Carrying Yarn

When you knit with multiple yarns, you don't have to start a new yarn supply every time a given color appears in a pattern. Instead, you can often carry the yarn across the wrong side of the fabric from one area to the next without cutting it. When the unused yarn is carried horizontally, the technique is called stranding (covered in more detail in Chapter 2, page 21). Be sure to carry a yarn only about 1"/[2.5cm]. Otherwise, you'll create an unwieldy strand of yarn that might get caught on buttons or jewelry or even fingers.

To work with a yarn already attached to your fabric: Grasp the new yarn *from underneath* the old one and begin using it (illustration 2).

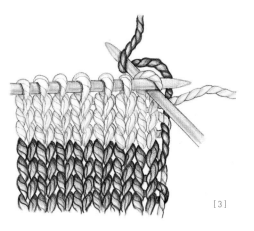

[3]

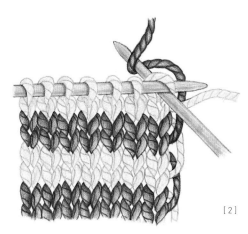

[2]

If you need to carry a yarn up the side of a fabric instead of across a row, twist the nonworking yarn *loosely* with the working color every inch or so along the wrong side of the fabric (illustration 3).

NOTE: *Stranded knitting requires a more specific method of carrying yarn. See page 25 for complete instructions.*

Weaving in Yarn Tails

Color knitting, by definition, involves lots of yarn ends. To make finishing your projects easier, use the techniques discussed on page 84 to work in the tails as you knit as often as possible. For any yarn tails that remain after all the knitting is complete, use a pointed-end yarn needle to make short running stitches on the wrong side of your fabric in a diagonal line for about 1"/[2.5cm] or so, piercing the yarn strands that comprise the stitches of your fabric. Then work back again to where you began, working alongside your previous running stitches. Finally, to secure the tail, work a stitch or two and actually pierce the stitches you just created. Be sure to work each tail individually, in opposite diagonal directions to secure your yarn ends while keeping the public side of your fabric neat and beautiful.

Designer's Workshop:
Choosing a Color Palette

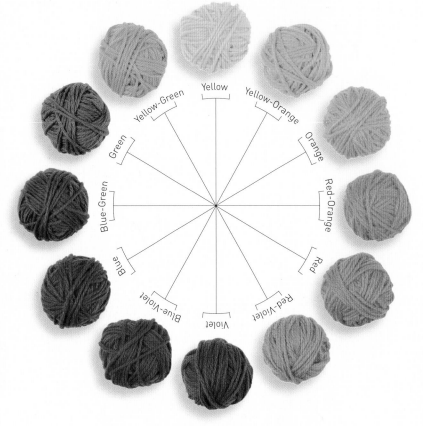

Yellow-Green

Yellow

Yellow-Orange

Green

Orange

Blue-Green

Red-Orange

Blue

Red

Blue-Violet

Red-Violet

Violet

Above: The arrangement of the 12 colors in the color wheel shows the relationships among hues.

For many people, myself included, choosing the colors and yarns for a project just might be the most fun part of the knitting process. But it can also be the part most fraught with uncertainty. We've all probably knitted a garment or two in a color combination that looked great on the model but didn't complement our skin tone. And from time to time we may have struggled to incorporate a favorite yarn into a color palette from a store-bought pattern. Sir Isaac Newton to the rescue!

In the seventeenth century, Newton developed modern color theory by arranging the twelve colors of the spectrum into a circle called the color wheel. The relationships of the colors around the circumference of that circle comprise color theory and can help us create beautiful color-ways for knitting.

COLOR TERMS

TEMPERATURE refers to a color's undertone, with one half of the color wheel comprised of "warm" colors (reds, oranges, and yellows) and the other half comprised of "cool" ones (violets, blues, and greens).

VALUE characterizes the relative lightness or darkness of a hue on an achromatic gray scale (which shows all the possible shades of gray from black through white). It describes the amount of contrast between two colors.

SATURATION describes the relative pureness of a color and is determined by the amount of gray, white, or black that it includes. Adding gray to a pure color muddies its saturation and creates a *tone*, adding white lightens its saturation and creates a *tint*, and adding black deepens its saturation and creates a *shade*.

Combining Colors

The color wheel presents *hues*, what we normally think of as "color": red, violet, blue, or yellow-green, for example. Each hue refers to a color family: a specific spot on the color wheel. The three primary colors (red, yellow, and blue) form the foundation hues of the color wheel, and together they create every other color in the spectrum. Their opposites across the wheel (green, violet, and orange, respectively) form the secondary colors. Combine a primary with its neighboring secondary color and you'll create a tertiary color, such as yellow-green, that falls between the two along the spectrum.

Arranging hues in this way allows us to more easily understand the relationships among colors and how our perception of a color can change depending on which colors appear next to it. Generally, most designers aim for harmony within a color palette as well as contrast between individual yarns when choosing colors for a project. This process can be trial and error, but color theory can help take out some of the guesswork.

The color combinations on the following pages are straight out of basic color theory. Simply decide how many colors to use in your next knitting project, then choose one of the following combinations for a never-fail color story!

As you experiment and play, keep in mind that while color is a scientific phenomenon based on physics, one's preference of one color or colorway over another is subjective. Use color theory as a guide, but always go with what looks—and feels—best to you.

Monochromatic Color Combinations

Monochromatic palettes consist of two or more colors of the same hue, such as pale pink, dusty rose, red, and burgundy. In monochromatic color combinations, each color is a different tint, shade, or tone of a single stop on the color wheel.

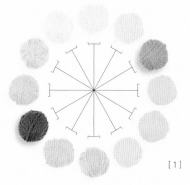

[1]

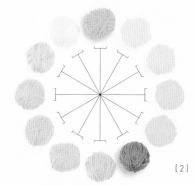

[2]

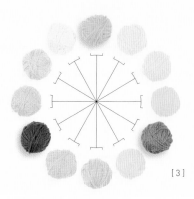

[3]

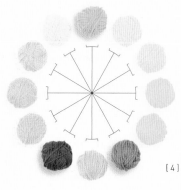

[4]

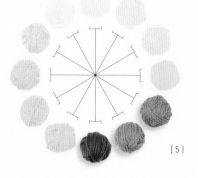

[5]

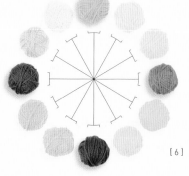

[6]

Two-Color Combinations

COMPLEMENTARY COLORS Colors directly opposite each other on the color wheel are called complementary colors. These colors, such as blue and orange, provide strong contrast within a design (illustration 1).

COUNTERPOINT COLORS This type of combination uses a color with one of the colors on either side of its complement across the color wheel. A counterpoint colorway—such as one combining yellow with red-violet—appears fresh, with a slightly more unexpected look than true complementary colors (illustration 2).

Three-Color Combinations

TRIAD COLORS A triad colorway consists of three hues that are evenly spaced apart on the color wheel. The three primary colors (red, yellow, and blue) make up one triad. (illustration 3).

SPLIT COMPLEMENTARY COLORS Split complementary combinations are comprised of one color plus the two colors on either side of its complement, such as yellow, red-violet, and blue-violet (illustration 4).

ANALOGOUS COLORS Analogous colorways consist of three colors immediately adjacent to one another on the color wheel. They're similar

in feel to monochromatic color combinations but have greater depth. Think about the richness of the combination of red, red-violet, and violet, for example (illustration 5).

Four-Color Combinations

SQUARE TETRAD COLORS Combine two pairs of equidistant complementary colors to create a square tetrad combination. Blue-green, red-orange, yellow, and violet comprise one possible square tetrad colorway (illustration 6).

RECTANGULAR TETRAD COLORS Two pairs of complementary colors that are separated by a single hue

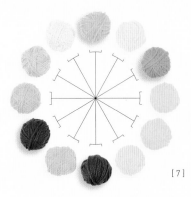

[7]

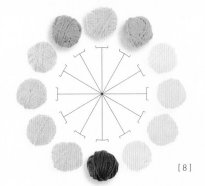

[8]

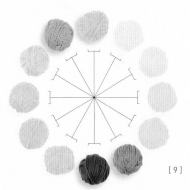

[9]

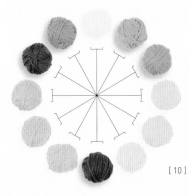

[10]

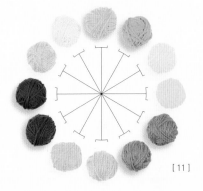

[11]

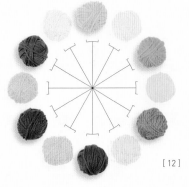

[12]

comprise a rectangular tetrad colorway. Yellow, violet, orange, and blue make up one possible combination. The interaction of four colors adds movement and excitement to any design (illustration 7).

ANALOGOUS COLORS WITH A COMPLEMENT Three adjacent colors on the color wheel plus the complementary color directly opposite them create this type of colorway. One such color combination is violet, yellow, yellow-green, and yellow-orange (illustration 8).

DOUBLE COMPLEMENTARY COLORS This harmonious type of colorway combines two adjacent colors on the color wheel with both of their

direct complements. Yellow, violet, red-violet, and yellow-green make up one possible double complement combination (illustration 9).

Five-Color Combinations

DOUBLE SPLIT COMPLEMENTARY COLORS The twelve double split complementary combinations utilize one hue with the two colors on each side of that hue's complement. Here's one example: violet, orange, yellow-green, green, and yellow-orange (illustration 10).

Six-Color Combinations

DOUBLE TRIAD COLORS This grouping of colors consists of two sets of

triads, one adjacent to the other. Red, blue-green, red-violet, blue, yellow, and yellow-orange is one possible double triad colorway (illustration 11).

HEXAD COLORS This combination is made up of every other color on the color wheel: three pairs of complementary colors that are all equidistant from one another. The combination of every primary and secondary color makes up one possible colorway: violet, yellow, blue, orange, green, and red. These colorways create a kaleidoscope of color (illustration 12).

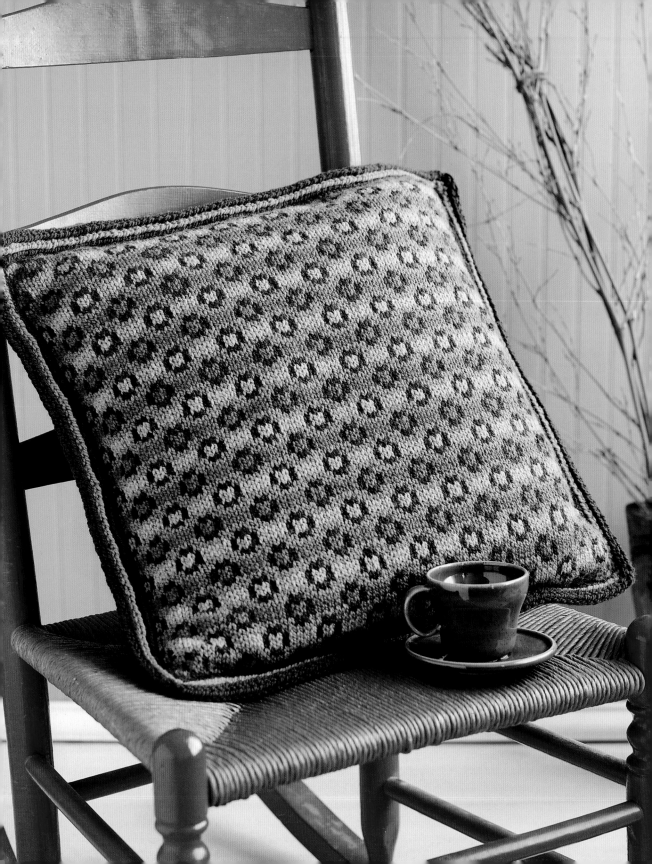

2

Stranded Knitting:
Sowing Your Wild Floats

When I was growing up, multicolor Fair Isle–style sweaters were all the rage, and my desire to make one of my very own was one of the reasons I wanted to learn to knit. I made myself (and then my father and then, later, my brother) gorgeous sweaters that were great fun to knit. Although I used only two colors in any given row, I changed those colors often, so the fabric of the finished garments looked incredibly complex. (To this day, I don't think my friends and family know how easy their pieces were to knit!) If you think you couldn't possibly knit one of these multicolor masterpieces, think again. It is really much easier than it looks.

Here's a piece of fabric knitted using the stranded technique. **Left:** On the right side it looks like basic stockinette stitch worked in a two-color geometric pattern. **Right:** On the wrong side the purl stitches are obscured by horizontal strands of yarn. These floats are created by carrying the yarns from the last place they are used to the next place they're needed. When not in use, the yarns are stranded loosely along the wrong side of the fabric.

Fair Isle is a type of stranded knitting: Two colors are worked across each row, and when a color is not in use, it is carried loosely across the wrong side of the fabric in horizontal floats or "strands" that give this knitting technique its name. If you can make a knit stitch, you can easily create a multicolor stranded sweater—or any project that uses small, colorful pattern repeats! As complicated as such a garment may look, after reading this chapter you will understand how simple—and fun—stranded knitting can be.

As you learn stranded technique, you'll practice maintaining an even tension, incorporate fun patterns into your fabric, and even conquer using steeks, a cool work-around technique that allows you to knit your colorwork in the round, with no purling.

FAIR ISLE KNITTING

Fair Isle knitting developed on Fair Isle, in the Shetland Islands of the UK, a crossroads for seagoing trade between northern Europe and North America. International influences from Russia, Spain, Iceland, and elsewhere combined with native interest in knitting to create the beautiful two-color patterned knitting known as Fair Isle knitting.

Today, we generally use the term "Fair Isle" to refer to any knitted pattern that uses the stranded technique to manipulate yarn floats on the wrong side of the fabric when using two colors per row.

Stranded Techniques

Following are the basics of stranded knitting, including how to hold two yarns and how to carry the yarns to create and maintain even floats. Later in the chapter we'll introduce special stitch patterns and textures into stranded fabrics. Also, we'll take the fear out of using steeks, a common construction method for this type of knitting.

Knitting with Two Yarns

When using the stranded-knitting technique, usually only two colors are worked across the row. Three or more yarns would create bulky, heavy fabrics with little or no drape. And they'd be quite warm to wear, almost like donning a three-layer (or more) garment!

Knitters have three options for holding the two yarns at once while working the stranded technique: one color in each hand, both colors in the left hand, or both colors in the right hand. Choose the option that's most comfortable for you. In this section I describe the technique as it relates to making a knit stitch, but the way to hold the yarn doesn't change when purling.

At first, holding two colors may seem awkward or uncomfortable, and it may be tempting to drop the non-working yarn and then pick it up again to knit. However, dropping the yarn will dramatically affect the tension of your knitting and, ultimately, will slow you down. As you'll see, it's important to keep the position of each color consistent as you knit, and hanging on to both yarns as you go will ensure their uniform placement. With practice, you'll develop a comfortable rhythm and nice, even stitches.

Holding One Color in Each Hand

If you've ever tried two-color knitting before but were frustrated by a tangled mess of yarn at the end of each row, I bet you'll love this technique! It uses the Continental method to "pick" one color in the left hand and the American method to "throw" the other color from the right hand. By holding each yarn in a different hand, you ensure that the yarns never get twisted together. For many knitters, this is the most efficient technique.

Hold one yarn in each hand, wrapping each yarn around a finger to control the tension the way you normally do (illustration 1). To work a stitch with the color from the right-hand yarn, insert the needle into the next stitch knitwise or purlwise according to your pattern, then wrap the right-hand yarn around the needle to make a knit or purl stitch. To make a stitch with the color of the yarn you're holding in your left hand, insert the needle into the next stitch knitwise or purlwise depending on your pattern and wrap the left-hand yarn around the needle to complete the stitch.

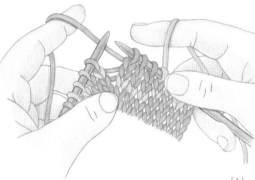

[1]

Holding Both Colors in the Right Hand

If you're normally an American-style "thrower," you can put both yarns in your right hand and use the appropriate color to work each stitch. Knitters have two possible methods from which to choose.

Method 1: Carry both yarns around the right index finger (illustration 2). Use the bend of the top joint of your finger to keep the two yarns apart.

Method 2: Carry one color yarn over the index finger and the other color yarn over the middle finger (illustration 3).

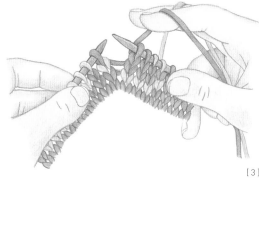

[3]

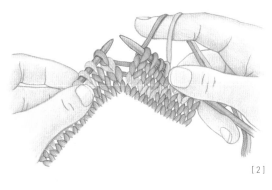

[2]

Holding Both Colors in the Left Hand

If you typically knit Continental-style, you can work with both yarns in your left hand. Again, knitters have two possible methods from which to choose. With either method, the right-hand needle can easily "pick" the yarn called for in the color pattern.

Method 1: Carry both color yarns over the left index finger (illustration 4). Use the bend of the top joint of your finger to keep the two yarns apart.

Method 2: Carry one color yarn over the left index finger and the other color yarn over the middle finger (illustration 5).

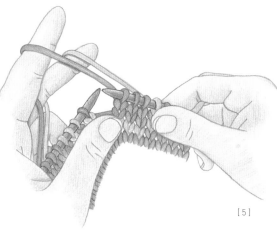

[5]

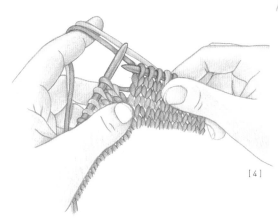

[4]

Carrying the Yarn

When you hold the yarns, you'll notice that one yarn is carried above the other in your hands. It is important that this position does not change. Because of the difference in tension, stitches knit from the bottom yarn will appear slightly larger than those worked in the yarn that's carried above, and so their color will appear more dominant. For example, these swatches look quite different, even though they were knitted from the same pattern.

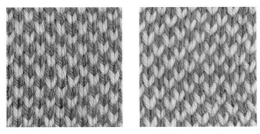

Left: In this swatch, the green yarn was held below the yellow yarn and appears more pronounced. **Right:** In this swatch, the yellow yarn was held below the green. Notice how the yellow color appears dominant, since its stitches are just slightly larger.

Use the position of the yarn to your design advantage. When knitting a project, it's smart to always carry the yarn of the contrasting pattern color below the yarn of the background color. This will make the contrasting design "pop" out from the background. The position of the two yarns in relation to each other is different for each method of stranding.

• When holding one color in each hand: The color in your left hand will be dominant because it is carried below the one in your right hand; accordingly, you should put the background color in your right hand and the pattern color in your left hand.

• When holding both colors in your right hand: If you are using two fingers to hold the yarns, the yarn color that is held over the middle finger will appear dominant. If you are using only one finger to hold the yarns, the yarn color closest to your fingertip will appear dominant.

• When holding both yarns in your left hand: The yarn that is carried closer to your palm will appear dominant because it floats below the other one while knitting and purling.

Maintaining Even Floats and Smooth Tension

When stranding the yarns, it is imperative to carry them *loosely.* If the floats are too tight, the fabric will pucker, and puckering could distort the color pattern. Even when worked perfectly, stranded technique actually changes the knitting tension widthwise. Other stockinette fabrics have rectangular stitches that are wider than they are tall, but *stitches in stranded fabrics are square in shape.* The floats on the wrong side of the fabric draw the fabric in, requiring more stitches per inch than regular stockinette stitch.

It's not surprising, then, that most stranded knitting is worked with wool yarns rather than cotton or acrylic. Wool is resilient and more forgiving for this type of knitting. When working with wool, a touch of steam may help ease the tension of a float that is a little too tight. In fact, if you notice a tight

color PLAY

Many knitters who hold both color yarns over the index finger like to use special tools called yarn guides and knitting thimbles to help separate the two yarns. With these tools the two yarns always stay in a consistent position—not to mention separate and free of tangles. Plastic yarn guides and metal knitting thimbles fit on the index finger and have either grooves or metal coils to hold each color. With practice, you'll be able to maintain an even tension while carrying your yarns consistently— and maybe even while smiling!

strand while still working on the same row, you can often smooth out the fabric by loosening stitches of that same color later in the row, gradually feeding extra working yarn from the ball, stitch by stitch, until you get to the offending area.

To avoid tight floats in the first place, spread the stitches that are near the tip of your right-hand needle just slightly before working the first stitch of a new color. This tiny amount of extra space helps keep the strands loose and prevents puckering.

color PLAY

To measure your gauge for a stranded-knitting project, be sure to work your gauge swatch *in the color pattern*, not simply in solid-colored stockinette. Floats change the shape of stitches and affect the tension of a knitted fabric, requiring more stitches per inch than other knitting techniques.

Length of Floats

It's no coincidence that most stranded-knitting patterns are comprised of small, tight graphic elements. Technically, this serves to control the length of the floats. If the distance between colors in any particular row is extremely wide, a superlong float will occur on the wrong side of the fabric. This strand of yarn can easily catch on buttons or fingertips and also causes especially loose and sloppy stitches on each end of the float. If the colorwork requires that you carry a yarn for a distance of 1"/[2.5cm] or more, you should catch, or twist, the unused strand with the working yarn. There's no hard-and-fast rule about how far you can comfortably strand, but I'd recommend no more than 1"/[2.5cm] of width—that's fewer stitches when working with a bulky yarn and more stitches for a fine one.

To catch a long float mid-carry while knitting: Bring the floating yarn to the left and *under* the working yarn to catch it, then continue across the row, knitting with the working yarn only (illustration 6).

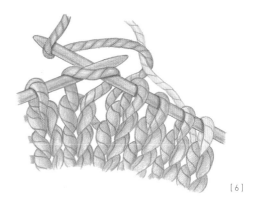

[6]

To catch a long float mid-carry while purling: Bring the floating yarn to the left and *over* the working yarn to catch it, then continue across the row, purling with the working yarn only (illustration 7).

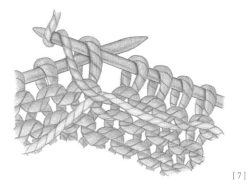

[7]

Stitch Patterns

Plain stockinette stitch is the most common fabric in stranded knitting, but the technique can create beautiful effects in other stitch patterns as well, including ribbing, cables, and other textured fabrics. Whatever stitch pattern you use, charts make the knitting easy. Just look at the chart and you know exactly what color—and texture—each stitch is!

When following a chart in stockinette stitch, on right-side rows, you'll knit the stitches in the colors shown in the chart; on wrong-side rows, you will purl with the colors shown in the chart. At all times, the yarns not in use will be held *to the wrong side* of the fabric to create the floats that are characteristic of stranded knitting.

For example, the chart at right shows a basic two-color stranded pattern. Notice that there are two colors on every row of the chart. Row 1 will be worked using all knit stitches, following the pattern from right to left, beginning with the square on the right-hand side of the chart, working the four-stitch repeat as many times as is necessary until there is one stitch left in the row, ending with the square that is on the left-hand side of the chart. Row 2 will be worked using all purl stitches, following the pattern from left to right, beginning with the first square on the left-hand side, repeating the four stitches of the pattern repeat as many times as is necessary to get to the end of the row. Of course, if you're knitting in the round, all rows—or rounds, in this case—are worked with the public side facing you and so always read from right to left.

STRANDED PATTERN

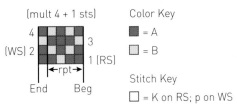

NOTE: *For more information on reading charts, turn to Reading Color Charts (page 10).*

Corrugated Ribbing

This type of ribbing, often used to effectively bring colorwork into the borders of garments, is made by alternating knit and purl stitches just as in ordinary ribbed fabrics, but the knit and purl stitches are worked in different colors.

In general, stranded fabric is much less elastic than nonstranded fabric. Inelasticity can present a challenge when knitting garments that require stretch (such as socks) or when using corrugated ribbing for borders you'd like to draw in (such as cuffs). The floats on the wrong side of the fabric limit the elasticity of the fabric. If your design requires tight ribbing, be sure to use knitting needles at least two sizes smaller for the corrugated ribbed sections, or use fewer stitches for the colorful ribbing and add stitches before beginning the main pattern. Stranded ribbing can be created in any stitch configuration but is most effective on K2 P2 ribbing, working the knit stitches with one color and the purl stitches with another.

CORRUGATED K2 P2 RIBBING

(mult 4 sts)

Pattern Row or Round

End Beg

Color Key

■ = A

☐ = B

Stitch Key

☐ = K on RS; p on WS

• = P on RS; k on WS

To work corrugated K2 P2 Ribbing on a right-side row: *With both colors to the back, knit 2 stitches with color A, bring color B to the front, and purl 2 stitches with color B; repeat from * to the end of the row or round. On successive rows or rounds,

maintain both the color and stitch patterns as set, being careful to always create your floats on the wrong side of the fabric.

NOTE: *On wrong-side rows, knit or purl the stitches as they face you, keeping the floats toward the wrong side of the fabric.*

CASTING ON IN COLOR

When casting on for corrugated ribbing, you must decide which color yarn to use, either the color of the knit stitches or the color of the purl stitches. This decision will affect the look of the knitted piece. Whichever you prefer, use that same color for the bind-off to ensure that both ends of the finished piece look alike.

Above: This cast-on edge is the same color as the knit columns. It noticeably frames the piece. **Right:** This cast-on edge uses the same color as the purl stitches of the corrugated rib. It creates a subtler edge to the ribbing.

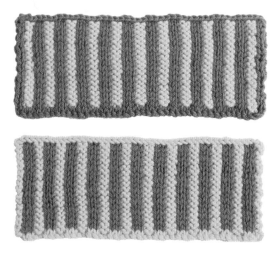

Cables

Cables are created when stitches are knitted out of sequence, and you can add cable to stranded knitting just as easily as when knitting with one color per row. (Refer to page 164 in the General Techniques section for cabling basics.) The combination of stranded knitting and cables creates beautiful textures and patterns, whether used all over or placed as isolated panels within projects.

For example, in this allover two-color cable pattern, two stitches of green and yellow alternate across every row, creating vertical stripes of color. Every fourth row, groups of stitches are cabled to break up the stripes. That's it! It's amazing how complex these patterns appear; it can be our secret how easy they are to knit.

NOTE: *Since cabling tightens the gauge of knitted fabrics, be sure to create very loose floats when incorporating cables into stranded colorwork.*

STRANDED ALLOVER TWO-COLOR CABLE

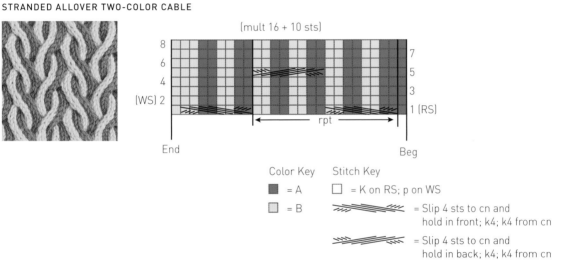

(mult 16 + 10 sts)

Color Key

☐ = A

☐ = B

Stitch Key

☐ = K on RS; p on WS

= Slip 4 sts to cn and hold in front; k4; k4 from cn

= Slip 4 sts to cn and hold in back; k4; k4 from cn

STRANDED TWO-COLOR CABLE PANEL

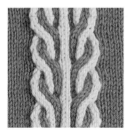

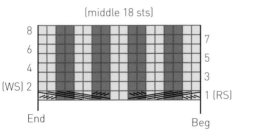

(middle 18 sts)

Two-color cables are also quite effective in vertical panels.

In the chart for this pattern, two stitches each of green and yellow yarn create the vertical stripes, just as in the allover cable pattern. In this example, groups of stitches are cabled every eight rows.

Color Key

☐ = A

☐ = B

Stitch Key

☐ = K on RS; p on WS

= Slip 4 sts to cn and hold in front; k4; k4 from cn

= Slip 4 sts to cn and hold in back; k4; k4 from cn

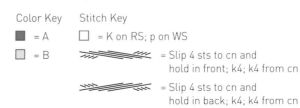

Other Textured Patterns

Most often, the stranded technique is used in fabrics with knit stitches worked on top of other knit stitches and purl stitches worked on top of other purl stitches. Other arrangements of knit and purl stitches introduce interesting textures but can also add unexpected effects when changing colors. If you want clear, separate colors, it's important to work the first stitch of any color change as a *knit* stitch, making purl stitches only over stitches of

that same color. Changing colors while purling creates little blips of color in surprising places.

For example, this stranded-knitting chart uses a combination of knit and purl stitches: Throughout this charted pattern, purl stitches are worked on top of stitches worked in a different color. This may not seem like a problem; however, once knitted, unsightly purl blips become apparent at the edge of the color change, breaking up the smooth color patterns in the fabric.

TEXTURED STRANDED PATTERN 1

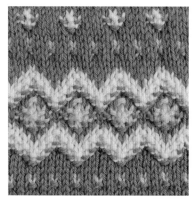

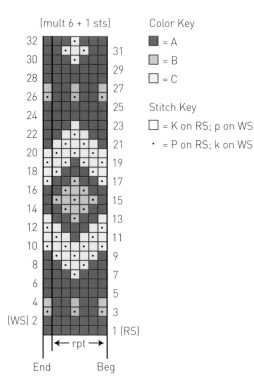

(mult 6 + 1 sts)

Color Key

■ = A

▨ = B

□ = C

Stitch Key

□ = K on RS; p on WS

• = P on RS; k on WS

The revised chart carefully places purl stitches only above stitches worked in the same color. This minor change in the chart makes a huge difference in the knitted swatch. The color pattern appears much stronger and brighter because it is not broken up by tiny blips of contrasting yarn.

color PLAY

Of course, all "rules" are made to be broken. Bauhaus-style designs, invented by a Swedish knitting cooperative in the mid-twentieth century, deliberately use those "purl blips" to create textured colorwork, and the results are stunning! By understanding the way color changes work in knitted fabrics, you can get the results you want for whatever project or design you take on.

TEXTURED STRANDED PATTERN 2

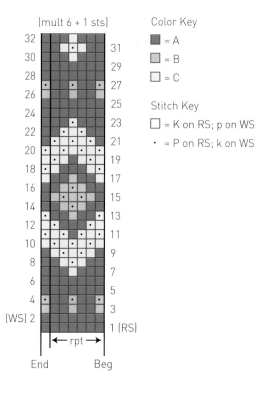

(mult 6 + 1 sts)

Color Key
= A
= B
= C

Stitch Key
= K on RS; p on WS
• = P on RS; k on WS

Using Steeks

When knitting a garment, knitters can choose among several construction methods: making several flat pieces that will be seamed together, knitting seamlessly in the round, or a combination of these two options. Many knitters prefer to work stranded projects in the round. For some, particularly for Continental-style knitters, the knit stitch is quicker and easier to do than the purl stitch, and when working in the round, every stitch of every round of stockinette is knitted. Also, it's easier—and more interesting—to watch a color pattern develop on the right side of the fabric. Plus, many knitters find it's simpler to follow a chart when reading every round in the same right-to-left direction.

Knitting in the round creates tubes of fabric. However, a knitted cylinder does not allow for openings in a garment, such as for the front of a cardigan, a neck opening, or an armhole. The knitter either has to switch from circular knitting to flat knitting, possibly changing the gauge, or knit the garment in the round and cut the fabric to create openings. To do this, you'll need to cast on and knit extra stitches, called steeks, into the fabric.

If the thought of taking a pair of scissors to your knitting makes you cringe in horror, never fear. Incorporating steeks into a garment where an opening will be needed ensures that your precious stitches stay put. For extra security, some form of reinforcement, such as crochet stitches or machine sewing, is often used to stabilize the edges of a steek before cutting. (If certain wool yarns are used, such as Shetland, the tiny fibers of the yarn tend to stick to themselves, making raveling unlikely—and reinforcement unnecessary. Most knitters, however, want the security of some sort of stabilization.)

Knitting the Steek Stitches

I recommend nine-stitch steeks for the projects in this book, although I've seen successful sweaters worked with as few as three stitches in the steek. For additional security, more stitches can be added. Using an odd number of stitches makes it easy to cut in the center of a column of stitches later. (Of course, if an even number of stitches were to be used, the steek would be cut *between* the two middle stitches.)

For the steek, a bridge of stitches is cast on using the e-wrap cast-on technique (see below) using alternating colors of yarn Frequent color changes in the steek, *even at the cast-on edge*, make the fabric sturdier and easier to cut, and help to prevent it from raveling.

To create the e-wrap cast-on: Wrap the yarn *from front to back* around your left thumb, then insert the right-hand needle *from front to back* to catch the strand (illustration 8).

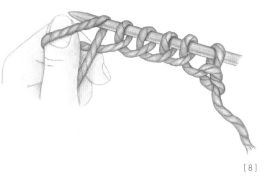

[8]

As you knit, the steek stitches should be worked in a simple color pattern, either in the same vertical pattern already set up in the cast-on or else in a simple alternating check pattern. Additionally, a stitch marker is often placed on either side of the steek stitches to set them off from the main knitting. Working the steek stitches in a vertical stripe pattern is beneficial in two ways: It will be a snap to cut a straight line up the center stripe, and it creates definite border stitches along the steek that will make picking up stitches much easier to do later.

For example, here's a five-stitch steek worked in a vertical stripe pattern (illustration 9). The cut will occur in the middle of the center green stitch. If you use a nine-stitch steek (as I've done for the projects in this book), the cut would occur in the middle of the fifth stitch of the steek.

color PLAY

Some knitters prefer to work all their steek stitches through the back loop. This technique twists the stitches, making them a bit tighter—and may create additional security. If you're especially queasy, it can't hurt!

[9]

When the steek stitches are no longer necessary (such as at the top of a garment), bind off the steek stitches before securing and cutting the steek (pages 34–37).

PLACEMENT OF STEEK STITCHES

Steeks are used in spots where the knitted tube will be cut open. Following are some common places:

• For the front opening of a cardigan: Cast on the extra steek stitches at the beginning of the knitting. Place a stitch marker before and after the steek stitches to keep them separate from the main patterned stitches.

• For necklines: Add the extra steek stitches where the neck opening would begin, and place a marker on each side of the new stitches. To shape the neck opening, work decreases before and after the steek stitches just as you would for a standard neckline, mirroring the slant of your decreases on either side.

• For an underarm: Knit the tube up to the armhole and bind off the stitches that will comprise the flat part of the underarm (remembering to center the bind-off over the beginning of the round if it's at the side "seam"). Then add the extra stitches for the steek. If your garment is knitted all in one piece, put those armhole bind-off stitches onto a piece of waste yarn to be picked up later for the sleeves. If your sweater design is a basic drop-shoulder style with no indentation at the armhole, simply cast on your steek stitches without binding off anything first. Again, place markers before and after the steek stitches to set them apart from the main patterned stitches.

• For an afghan: Work the afghan in the round with one steek. When the knitting is completed, simply snip the steek and secure it. This type of project would probably benefit from a fabric lining to hide the floats on the wrong side.

Steeks and Shaping

Steeks make it easy to knit straight tubes, but sometimes you want to shape circular-knit pieces, such as for a waistline or sleeve. Obviously, those increases and decreases must be made within the main fabric and not the steeks. For an elegant, fully fashioned look, work your shaping one or two stitches before or after your steek stitches. This technique will create a subtle frame for your pieces and will make seaming or picking up stitches easier during the finishing stage of your project.

For an especially beautiful effect, slant your increases or decreases *toward* the steek and *not* in the direction of the slope of the fabric. When decreasing, for example, work a k2tog decrease *after* the steek stitches; *before* steek stitches, work an ssk decrease. When working your decreases this way, it'll be easy to determine which color yarn your decreases should be worked in to maintain the pattern. Bonus!

Securing the Steek

After the knitting has been completed for the garment, the steek edges are usually reinforced prior to cutting, either by crocheting or by sewing. Crochet works for most fibers, including wool and wool-blend yarns, while sewing may better secure projects worked in slippery or plant-based fibers such as rayon or cotton. When in doubt, test your preferred method for securing a steek on a swatch before doing it on your precious garment!

Prior to securing the steeks, it's a good idea to wet-block the garment. Washing the fabric evens out the stitches a bit, and when using a wool yarn, it is the first step in the felting process that stabilizes the fabric and prevents unraveling.

Crocheted Steeks

My favorite way to secure a steek before cutting utilizes simple single crochet stitches. If you've never tried crochet, this stitch is very easy to do. (But this, of course, is coming from an author who's about to tell you to cut your precious knitting!) Complete instructions follow.

First, choose a crochet hook at least one or two sizes smaller than your main knitting needle, and choose a yarn that is thinner than your main knitting yarn. Be sure that this yarn highly contrasts in color so that you will be sure not to cut this crochet yarn by accident later! (And don't worry: The yarn will not show on the public side of the garment, so any color can be used.) Then work single crochet stitches as discussed below to join the right-hand leg, or side, of one stitch to the left-hand leg of the adjacent stitch on either side of the cutting line.

For example, let's look at a five-stitch steek. Each leg of each stitch has been numbered for easy reference (illustration 10). You will use a single crochet stitch to join legs 4 and 5 for one column of stitches and then legs 6 and 7 for the second side. *Each crocheted stitch joins one leg of the center stitch and one leg of an adjacent stitch.*

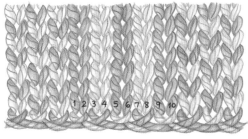

[10]

To secure the steek with crochet: Make a slip knot, then turn your knitted piece sideways. Insert your crochet hook *from front to back to front* through legs 4 and 5 (illustration 11). Then place the reinforcement yarn onto the hook, wrap the yarn over the hook, and draw the yarn through the two legs (illustration 12). Wrap the working yarn over the hook, and draw the yarn through the loop on the hook to complete a slip stitch.

Reinforce the steek by working a single crochet stitch as follows: Insert the crochet hook into legs 4 and 5 in the next row of knitting, wrap the yarn over the hook and pull up a loop (you'll have two loops on the hook) (illustration 13). Then wrap the yarn over again and draw the yarn through both loops to make a single crochet stitch. Repeat to the top of the steek (illustration 14).

For the other side of the steek: Turn your work in the other direction and, beginning at the bind-off row, work downward to join legs 6 and 7 of each row. You will be joining the other leg of the center stitch with one leg of the adjacent stitch.

Once both legs of the center stitch are crocheted, the stitch will be pulled in two directions, leaving horizontal ladders right down the center between the legs—you can see this in the middle of the center green stitch in illustration 15. This is where the steek will eventually be cut.

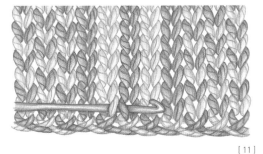

[11]

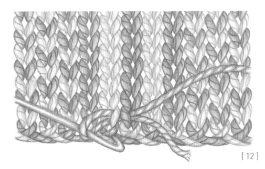

[12]

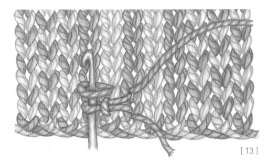

[13]

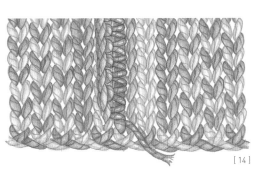

[14]

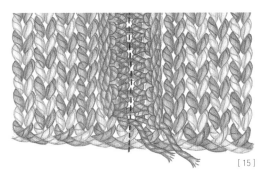

[15]

color PLAY

Some knitters prefer to crochet a few slip or single crochet stitches along the cast-on edge of the steek for additional security.

color PLAY

Garments knitted in superwash wool yarns usually require a sewn reinforcement before cutting. Although the fiber is made from animal fiber, the characteristic sticky barbs that normally make wool ideal for steeking (and for felting, for that matter) are stripped away in the chemical superwash process.

Sewn Steeks

If not using crochet stitches to secure the steek in your project, secure it using a sewing machine. Or, if you prefer to sew by hand, tightly hand-stitch two rows of stitching on both sides of the vertical line where the cutting will occur. It's a good idea to first baste along the center cutting line with a contrasting yarn to guide your sewing and cutting. Be sure to use a highly contrasting sewing thread and very small stitches, catching each and every steek stitch—preferably more than once.

BACK TO BASICS: HIDING THE JOG

When working in the round, you might see a jog, or a hitch in the color pattern, at the beginning of rounds, especially when the background color changes (below left). If the beginning of a round coincides with a steek, the jog will never been seen. If, however, you are making an item such as a hat that won't be cut and the jog appears unsightly, try one of these tricks for hiding the jog.

SLIP STITCHES: The slip stitch technique is quick and may seem like an intuitive solution to many knitters.

To use slip stitches: On the first round of each new color, knit around normally. On the second round, slip the first stitch of the new round purlwise without knitting it and then knit the rest of the pattern as normal. The slipped stitch pulls up the beginning and the end of the round to the same height to disguise the shift in colors (below center).

ROW BELOW STITCHES: Another option is to knit the first stitch of the second round *in the row below* (below right). This technique might feel slightly awkward at first, but it does a good job of hiding the jog.

To knit in the row below: On the first round of each new pattern, knit around as usual, doing nothing out of the ordinary. At the beginning of the second round, pick up the right leg of the first stitch from the row below (the old color) and put it on the left-hand needle. Knit it together with the first stitch on the needle and continue to the end of the round. Working the first stitch of the round this way blends the beginning and end of each round together, hiding the jog.

Note that each of these tricks requires that your pattern be at least two rounds high. If your pattern is only one row, you can often wiggle the fabric as you deal with the yarn tails to even out the jog.

Left: Color knitting in the round produces a noticeable jog in the fabric. **Center:** Slip stitches minimize the appearance of the jog. **Right:** Working stitches in the row below also minimizes the visibility of the jog.

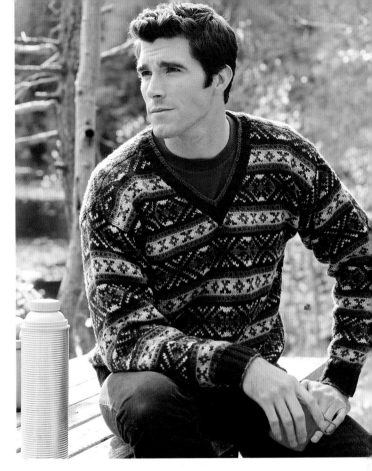

Cutting and Finishing a Steek

Take a deep breath. Use the sharpest scissors you can find to cut through the center steek stitch. Be sure to cut your steeks slowly and carefully, taking care not to cut the fabric on the other side of the tube. You wouldn't be the first knitter of all time to do so! (Don't ask me how I know.) As you work, be careful not to cut any reinforcing stitches—and don't forget to breathe.

Whew! With your steek cut, you are now ready to finish your garment, attaching sleeves or adding a zipper, cuffs, a decorative neckline, or any other finishing detail you like. You may choose to sew another part of the garment (such as a sleeve) along the steek, or you can pick up and knit stitches along the steek's edge. Since the steek has been worked in stockinette stitch, the leftover steek stitches will conveniently and neatly roll to the wrong side of the garment, making it easy to pick up and knit under both legs of the edge stitch of the steek. This method is often used when making sleeves. Stitches are picked up along the armhole, and the sleeves are worked downward to the cuff.

Many knitters finish their steeks after the garment has been completed by folding the remaining stitches over and sewing them down, using whipstitch or overcast stitches. Unless a very wide steek has been used, this step is often unnecessary. If the garment has been knitted in wool or another animal fiber (except superwash wool), the cut edges will felt with every wearing to create a strong bond.

color PLAY

A decorative effect can be created by picking up stitches between the first and second stitch of the steek rather than between the steek and the main stitches. In this case, a narrow vertical line will travel the edge, adding a special touch. Be sure you've included enough stitches in your steek to accommodate this design detail.

Designer's Workshop: Designing for Stranded Knitting

It is exciting to design color patterns for stranded knitting. Often they're just geometric designs (and not pictorial representations of real things), so there's no need to worry about getting anything "right." Really, no art degree is required. I've included a treasury of patterns that you can color and use for your knitting (pages 40–55). Cross-stitch and needlepoint charts are also great sources for stranded-knitting charts, since their square grids match the gauge of stranded fabrics. I hope you'll take my lead and have fun creating new patterns to knit. Since stitches are square in shape when knitted using stranded-knitting technique, you can use regular square graph paper when designing stranded patterns. (There can never be too many designers out there!)

Pattern Categories

Traditional stranded Fair Isle designs use the following kinds of patterns.

· Peerie patterns (pages 40–45) are small one- to seven-row patterns that are often interjected between larger patterns. They can be worked with contrasting background colors for extra color and impact.

· Horizontal borders (pages 46–51) are large patterns, usually seven or more rows high. They are often based on traditional X-O-X patterns to eliminate long floats on the wrong side of the fabric. Two Xs next to each other would create superlong floats in the middle of the pattern; two adjacent Os would have two sloppy floats (one at the top and one at the bottom). An X-O-X arrangement deals with this issue neatly—and beautifully.

· Seeding patterns (pages 52–53) are tiny allover patterns that are perfect for areas where shaping is going to occur and where more complicated patterning will become obscure—and difficult to knit.

· Allover patterns (pages 54–55) are repeated horizontally and vertically throughout a fabric. These patterns have no solid-colored rows or rounds. See the Fleur de Lis Jacket on page 68 for a knitted example.

Pattern Placement

· When working in the round, try to adjust your stitch count so it is an *exact* multiple of the number of stitches called for in your color pattern. Or, work several stitches at the sides in a contrasting seeding pattern, centering your main pattern between them.

· To ensure that your pattern matches up neatly at the shoulders when knitting in the round, it is critical that an *even* number of repeats of the largest pattern repeat is used.

· Try to plan that your shoulders end in the *middle* of a large border pattern rather than near the end of one. This way, once the shoulders are seamed, the join will be more harmonious with the rest of the garment.

· To knit a cuff-to-cuff sweater, use a steek for the lower edge of the garment. Once you cut your steek, just pick up and knit your ribbed band.

· For visual interest, alternate wide and narrow bands of patterns, as in David's Favorite Fair Isle V-Neck on page 62.

· For children's garments, use isolated bands of patterns along the lower edge or near the top of the garment. Allover patterning can overwhelm small bodies.

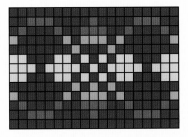

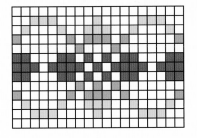
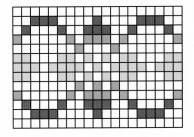

The placement of colors in a pattern affects the overall success of the design. **Left:** When placed toward the outside of the design, the color yellow contrasts well with the purple background. **Right:** Placing yellow at the center of the design is less successful.

The opposite is true with a white background. **Left:** Here, the color red seems clunky and heavy at the center of the design. **Right:** When moved to the outside of the pattern, the red pops out from the white background, making for a more successful design.

Color Placement within Patterns

· To start, keep one color consistent throughout a project—the background, perhaps—and change the contrast color every few rows. You'll still get complexity of pattern and lots of eye movement without much design stress.

· When changing colors within a border pattern, keep in mind that in order for the pattern to "pop," there must be enough contrast at the top and bottom of the border.

For example, the charts above are identical in pattern, but the color placement is different in each one. Of the topmost charts, the left chart is more successful because the yellow patterning on the upper and lower edges of the chart spring off the page.

Interestingly, when these two charts are worked on a light background, the opposite is true, since the red color toward the outer edges of the border "pop" more than the yellow.

· Want to add some complexity without much work? Use a variegated or hand-painted yarn as either the background or patterning color. Be certain that all hues within the colorway contrast sharply with the other color you're using or else sections of your pattern will be lost!

color PLAY

Try rotating one of the horizontal borders on pages 46–51 to create a vertical design element!

Pattern Treasury of Stranded Knitting

Here's a collection of graphic motifs to color and use in your stranded-knitting projects. Several repeats of each pattern are shown. I suggest you make several black-and-white copies of the patterns that interest you and then use colored pencils to decide color arrangement. Or you can place a clear transparency sheet over them and use colored markers to make the patterns come alive.

Peeries

ONE-ROW PEERIES

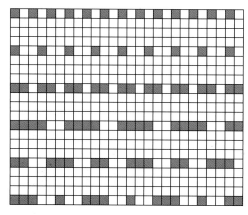

THREE-ROW PEERIES

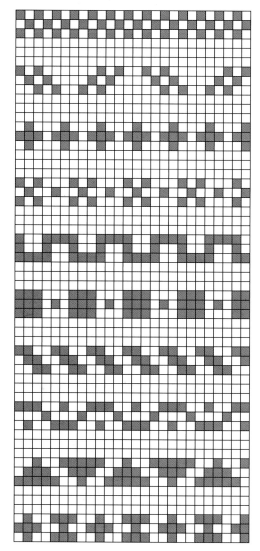

TWO-ROW PEERIES

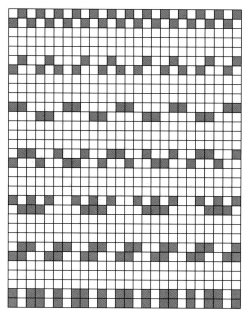

THREE-ROW PEERIES

FOUR-ROW PEERIES

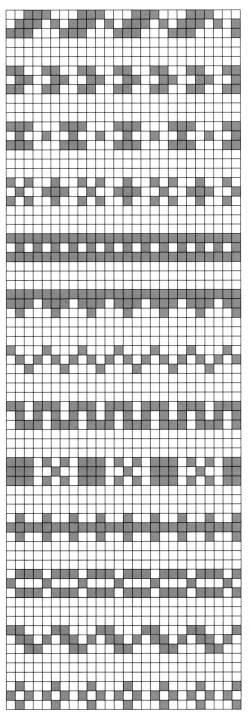

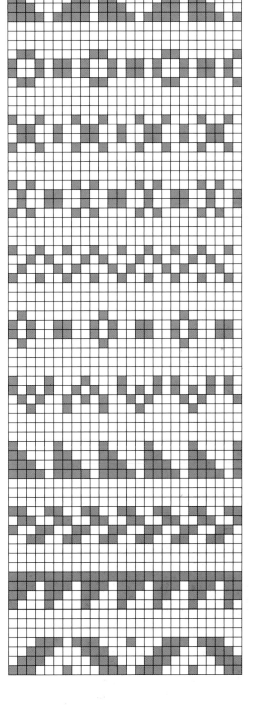

FIVE-ROW PEERIES

FIVE-ROW PEERIES

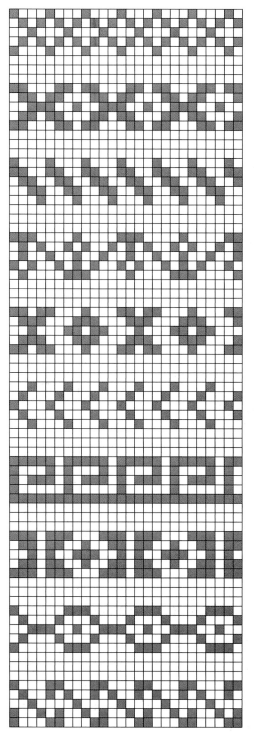

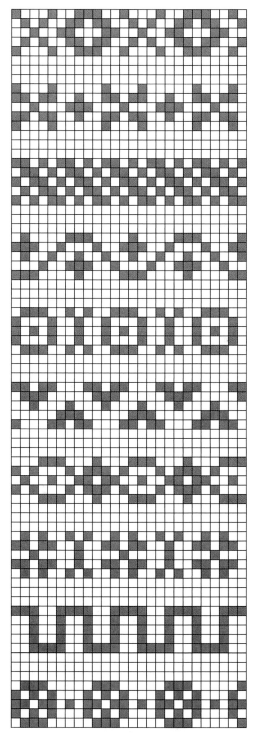

FIVE-ROW PEERIES

SIX-ROW PEERIES

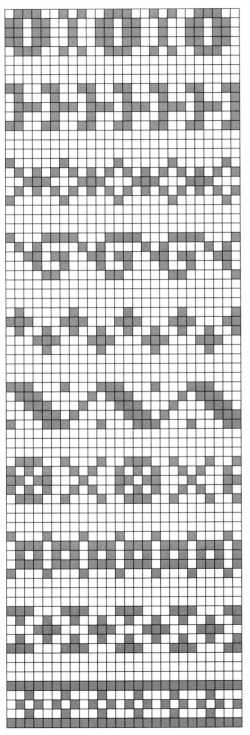

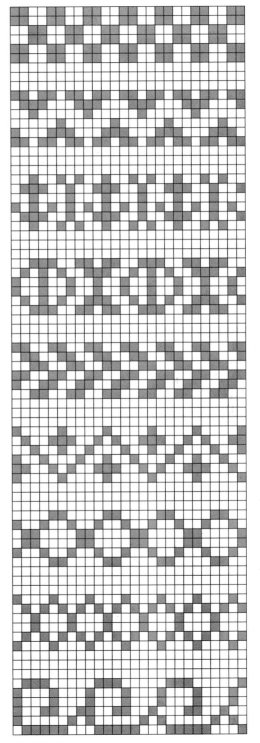

SIX-ROW PEERIES

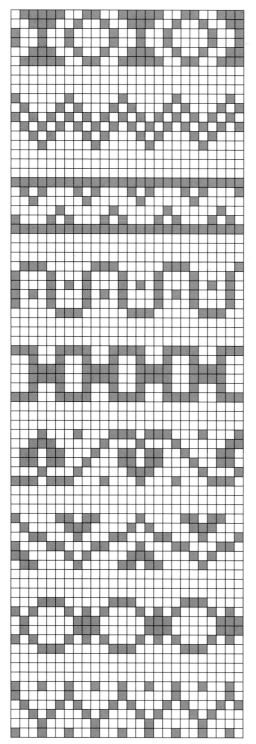

SEVEN-ROW PEERIES

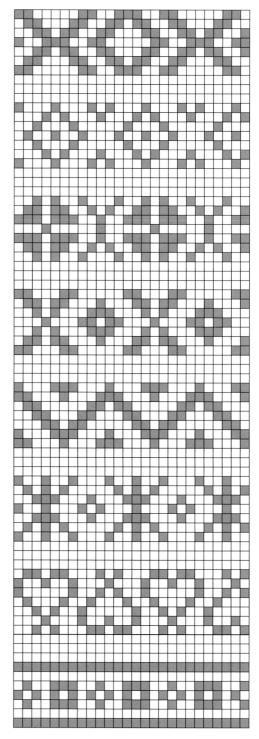

SEVEN-ROW PEERIES

EIGHT-ROW PEERIES

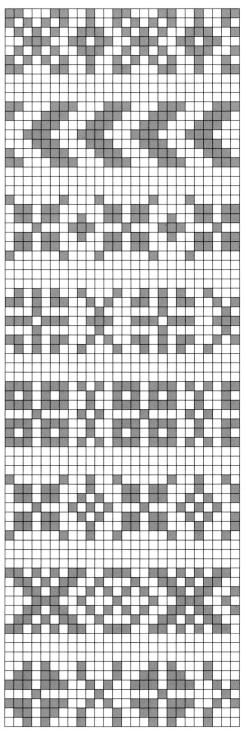

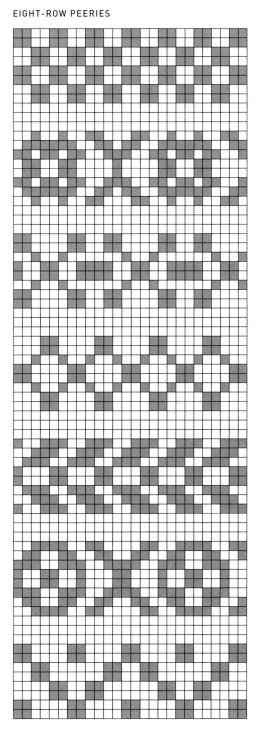

Borders

NINE-ROW BORDERS

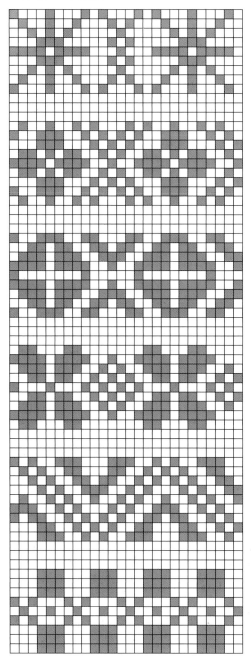

NINE-ROW BORDERS

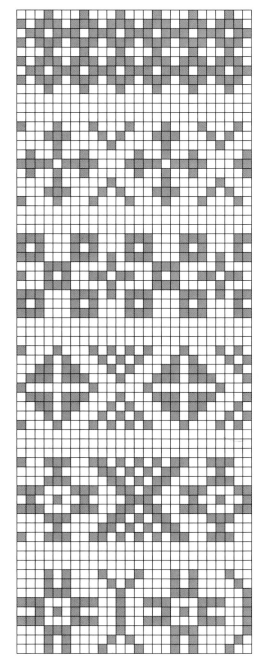

NINE-ROW BORDERS

TEN-ROW BORDERS

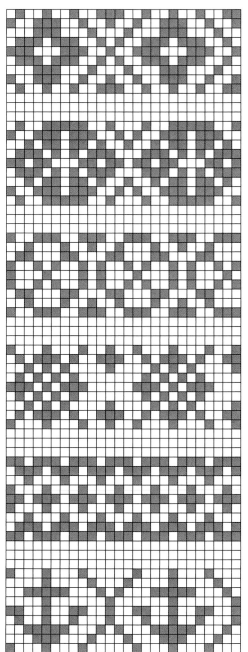

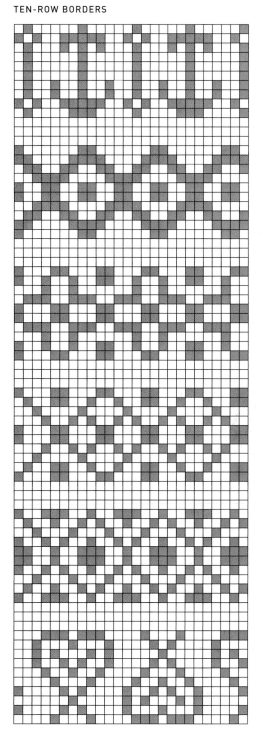

ELEVEN-ROW BORDERS

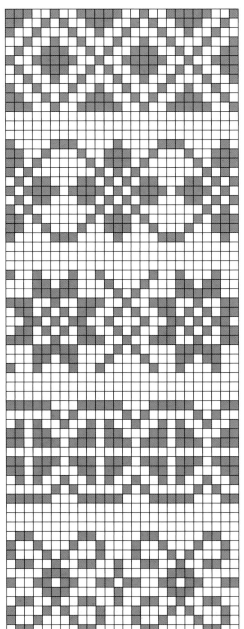

ELEVEN-ROW BORDERS

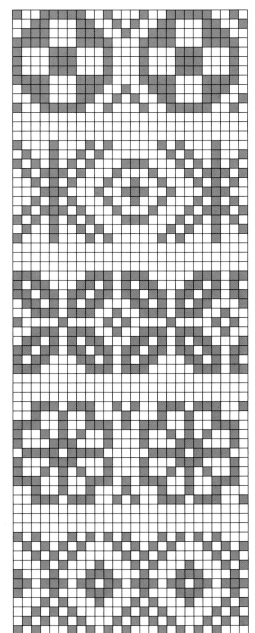

THIRTEEN-ROW BORDERS

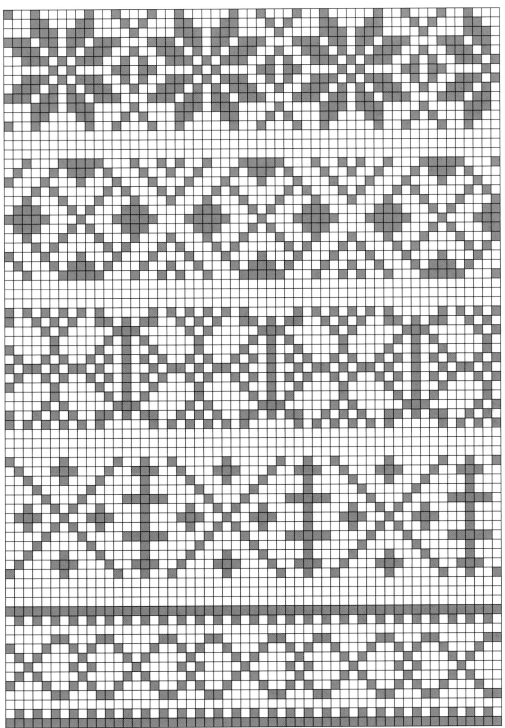

THIRTEEN-ROW BORDERS

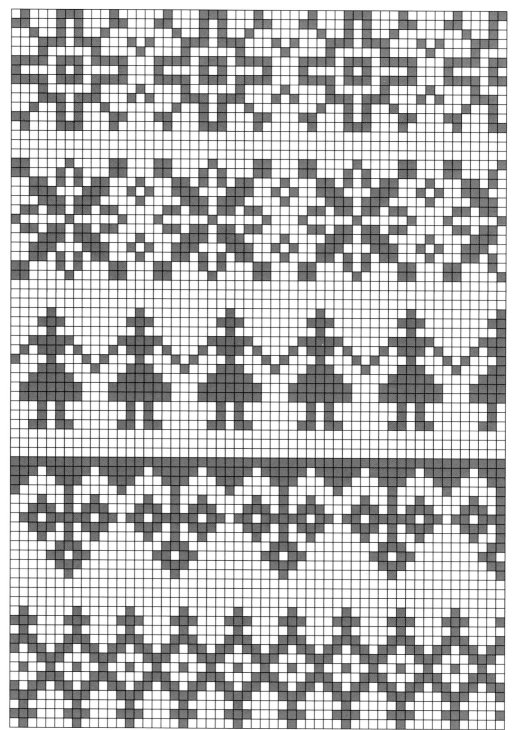

FIFTEEN-ROW BORDERS

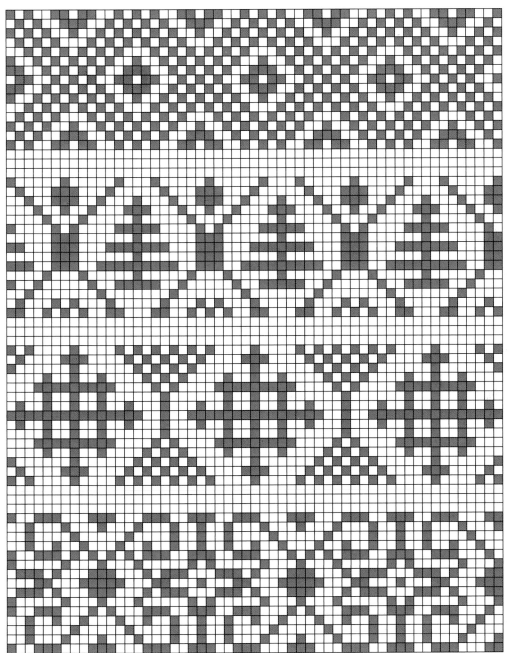

Seeding

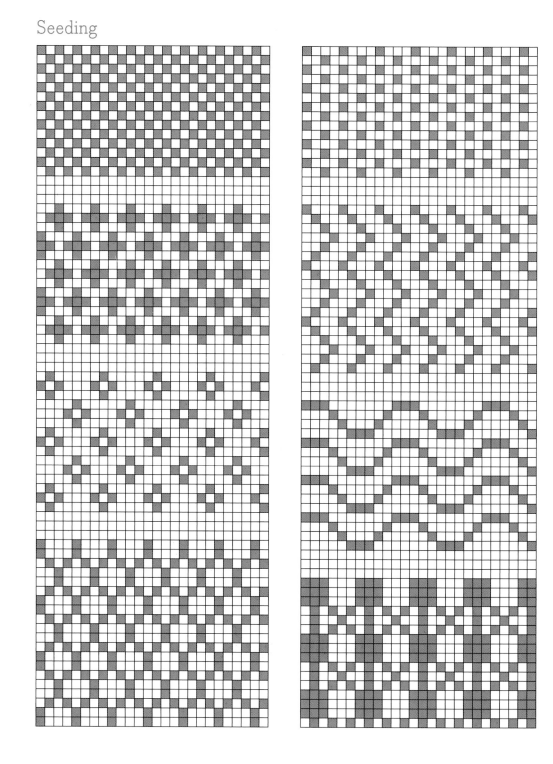

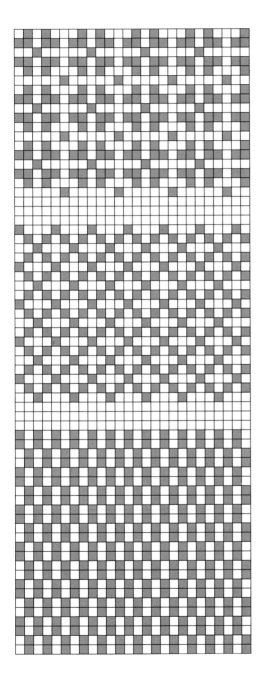
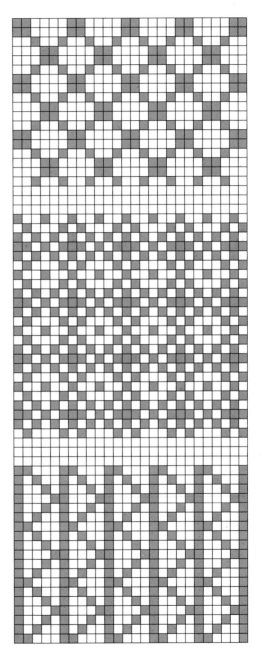

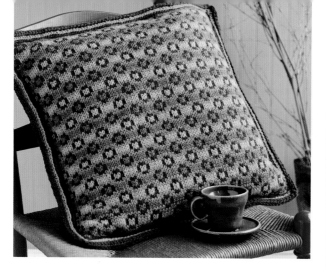

Stripes 'n' Dots Throw Pillow

Working stranded knitting in the round

Do you think stranded knitting is only for cold-weather wear? Think again. Knit this throw pillow to make your already-comfy couch a little cozier!

SUGGESTED ALTERNATE COLORWAYS
Alternate Colorway 1, left: JCA/Reynolds' *Soft Sea Worsted* in Tan #9742 (A), Dark Green #9661 (B), Natural #9260 (C), and Purple #9321 (D)

Alternate Colorway 2, right: Natural #9260 (A), Black #9220 (B), Red #9968 (C), and Cobalt #9501 (D) (4)

SKILL LEVEL
Intermediate

SIZE
One size

FINISHED MEASUREMENTS
Approximately 16" x 16"/[40.5cm x 40.5cm] square, not including border

MATERIALS
JCA/Reynolds' *Soft Sea Worsted:* 4-weight; 100% wool; each approximately 1¾ oz/[50g] and 77 yds/ [70.5m]. 3 hanks of Avocado #9652 (A), 2 hanks *each* of Chocolate #9470 (B) and Camel #9412 (C), and 1 hank of Harvest Gold #9742 (D) (4)

Size 8 (5mm) 24"/[60cm] circular needle, or size needed to obtain gauge

Size 8 (5mm) double-pointed needles

Four stitch markers

One pillow form, 16"/[40.5cm] square

Blunt-end yarn needle

GAUGE
18 stitches and 18 rows = 4"/[10cm] in Stranded Pillow Pattern.

To save time, take time to check gauge.

STITCH PATTERNS
Stockinette Stitch (any number of stitches)
Row 1 (RS): Knit across.

Row 2: Purl across.

Repeat Rows 1 and 2 for the pattern.

Stranded Pillow Pattern (multiple of 8 stitches)
See the chart (opposite).

Pillow

With A, cast on 152 stitches.

Place a marker on the needle to indicate the beginning of the round; slip the marker every round. *Join, being careful not to twist the stitches.*

Work even in Stockinette Stitch following the Stranded Pillow Pattern chart until the piece measures approximately 16½"/[42cm], ending after Round 4.

Bind off.

Finishing

Weave in all remaining yarn tails.

Block the piece to the finished measurements.

Use mattress stitch (page 168) to sew the bottom seam, placing the beginning of the round at one side edge.

Insert the pillow form.

Use mattress stitch to sew the top seam.

I-CORD BORDER

First Round of I-Cord

Place a marker in each corner stitch of the pillow.

With the right side facing, using the circular needle and B, pick up and knit 1 stitch for every row or stitch around the outside edge of the pillow.

Continuing with B, use the cable cast-on method (page 164) to cast on 3 stitches onto the tip of the circular needle; these 3 stitches will form your I-cord.

Using a double-pointed needle in your right hand, work applied I-cord as follows (page 168): *K2, ssk (joining the 3rd I-cord stitch with 1 picked-up stitch on the pillow); *do not turn*; slip the 3 stitches from the double-pointed needle back to the circular needle; repeat from * around until you reach a marked corner stitch.

Joining the corner stitch (3 rows): K3 (without joining stitches with an ssk), then slip the 3 stitches back to the circular needle; k2, ssk (joining the I-cord with the marked corner stitch—keep the marker in the corner stitch), then slip the 3 stitches from the double-pointed needle back to the circular needle; k3, then slip the 3 stitches back to the circular needle.

Continue working applied I-cord on the straight edges and working the 3 corner rows at each marked corner stitch until you have worked all around the pillow.

Use mattress stitch to sew the 2 ends of the I-cord together. Hide the yarn tails inside the I-cord.

Second Round of I-Cord

With the right side facing, using the circular needle and A, pick up and knit 1 stitch for every I-cord row, then cast on 3 stitches onto the tip of the circular needle. (If you are counting stitches, this round will have 8 more stitches than the previous one.)

Work as for the first round of applied I-cord, remembering to work 3 rows at each marked corner stitch.

Third Round of I-Cord

With B, work as for the 2nd round of I-cord. (If you are counting stitches, this round will have 8 more stitches than the previous one.)

STRANDED PILLOW PATTERN

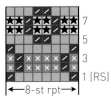

7
5
3
1 (RS)

←—8-st rpt—→

Color Key

□ = A

◪ = B

⊠ = C

★ = D

Stitch Key

□ = K

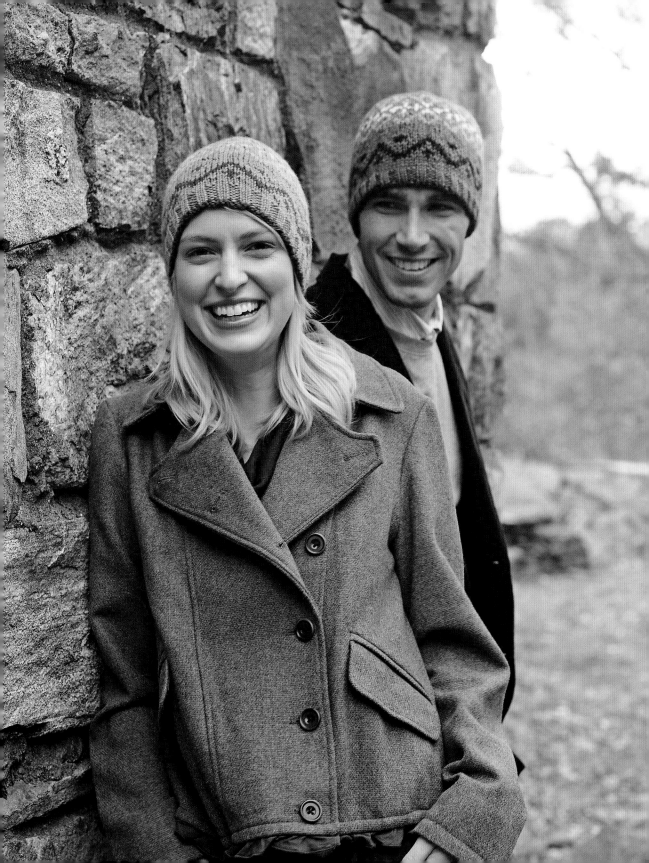

SKILL LEVEL
Easy

SIZES
Woman's (Man's). Instructions are for the smaller size, with changes for the larger size noted in parentheses as necessary.

FINISHED MEASUREMENTS
Circumference: 19¼ (21½)"/[49 (54.5)cm]

Length: 7¾ (8¼)"/[19.5 (21)cm]

MATERIALS
Plymouth Yarn Company's *Galway:* 4-medium/worsted weight; 100% wool; each approximately 3½ oz/[100g] and 210 yds/[192m]. For woman's version: 1 ball *each* of Kiwi #127 (A), Dark Teal #116 (B), Medium Blue #139 (C), Ocean Blue #111 (D), and Sky Blue #172 (E); for man's version: 1 ball *each* of Dusty Blue #159 (A), Dark Charcoal #704 (B), Medium Grey #751 (C), Pearl Grey #702 (D), and Aran #01 (E) **4**

Size 6 (4mm) 16"/[40.5cm] circular needle

Size 7 (4.5mm) 16"/[40.5cm] circular needle, or size needed to obtain gauge

Size 7 (4.5mm) double-pointed needles (set of 5), or size needed to obtain gauge

Stitch marker

Blunt-end yarn needle

GAUGE
20 stitches and 24 rounds = 4"/[10cm] in the Stranded Hat Pattern with the larger needle.

To save time, take time to check gauge.

STITCH PATTERNS
Rib Pattern (multiple of 4 stitches)
Pattern Round (RS): *K2, p2; repeat from * around.

Stranded Hat Pattern (multiple of 12 stitches, decreasing to a multiple of 4 stitches)
See the chart (page 60).

His and Hers Reflection Hat

Changing pattern colors

Sized for women and men, this little hat will help you hone your stranded knitting skills while keeping your friends and family warm. And beginning Fair Islers take note: Like the Stripes 'n' Dots Throw Pillow project on pages 56–57, no steeking is involved!

NOTES

- This hat is made in the round from the bottom up.

- Change to double-pointed needles when there are too few stitches remaining to knit comfortably with the circular needle.

- After completing one hat, you will have lots of the contrast colors left over; to knit a second hat, just purchase one more ball of background color.

SUGGESTED ALTERNATE COLORWAYS
Alternate Colorway 1, left: Plymouth Yarn Company's *Galway* in Aran #01 (A), Burgundy Plum # 66 (B), Raisin #152 (C), Dark Butterscotch #156 (D), and Butter #137 (E)

Alternate Colorway 2, right: Pearl Gray #702 (A), Eggplant #30 (B), Violet #13 (C), Light Plum #132 (D), and Rose #142 (E) **4**

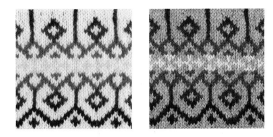

Hat

With the smaller circular knitting needle and B, use the cable cast-on method (page 164) to cast on 96 (108) stitches. Place a marker on the needle to indicate the beginning of the round; slip the marker every round. Join, being careful not to twist the stitches.

Change to A; work even in the Rib Pattern until the piece measures approximately 1"/[2.5cm].

Change to the larger circular needle; knit 2 (3) rounds.

Work the desired Stranded Hat Pattern chart through Round 37, changing to double-pointed needles when too many stitches have been decreased away to continue comfortably using

the circular needle, then knit 0 (1) round(s) with B—32 (36) stitches remain.

Next Round: With B, *ssk, k2tog; repeat from * around—16 (18) stitches remain.

Next Round: With B, k2tog around—8 (9) stitches remain.

Do not bind off. Cut the yarn, leaving a 12"/ [30.5cm] tail.

Finishing

Using a blunt-end yarn needle, thread the yarn tail through the remaining stitches and pull tight. Secure the yarn tail.

Weave in all remaining yarn tails.

Block the hat to the finished measurements.

WOMAN'S STRANDED HAT PATTERN
(mult 12 sts, dec to mult of 4 sts)

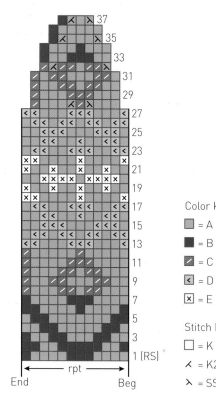

MAN'S STRANDED HAT PATTERN
(mult 12 sts, dec to mult of 4 sts)

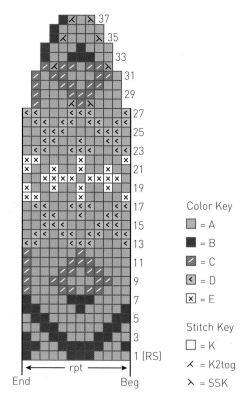

Color Key

■ = A
■ = B
◪ = C
◧ = D
☒ = E

Stitch Key

□ = K
◿ = K2tog
◺ = SSK

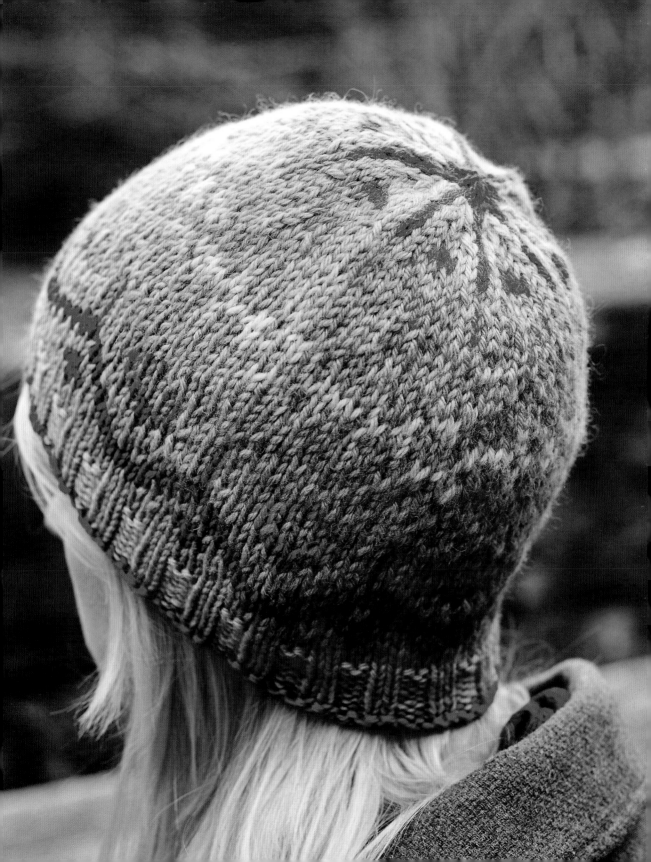

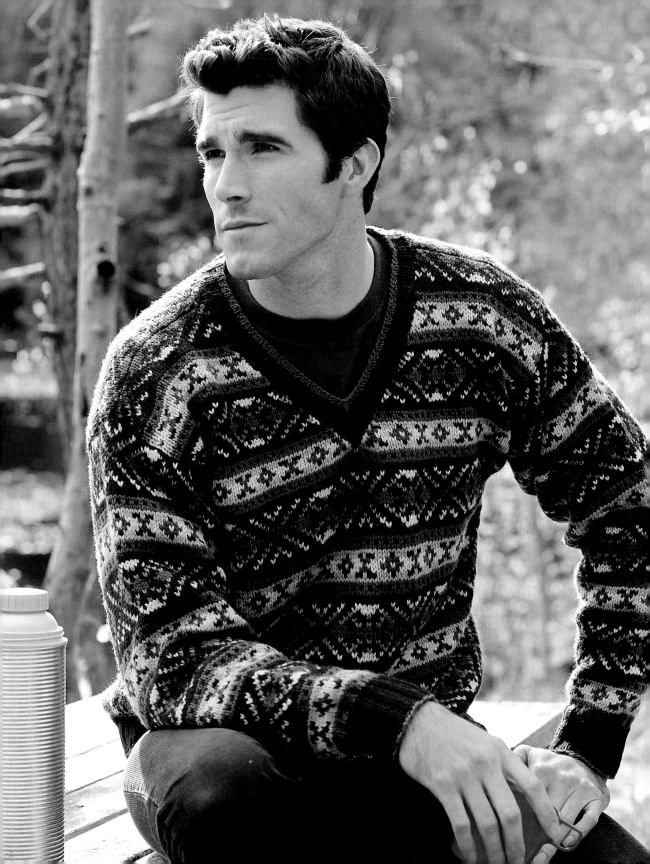

SKILL LEVEL
Challenging

SIZES
Man's XS (S, M, L, 1X, 2X). Instructions are for the smallest size, with changes for the other sizes noted in parentheses as necessary.

FINISHED MEASUREMENTS
Chest: 39¼ (43¼, 48, 53, 57½, 62½)/ [99.5 (110, 122, 134.5, 146, 159)cm]

Length: 26 (26½, 26½, 27, 27, 27)"/ [66 (67, 67, 68.5, 68.5, 68.5)cm]

MATERIALS
Classic Elite's *Renaissance:* 4-medium/ worsted weight; 100% wool; each approximately 1¾ oz/[50g] and 110 yds/ [100.5m]. 4 (4, 5, 6, 6, 7) hanks of Giotto Grape #7124 (A), 8 (8, 9, 10, 10, 11) hanks of Marine #7110 (B), 2 (2, 2, 3, 3, 3) hanks of Green Grape #7181 (C), 1 (1, 1, 1, 2, 2) hank(s) *each* of African Violet #7105 (D), Celery #7135 (E), Pesto #7160 (F), and Mountain Forest #7115 (G) 🧶

Size 6 (4mm) 16"/[40.5cm] circular needle

Size 6 (4mm) 32"/[80cm] circular needle

Size 6 (4mm) double-pointed needles [set of 4]

Size 8 (5mm) 16"/[40.5cm] circular needle, or size needed to obtain gauge

Size 8 (5mm) 24"/[60cm] circular needle, or size needed to obtain gauge

Size 8 (5mm) 32"/[80cm] circular needle, or size needed to obtain gauge

Size 8 (5mm) double-pointed needles [set of 4]

(continued on next page)

David's Favorite Fair Isle V-Neck

Using steeks for shaping

Knit this warm sweater for a special guy in your life. Since it's made of worsted-weight yarn, it won't take you eons to complete. But you might as well choose colors you like, because chances are you'll be borrowing this sweater often!

NOTES

- This sweater is worked entirely in the round from the bottom up, using steeks for the armholes and neck openings; the Sleeves are worked in the round separately from the Body, using steeks to shape the upper portion.

- The 9-stitch steeks are worked in a vertical stripe pattern as follows: *k1 background color, k1 pattern color; repeat from * 3 times more, k1 background color. The steek stitches are not included in the stitch counts; the number of steek stitches used is knitter's choice.

- When casting on for the steeks, use the e-wrap cast-on [page 32], alternating colors to match the steek stripe pattern.

- To increase within the Fair Isle Pattern, use the M1-L technique [page 165] in the color needed to maintain the Fair Isle Pattern.

- For sweater assembly, refer to the illustration for square-indented construction on page 169.

Stitch markers (1 in patterning color for beginning of round)

One safety pin

Blunt-end yarn needle

Size H/8 (5mm) crochet hook for crocheted steek (optional)

GAUGE

20 stitches and 20 rounds = 4"/[10cm] in Fair Isle Pattern with the larger needle.

To save time, take time to check gauge.

SPECIAL ABBREVIATION

s2kp2: Slip 2 stitches together knitwise, k1, pass the 2 slipped stitches over; this is a central double decrease (page 166).

STITCH PATTERNS

Rib Pattern (multiple of 4 stitches)
Pattern Round (RS): *K2, p2; repeat from * around.

Fair Isle Pattern
See the chart (page 67).

SUGGESTED ALTERNATE COLORWAYS

Alternate Colorway 1, left: Classic Elite's *Renaissance* in Portofino Orange #7185 (A), Mountain Forest #7115 (B), Vatican Gold #7168 (C), Tiled Roof #7178 (D), Celery #7135 (E), Green Grape #7181 (F), and Espresso #7138 (G)

Alternate Colorway 2, right: Chianti #7127 (A), Denim #7114 (B), Vatican Gold #7168 (C), African Violet #7105 (D), Celery #7135 (E), Portofino Orange #7185 (F), and Renaissance Red #7155 (G) (4)

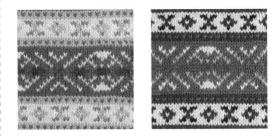

Body

With the smaller circular needle and A, cast on 196 (216, 240, 264, 288, 312) stitches; place a marker for the beginning of the round and join, being careful not to twist the stitches.

Change to B; work the Rib Pattern until the piece measures approximately 2½"/[6.5cm].

Pattern Set-Up Round: Change to the larger circular needle; work Round 1 of the Fair Isle Pattern, beginning and ending as indicated for your desired size on the front and back as follows: *work 0 (5, 11, 5, 11, 5) stitches before the marked pattern repeat, work the 24-stitch repeat 4 (4, 4, 5, 5, 6) times, work 1 (6, 12, 6, 12, 6) stitch(es) after the marked pattern repeat, place a marker, p1 in the background color for a "side seam" stitch, place a marker; repeat from * once more.

Work even in the established pattern until the piece measures approximately 16½"/[42cm], ending 5 (6, 7, 8, 9, 10) stitches before the beginning-of-the-round marker.

ESTABLISH ARMHOLE STEEKS

Next Round: Break the pattern-color yarn; remove the markers as you come to them, and with the background color, bind off the next 11 (13, 15, 17, 19, 21) stitches. Rejoin the pattern color and work to 5 (6, 7, 8, 9, 10) stitches before the seam stitch; break the pattern color.

With the background color, bind off the next 11 (13, 15, 17, 19, 21) stitches, rejoin the pattern color, work to the end of the round—87 (95, 105, 115, 125, 135) stitches each on front and back.

Next Round: Cast on 9 armhole-steek stitches (Notes, page 63), place a marker, work to the next set of bound-off stitches, place a marker, cast on 9 armhole-steek stitches, place a marker, work to the end of the round. Place a marker for the new beginning of the round.

Work even until the armhole measures approximately 1½ (2, 2, 2½, 2½, 2½)"/[3.8 (5, 5, 6.5, 6.5, 6.5)cm].

ESTABLISH FRONT NECK STEEK
AND SHAPE FRONT NECK

Next Round: Slipping the markers as you come to them, work the steek, work 43 (47, 52, 57, 62, 67) left front stitches, slip the next stitch onto a safety pin for the front of the neck, place a marker, cast on 9 front-neck-steek stitches, place a marker, work 43 (47, 52, 57, 62, 67) right front stitches, work the steek, work to the end of the round.

Decrease Round: Slipping the markers as you come to them, work the steek, work to 2 stitches before the front neck marker, ssk, work the steek, k2tog, work to the end of the round—42 (46, 51, 56, 61, 66) stitches remain for each front; 87 (95, 105, 115, 125, 135) back stitches.

Repeat the Decrease Round every round 5 more times, then every other round 14 times—23 (27, 32, 37, 42, 47) stitches remain for each front.

Work even until the armhole measures approximately 8½ (9, 9, 9½, 9½, 9½)"/[21.5 (23, 23, 24, 24, 24)cm].

ESTABLISH BACK NECK STEEKS
AND SHAPE BACK NECK

Next Round: Slipping the markers as you come to them, work the steek, work the left front stitches, work the steek, work the right front stitches,

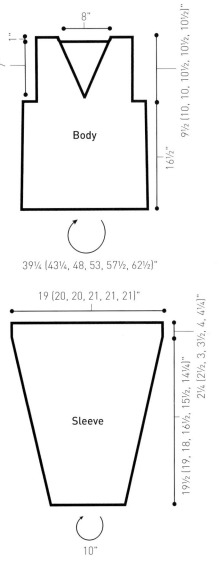

Body

8"

1"

7"

9½ (10, 10, 10½, 10½, 10½)"

16½"

39¼ (43¼, 48, 53, 57½, 62½)"

Sleeve

19 (20, 20, 21, 21, 21)"

2¼ (2½, 3, 3½, 4, 4¼)"

19½ (19, 18, 16½, 15½, 14¼)"

10"

NOTE: Measurements in schematic illustrations are finished measurements and do not include steek stitches.

work the steek, work 25 (29, 34, 39, 44, 49) back stitches, break the pattern color. With the background color, bind off the next 37 stitches, rejoin the pattern color, work to the end of the round.

Next Round: Slipping the markers as you come to them, work around to the bound-off stitches, place a marker, cast on 9 back-neck-steek stitches, place a marker, work to the end of the round.

Decrease Round: Slipping markers as you come to them, work around to 2 stitches before back-neck-steek marker, ssk, work the steek, k2tog, work to end of round—24 (28, 33, 38, 43, 48) stitches remain for each side of the back.

Repeat Decrease Round once more—23 (27, 32, 37, 42, 47) stitches remain for each side of back.

Work even until the armholes measure approximately 9½ (10, 10, 10½, 10½, 10½)"/[24 (25.5, 25.5, 26.5, 26.5, 26.5)cm]. Bind off.

Sleeves (Make 2)

With the smaller double-pointed needles and A, cast on 48 stitches; distribute on 3 needles, place a marker for the beginnning of the round, and join, being careful not to twist the stitches.

Change to B; work the Rib Pattern until the piece measures approximately 2½"/[6.5cm].

Set-Up Round: Change to the larger double-pointed needles and work Round 1 of the Fair Isle Pattern beginning and ending where indicated in the chart for the Sleeves as follows: Work 11 stitches before the marked pattern repeat, work the 24-stitch pattern repeat once, work 12 stitches after the marked pattern repeat, place a marker, p1 in the background color for the "seam" stitch.

Next (Increase) Round: M1 in pattern, work the established pattern to the first marker, M1 in pattern, slip the marker, p1 in the background color—50 stitches.

Continue the established pattern and repeat the Increase Round every round 0 (0, 0, 0, 0, 1) time(s), every other round 0 (0, 3, 18, 24, 27) times, every 3 rounds 13 (23, 22, 10, 4, 0) times, then every 4 rounds 10 (2, 0, 0, 0, 0) times—96 (100, 100, 106, 106, 106) stitches.

Work even until the piece measures approximately 19½ (19, 18, 16½, 15½, 14¼)"/[49.5 (48.5, 45.5, 42, 39.5, 37)cm].

ESTABLISH SLEEVE STEEKS

Next Round: Cast on 9 stitches for a steek, slip the beginning-of-round marker, work to the next marker, slip the marker, bind off the purled seam stitch—95 (99, 99, 105, 105, 105) stitches remain.

Work even until the Sleeve measures approximately 21¾ (21½, 21, 20, 19½, 18½)"/[55 (54.5, 53.5, 51, 49.5, 47)cm]. Bind off.

Finishing

Secure the back neck, front neck, armhole, and sleeve steeks.

Block the pieces to the finished measurements.

Cut the steeks (page 37). Trim the steeks as necessary; fold back and tack to the wrong side.

Use mattress stitch (page 168) to sew the shoulder seams.

Neckband

With the right side facing, using the smaller circular needle and B and beginning at the left shoulder neck edge, pick up and knit 40 stitches to the center front, knit the stitch on the safety pin and mark it, pick up and knit 40 stitches along the right front neck and 50 stitches along the back neck, place a marker, and join—131 stitches.

Decrease Round: Work in the Rib Pattern to 1 stitch before the marked center stitch; s2kp2; beginning with p1, work in the Rib Pattern to the end of the round—129 stitches.

Repeat Decrease Round every round, adjusting the Rib Pattern at center front as stitches are decreased, until the band measures 1"/[2.5cm].

Next Round: Change to A, and work in the established rib. With A, bind off loosely in rib.

Sew each Sleeve into an armhole, sewing the steeked edges at the top of the Sleeve to the bound-off stitches of the Body.

FAIR ISLE PATTERN

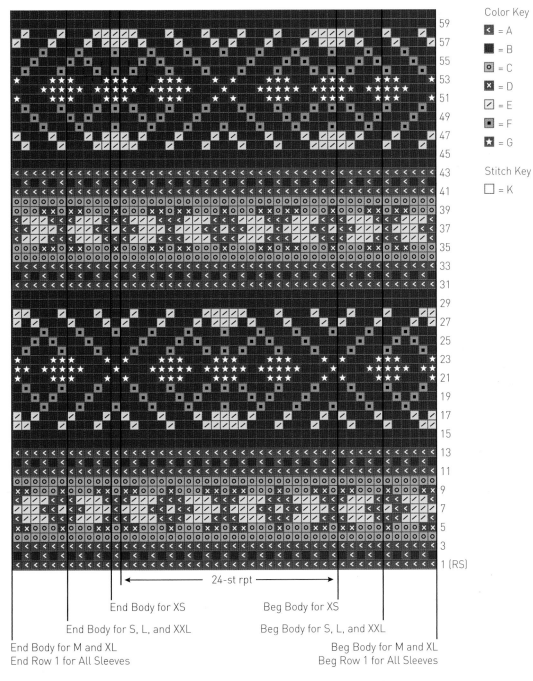

Color Key

< = A

■ = B

◉ = C

✕ = D

╱ = E

▪ = F

★ = G

Stitch Key

☐ = K

End Body for XS
Beg Body for XS

End Body for S, L, and XXL
Beg Body for S, L, and XXL

End Body for M and XL
End Row 1 for All Sleeves
Beg Body for M and XL
Beg Row 1 for All Sleeves

24-st rpt

NOTE: In the chart, the background color is A on Rnds 1–3, 11–13, 31–33, and 41–43; C on Rnds 4, 5, 9, 10, 34, 35, 39, and 40; E on Rnds 6–8 and 36–38; B on Rnds 12–30 and 44–60.

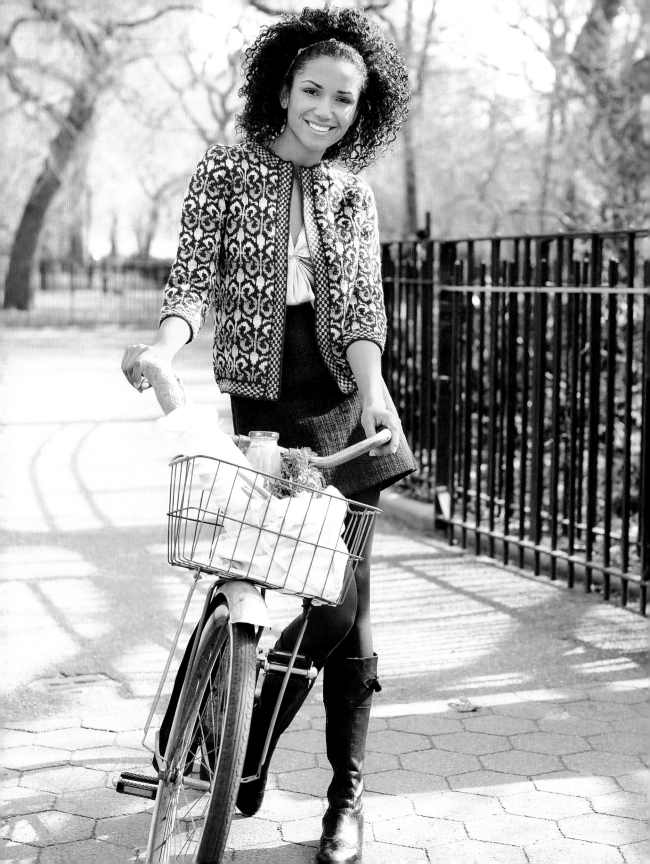

SKILL LEVEL

Challenging

SIZES

XS (S, M, L, 1X). Instructions are
for the smallest size, with changes
for the other sizes noted in parentheses
as necessary.

FINISHED MEASUREMENTS

Bust: 32¼ (35½, 39, 41½, 44¼)"/
[82 (90, 99, 105.5, 112.5)cm]

Hip: 34½ (36¾, 38½, 41¾, 44¾)"/
[87.5 (93, 98, 106, 113.5)cm]

Length: 20½ (21¼, 22, 23, 24)"/
[52 (54, 56, 58.5, 60)cm]

MATERIALS

Simply Shetland/Jamieson's *Spindrift:*
1-super fine weight; 100% wool; each
approximately 1 oz/[28g] and 115 yds/
[105m]. 7 (8, 9, 10, 11) balls of Sunrise
#187 (A), 2 *each* of Yellow Ochre #230
(B), Scotch Broom #1160 (C), Daffodil
#390 (D), and Lemon #350 (E) **1**

Size 2 (2.75mm) 29"/[74cm]
circular needle

Size 2 (2.75mm) 24"/[60cm]
circular needle

Size 2 (2.75mm) double-pointed needles
(set of 4)

Size 3 (3.25mm) 29"/[74cm] circular
needle, or size needed to obtain gauge

Size 3 (3.25mm) 24"/[60cm] circular
needle, or size needed to obtain gauge

Size 3 (3.25mm) 16"/[40.5cm] circular
needle, or size needed to obtain gauge

Size 3 (3.25mm) double-pointed needles
(set of 4)

(continued on next page)

Fleur de Lis Jacket

Increasing and decreasing in a steeked garment

Knitted using the traditional stranded technique with
steeks, this little jacket is anything but old-fashioned. A
slightly shaped silhouette and open front make it up-to-
date and particularly figure flattering.

NOTES

- This sweater is worked entirely in the round from the
 bottom up, using steeks for the front opening and the
 armhole and neck shapings; the Sleeves are worked in
 the round separately from the Body, using a steek to
 shape the sleeve cap.

- The background color is A throughout.

- The 9-stitch steeks are worked in a vertical stripe
 pattern as follows: *k1 with A, k1 with the pattern
 color; repeat from * 3 times more, k1 with A. The steek
 stitches are not included in the stitch counts; the num-
 ber of steek stitches used is knitter's choice.

- When casting on for the steeks, use the e-wrap cast-
 on (page 32), alternating colors to match the steek
 stripe pattern.

- To increase within the pattern, use the M1-L technique
 (page 165) in the color needed to maintain
 the pattern.

- The sweater is designed so that the patterns on the
 Body and Sleeves will line up at the armhole.

- For sweater assembly, refer to the illustration for set-in
 construction on page 169.

Eight stitch markers (1 in a contrasting color to mark the beginning of the rounds)

Blunt-end yarn needle

Size B/1 (2.25mm) crochet hook for crocheted steek (optional)

GAUGE
28 stitches and 32 rounds = 4"/(10cm) in Fleur de Lis Pattern with the larger needle.

To save time, take time to check gauge.

STITCH PATTERNS
Border Pattern Knitted in the Round (multiple of 4 stitches)
See the chart (opposite).

Border Pattern Knitted Flat (multiple of 4 stitches)
See the chart (opposite).

Side Panel Pattern
See the chart (opposite).

Fleur de Lis Pattern
See the chart (page 75).

SUGGESTED ALTERNATE COLORWAYS
Alternate Colorway 1, left: Simply Shetland/Jamieson's *Spindrift* in Gentian #710 (A), Maroon #595 (B), Rouge #563 (C), Sorbet #570 (D), and Rose #550 (E)

Alternate Colorway 2, right: Mulberry #598 (A), Peacock #258 (B), Seabright #1010 (C), Surf #135 (D), and Cloud #764 (E) **1**

Body
With the smaller circular needle and A, cast on 217 (233, 241, 261, 281) stitches.

BORDER
Work 9 stitches for the steek (Notes, page 69), place a marker for the beginning of the round, work Round 1 of the Border Pattern across the next 208 (224, 232, 252, 272) stitches, place a marker for the end of the round.

Maintain the steek stitches in the steek pattern throughout.

Work even until Round 10 of the Border Pattern is completed.

Next Round: Work Round 11 of the Border Pattern and increase 23 (25, 27, 29, 31) stitches evenly between the 2 markers—231 (249, 259, 281, 303) Body stitches.

Change to the larger circular needle.

Pattern Set-Up Round 1: With A, work the 9-stitch steek, slip the marker, k51 (56, 58, 63, 69) right front stitches, place a marker for the side, k8, place a marker for the side, k113 (121, 127, 139, 149) back stitches, place a marker for the side, k8, place a marker for the side, k51 (56, 58, 63, 69) left front stitches.

Pattern Set-Up Round 2: Slipping the markers as you come to them, work the 9-stitch steek; begin where indicated for

the right front for your size and work Round 1 of the Fleur de Lis Pattern over the next 51 (56, 58, 63, 69) stitches; work Round 1 of the Side Panel Pattern over the next 8 stitches; begin where indicated for the back for your size and work Round 1 of the Fleur de Lis Pattern over the next 113 (121, 127, 139, 149) stitches; work Round 1 of the Side Panel Pattern over the next 8 stitches; begin where indicated for the left front for your size and work Round 1 of the Fleur de Lis Pattern over the last 51 (56, 58, 63, 69) stitches.

SHAPE WAIST

Next (Decrease) Round: *Work to 2 stitches before the 1st side marker, ssk, slip the marker, work the Side Panel Pattern, slip the marker, k2tog; repeat from * once more, then work to the end of the round—50 (55, 57, 62, 68) stitches remain for each front; 111 (119, 125, 137, 147) stitches remain for the back.

Repeat the Decrease Round every 8 rounds 4 (0, 0, 0, 0) more times, every 10 rounds 0 (3, 3, 1, 1) more time(s), then every 12 rounds 0 (0, 0, 2, 2) times—46 (52, 54, 59, 65) stitches remain for

each front; 103 (113, 119, 131, 141) stitches remain for the back.

Work even until the piece measures approximately 6½ (6¾, 7, 7¼, 7¾)"/(16.5 (17, 18, 18.5, 19.5)cm).

Next (Increase) Round: *Work to the 1st side marker, M1-L, slip the marker, work the Side Panel Pattern, slip the marker, M1-L; repeat from * once more, then work to the end of the round—47 (53, 55, 60, 66) stitches for each front; 105 (115, 121, 133, 143) back stitches.

Repeat the Increase Round every 12 rounds 0 (0, 3, 2, 0) times, every 14 rounds 0 (0, 1, 1, 0) time(s), every 16 rounds 0 (0, 0, 0, 1) time(s), then every 18 rounds 0 (0, 0, 0, 1) time(s)—47 (53, 59, 63, 68) stitches for each front; 105 (115, 129, 139, 147) back stitches.

Work even until the piece measures approximately 13 (13½, 14, 14½, 15)"/(33 (34.5, 35.5, 37, 38)cm), ending after Round 24 (4, 8, 12, 16) of the Body pattern.

BORDER PATTERN

Knitted in the Round (mult 4 sts)

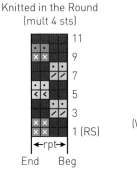

End Beg

NOTE: On Rnds 2, 4, 6, 8, and 10 only: Purl sts worked in colors B, C, and D; knit sts worked in color A.

Knitted Flat (mult 4 sts)

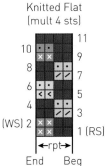

End Beg

NOTE: On Rows 2, 4, 6, 8, and 10 only: Knit sts worked in colors B, C, and D; purl sts worked in color A.

SIDE PANEL PATTERN

(8 sts)

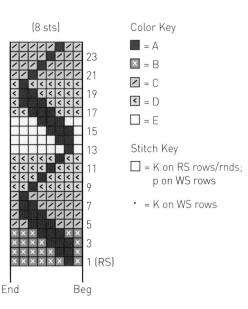

End Beg

Color Key

■ = A
☒ = B
◪ = C
◨ = D
☐ = E

Stitch Key

☐ = K on RS rows/rnds; p on WS rows

· = K on WS rows

ESTABLISH ARMHOLE STEEKS
AND SHAPE ARMHOLES

Next Round: Removing the side markers as you come to them, work to 2 (4, 5, 6, 7) stitches before the 1st side marker; break the pattern color. Bind off the next 12 (16, 18, 20, 22) stitches with A, then rejoin the pattern color and work to 2 (4, 5, 6, 7) stitches before the next side marker. Break the pattern color, bind off the next 12 (16, 18, 20, 22) stitches with A, rejoin the pattern color, and work to the end of the round—45 (49, 54, 57, 61) stitches remain for each front; 101 (107, 119, 127, 133) stitches remain for the back.

Next Round: Work to the 1st set of bound-off stitches, place a marker, cast on 9 stitches for the armhole steek, place a marker, work to the 2nd set of bound-off stitches, place a marker, cast on 9 stitches for the armhole steek, place a marker, work to the end of the round.

Next (Decrease) Round: Slipping the markers as you come to them, *work to 2 stitches before the armhole steek, ssk, work 9 stitches for the steek, k2tog; repeat from * once more, then work to the end of the round—44 (48, 53, 56, 60) stitches remain for each front; 99 (105, 117, 125, 131) stitches remain for the back.

Repeat the Decrease Round every other round 0 (2, 11, 10, 16) times, then every 4 rounds 6 (6, 2, 3, 0) times—38 (40, 40, 43, 44) stitches remain for each front; 87 (89, 91, 99, 99) stitches remain for the back.

Work even until the armholes measure 4½ (4¾, 5, 5½, 6)"/[11.5 (12, 12.5, 14, 15)cm], ending 9 (10, 10, 10, 10) stitches before the end of the round marker.

ESTABLISH FRONT NECK STEEKS
AND SHAPE FRONT NECK

Next Round: Break the pattern color; removing the front steek markers as you come to them, bind off 23 (25, 25, 25, 25) front neck stitches with A, rejoin the pattern color, work to the end of the round—29 (30, 30, 33, 34) stitches remain for each front.

Next Round: Place a marker, cast on 9 stitches for the front neck steek, place a marker, work to the end of the round.

Next (Decrease) Round: Slipping the markers as you come to them, work 9 stitches for the steek, k2tog, work around to 2 stitches before the front neck steek, ssk—28 (29, 29, 32, 33) stitches remain for each front.

Repeat the Decrease Round every round twice, every other round twice, then every 4 rounds twice—22 (23, 23, 26, 27) stitches remain for each front.

Work even until the armholes measure approximately 7 (7¼, 7½, 8, 8½)"/[18 (18.5, 19, 20.5, 21.5)cm].

ESTABLISH BACK NECK STEEKS
AND SHAPE BACK NECK

Next Round: Slipping the markers as you come to them, work to 24 (25, 25, 28, 29) stitches past the armhole steek, break the pattern color, bind off the next 39 (39, 41, 43, 41) back neck stitches with A, rejoin the pattern color, and work to the end of the round—24 (25, 25, 28, 29) stitches remain for each back shoulder.

Next Round: Work to the bound-off stitches, place a marker, cast on 9 stitches for the back neck steek, place a marker, work to the end of the round.

Next (Decrease) Round: Slipping the markers as you come to them, work to 2 stitches before the 1st back neck steek marker, ssk, work 9 stitches for the back neck steek, k2tog, work to the end of the round—23 (24, 24, 27, 28) stitches remain for each back shoulder.

Repeat the Decrease Round once more—22 (23, 23, 26, 27) stitches remain for each back shoulder.

Work even until the armholes measure approximately 7½ (7¾, 8, 8½, 9)"/[19 (19.5, 20.5, 21.5, 23)cm].

With A, bind off all stitches.

Sleeves (Make 2)

With the smaller double-pointed needles and A, cast on 64 (68, 72, 72, 76) stitches; place a marker for the beginning of the round and join, being careful not to twist the stitches.

Work Rounds 1–11 of the Border Pattern, and on the last round, increase 5 (5, 5, 9, 9) stitches evenly around—69 (73, 77, 81, 85) stitches.

Pattern Set-Up Round: Change to the larger double-pointed needles; work Round 1 of the Side Panel Pattern over the first 8 stitches, place a marker; beginning where indicated for Sleeves for your size, work Round 17 of the Fleur de Lis Pattern to the end of the round.

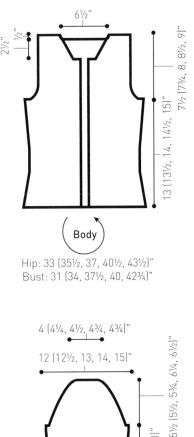

Hip: 33 (35½, 37, 40½, 43½)"
Bust: 31 (34, 37½, 40, 42¾)"

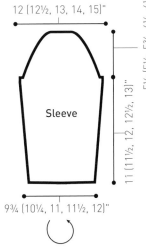

NOTE: Measurements in schematic illustrations are finished measurements and do not include steek stitches or front borders.

Next (Increase) Round: Work the Side Panel Pattern, slip the marker, M1 in pattern, continue the Fleur de Lis Pattern to the next marker, M1 in pattern—71 (75, 79, 83, 87) stitches.

Repeat the Increase Round every 8 rounds 0 (0, 0, 0, 2) times, every 9 rounds 0 (0, 0, 0, 8) times, every 10 rounds 7 (5, 3, 7, 0) times, then every 12 rounds 0 (2, 4, 1, 0) times, changing to a circular needle as the stitches accumulate—85 (89, 93, 99, 107) stitches.

Work even until the piece measures approximately 11 (11½, 12, 12½, 13)"/[28 (29, 30.5, 32, 33)cm], ending after Round 24 (4, 8, 12, 16) of the Fleur de Lis Pattern, 6 (8, 9, 10, 11) stitches before the end of the round.

ESTABLISH SLEEVE CAP STEEKS AND SHAPE CAP
Next Round: Cut the pattern color; with A, bind off 12 (16, 18, 20, 22) stitches; rejoin the pattern color, and work to the end of the round—73 (73, 75, 79, 85) stitches remain.

Next Round: Cast on 9 stitches for the sleeve cap steek, place a marker, work to the end of the round.

Next (Decrease) Round: Slipping the markers as you come to them, work 9 stitches for the steek, k2tog, work to the last 2 stitches of the round, ssk—71 (71, 73, 77, 83) Sleeve stitches remain.

Repeat the Decease Round every 4 rounds 0 (0, 0, 2, 0) times, every other round 22 (21, 17, 20, 25) times, then every round 0 (0, 4, 0, 0) times, changing to double-pointed needles as necessary—27 (29, 31, 33, 33) Sleeve stitches remain.

With A, bind off.

Finishing
Secure the front, back neck, front neck, and armhole steeks (page 34).

Block the pieces to the finished measurements.

Cut the steeks (page 37).

Trim the steeks as necessary; fold back and tack to the wrong side.

Use mattress stitch (page 168) to sew the shoulder seams.

NECKBAND
With the right side facing, using the smaller circular needle and A, pick up and knit 104 stitches along the neckline.

Next Row (WS): With A, purl across.

Work Rows 1–11 of the Border Pattern.

With A, bind off all stitches.

FRONT BANDS
With the right side facing, using the smaller circular needle and A, pick up and knit 148 (156, 164, 176, 188) stitches along the left front edge, including the side of the neckband.

Work Rows 1–11 of the Border Pattern.

With A, bind off all stitches.

Repeat along the right front edge, including the side of the neckband.

EDGING FOR FRONT BANDS
With the right side facing, using a smaller double-pointed needle and A, pick up and knit 8 stitches along the top of the right front band.

Next Row (WS): Bind off knitwise.

Repeat along the top edge of the left front band.

Repeat along the bottom edge of both the right and left front bands.

Set in the Sleeves.

FLEUR DE LIS PATTERN

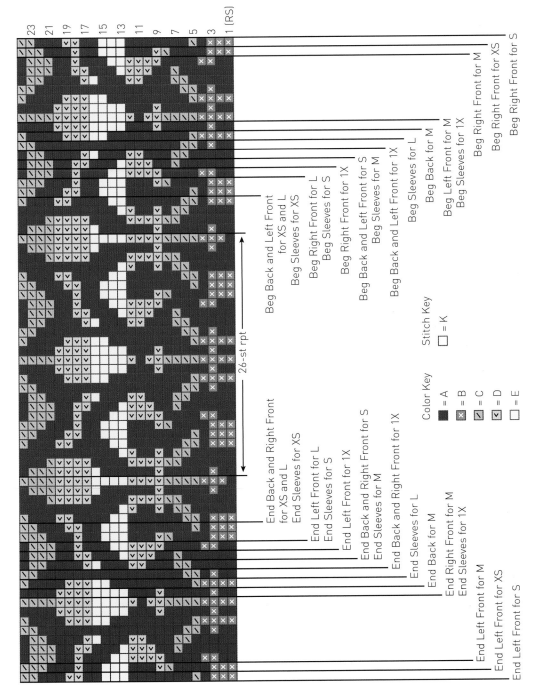

23 21 19 17 15 13 11 9 7 5 3 1 (RS)

Beg Right Front for S
Beg Right Front for XS
Beg Right Front for M

Beg Left Front for S
Beg Sleeves for 1X
Beg Left Front for M
Beg Back for M
Beg Sleeves for L

Beg Back and Left Front for 1X
Beg Sleeves for M
Beg Back and Left Front for S
Beg Right Front for S
Beg Sleeves for S
Beg Right Front for L

Beg Back and Left Front
for XS and L
Beg Sleeves for XS

26-st rpt

End Back and Right Front
for XS and L
End Sleeves for XS

End Left Front for L
End Sleeves for S

End Left Front for 1X

End Back and Right Front for S
End Sleeves for M

End Back and Right Front for 1X

End Sleeves for L

End Back for M

End Right Front for M
End Sleeves for 1X

End Left Front for M
End Left Front for XS

End Left Front for S

End Left Front for S

Stitch Key
☐ = K

Color Key
■ = A
☒ = B
◪ = C
⊻ = D
☐ = E

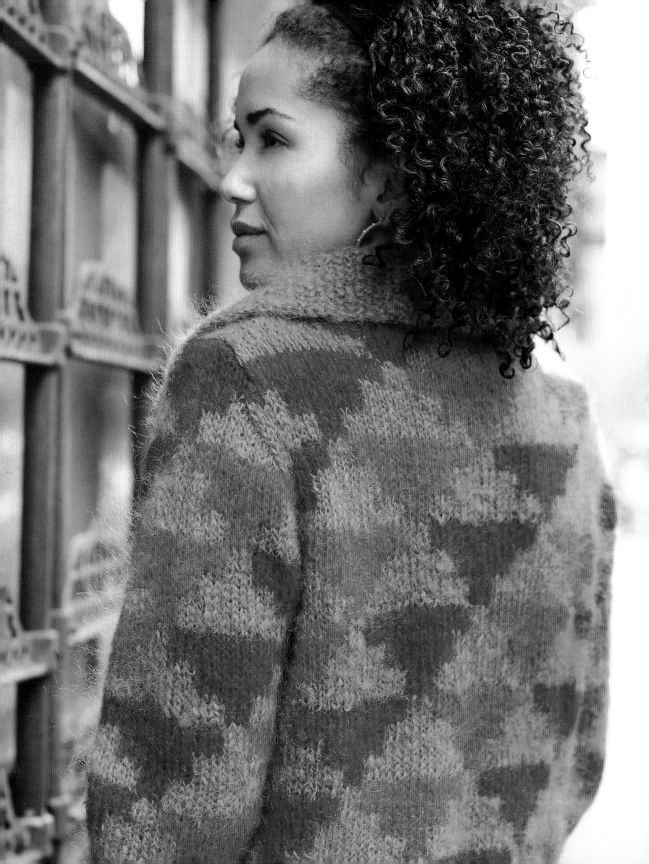

3

Intarsia Knits:

Just Picture It

Knitters use intarsia to "draw" with stitches. With this technique, the fabric appears to be stamped with a colorful graphic, but the picture is knitted right in! Unlike stranded knitting, you do not float yarn along the wrong side of the work. In intarsia patterns the sections of each color are typically too wide for manageable floats—and catching them on the wrong side of the fabric every few stitches would create a mighty thick fabric! Instead, different yarn supplies must be used for each isolated section of color. With no floats on the wrong side, intarsia fabrics tend to behave like plain stockinette: They drape nicely and are comfortable to wear.

Left: Clear, well-defined color patterns are a signature of intarsia fabric. The right side of this swatch shows off a brightly colored Diamond Harlequin Pattern. **Right:** The wrong side of intarsia knitting is as smooth as the front, but where the colors meet, some overlapping of color occurs. Note that there are no floats of yarn across the back of the fabric as there are in stranded knitting (Chapter 2, page 21).

Although many colors might be worked across each row of intarsia—each requiring a separate yarn supply—the process is really not much different from regular stockinette once you learn and practice some simple maneuvers. Even the gazillions of yarn tails are easy to deal with once you know how!

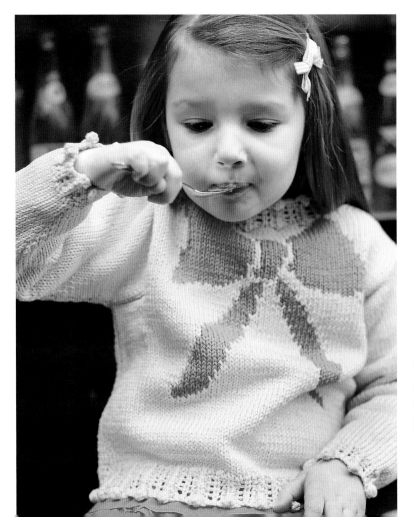

Left: The gauge for intarsia and stockinette fabrics is the same, so it's easy to insert a charted intarsia motif into any plain sweater or other project as you knit. You could even knit a heart to wear on your sleeve!

Preparing Yarns

For many people the word *intarsia* is synonymous with *tangle*. Because intarsia requires multiple supplies, or balls, of yarn for each row of the pattern, tangles and twists among the yarns inevitably ensue. However, these tangles do not necessarily mean frustration or failure, and investing a little prep time before beginning to knit will allow you to stay organized and frustration-free.

First, use your pattern chart to determine how many balls of yarn you'll need. For example, take a look at the chart for the Diamond Harlequin Pattern below. To knit just one repeat of the chart on thirteen stitches, one ball of orange and two balls of red would be required. And, if three repeats were to be knitted on thirty-seven stitches, as in the photographs, three balls of orange and four balls of red would be used. The row of your pattern that has the most colors is the row you'll want to use to determine the number of balls needed.

Some of the colored sections in a pattern could be large enough that you would need a full ball of that color at the ready. Center-pull balls are easiest to work from since they tend to stay put while dispensing their goodies—and they tangle less! But for smaller sections of color, use partial balls. You can use commercially available bobbins to wind the yarn around or cut your own bobbins out of cardboard. Many knitters prefer to make little self-contained yarn butterflies for each section, as they find these smaller bits of yarn lighter and easier to manage than yarn wrapped on a bobbin. However, there are a myriad of ways to organize your yarn, so try a few methods until you find the one that you like best. Don't get too concerned about having the perfect length of yarn on a butterfly or bobbin. If you run short, simply start a new one!

DIAMOND HARLEQUIN PATTERN

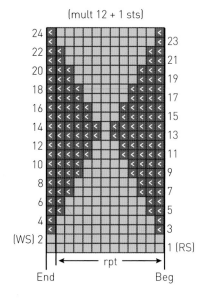

(mult 12 + 1 sts)

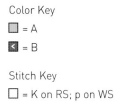

Color Key

☐ = A

◼ = B

Stitch Key

☐ = K on RS; p on WS

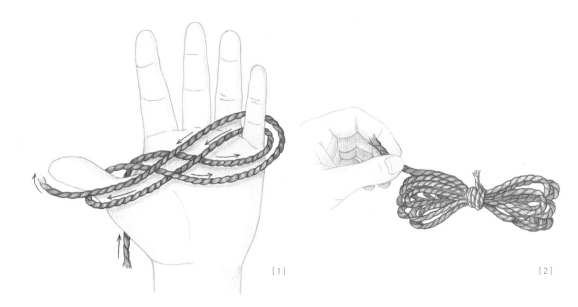

[1]

[2]

To make a yarn butterfly: Leave a 6"/[15cm] tail and wind the yarn in figure-eight fashion around your thumb and pinkie (illustration 1). When enough yarn has been wound, cut it, leaving a 7"/ [18cm] tail. Wrap the tail around the middle of the butterfly several times and tie it into a knot to secure it (illustration 2). Knit from the unknotted end, releasing only what you need at a time.

Other knitters, myself included, prefer to knit intarsia without bobbins or butterflies. Instead, I simply use long lengths of yarn (no more than 1 or 2 yards long/[1 or 2m] each). These straight lengths of yarn are easy to untangle. Just pull them out one at a time when you can't stand the jumbled mess! (It's my cat's favorite part of my knitting routine.)

color PLAY

To conserve yarn (and possibly your sanity, too), when you're knitting an allover pattern that consists of one repeated geometric motif (such as for the Traveling Triangles Jacket on page 114), you can knit one motif and then rip it out to determine exactly how much yarn each little section of color requires. Add a little extra length to accommodate the two yarn tails that each section requires, and cut all your yarns to that measurement.

Intarsia Techniques

Following are some basic skills you'll use when knitting intarsia, including how to change yarn colors in the middle of a row, how to easily manage all those pesky yarn tails, and how to use an embroidery technique called duplicate stitch to add tiny sections of color to a design. We'll even explore some painless ways to work intarsia when knitting in the round.

Interlocking to Prevent Holes

To begin knitting with a new color yarn, we often just pick up the new yarn and begin! Not so with intarsia, which demands that we change yarns frequently within a pattern row. When starting a new yarn and switching between yarns, use an interlocking maneuver—twisting the yarns together—to avoid creating unwanted holes in the fabric.

Starting a New Yarn Supply Mid-Row

Here's how to attach a new yarn supply in the middle of a row. It might seem counterintuitive to leave the yarn tail hanging on the right side of the fabric, but it interlocks the tail securely with the fabric. Later you'll pull the tail to the back and weave it in.

On a right-side row: Place the new ball of yarn on the wrong side of the fabric, leaving a 6"/[15cm]

color PLAY

I use the yarn-tail-to-the-right-side-of-the-fabric technique every time I join a new supply of yarn in the middle of a row, not just for intarsia! It interlocks the pesky tails within the knitted fabric and helps stabilize it, making finished measurements and gauge much more accurate.

tail dangling on the right side of the fabric. Lift the old yarn and bring it over and to the left of the new yarn (illustration 3). Grab the new yarn and simply begin knitting with it.

On a wrong-side row: Place the new ball of yarn on the wrong side of the fabric, leaving a 6"/[15cm] tail hanging on the right side of the fabric. Lift the old yarn and bring it over and to the left of the new yarn (illustration 4). Grab the new yarn and start purling with it.

[3]

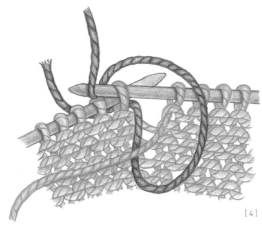

[4]

[5]

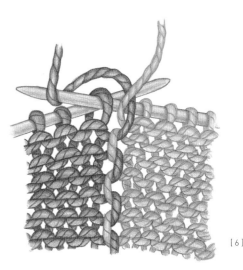

[6]

Switching Between Yarns

The method for changing from one color to another color is surprisingly easy and is the same no matter which side of the fabric you're on.

To pick up a yarn already in use: Drop the old yarn to the left of the new one, then pick up the new one from underneath the old one, bring it over the new one, and begin knitting (illustration 5) or purling (illustration 6), whichever is appropriate.

NOTE: *Use the same method for switching between yarns whether the new stitches are directly above stitches previously knit in that color or placed diagonally.*

color PLAY

When working in the round with double-pointed needles, try not to place the beginning of rounds at the intersection of two needles. Your fabric will be neater—and you'll be a much happier knitter—if you're not changing needles while dealing with the beginning- and end-of-round joins.

Intarsia in the Round

In most cases, intarsia is knitted back and forth in rows. However, to make finishing quicker and easier, some knitters prefer to knit in the round. But working intarsia in the round leaves yarn supplies hanging on the left-hand side of each area of color, while the knitter needs them on the right side in order to knit. For knitters devoted to circular knitting, I offer three work-arounds for this issue. Technically, these methods are knitted back and forth, even though circular or double-pointed knitting needles are used. Special tricks connect the beginnings and ends of the rounds-rows so they appear seamless.

Connecting Ends of the Rounds Using Yarn Overs

The first method of working intarsia in the round uses yarn over stitches. A yarn over is added at the beginning of every round. This extra stitch is decreased away at the end of the round to maintain the stitch count.

To begin, place a marker on the first and last stitches of the round. With the right side of the

fabric facing you, starting at the beginning-of-round marker, yarn over, then knit in your pattern across the entire first round, ending just before the marked last stitch of the round (just one stitch before the yarn over). Join this next stitch and the yarn over together by making an ssk.

Turn the work (the "rows" will be joined later) and, with the wrong side facing you, yarn over, then continue across the next round, purling in your pattern, again ending just before the marked first stitch of the round. P2tog to join the yarn over and this next stitch together.

Repeat these two rounds, always working a yarn over as you start every new round and finishing with a p2tog or ssk, combining the last stitch of the round with the yarn over.

Connecting Ends of the Rounds Using a Fake Seam

This technique uses a slipped stitch to give the appearance of a seam. Try it the next time you're knitting intarsia socks—you can use whatever cast-on you'd like, whether toe up or top down. Just add one extra stitch at the end of the round, usually placed at the back seam of the garment.

To begin, cast on the number of stitches needed plus one. Place a marker on this extra stitch. With the right side of the fabric facing you, work across the entire first round, including the extra stitch.

Turn, and with the wrong side facing you, slip the extra stitch purlwise (page 166), then work in your pattern across to end the round, ending the round by purling the extra stitch.

Turn, and with the right side facing you, slip the extra stitch purlwise, then work in your pattern across to end the round, ending the round by knitting the extra stitch.

Repeat these last two rounds, always slipping the extra stitch purlwise at the beginning of every round and knitting or purling it at the end of the round.

Connecting Ends of the Rounds Using a Pole Yarn

If your intarsia fabric is mostly background color with various contrast-colored motifs, try this method. It utilizes a separate, freestanding piece of the background yarn, called a pole yarn, around which the working yarns are wrapped before turning at the end of each round.

To begin, knit along to the beginning of the round, then bring the working yarn around the pole yarn as you normally would when interlocking to twist yarns at any intarsia join, then turn and purl in the opposite direction, working the intarsia pattern. At the end of each round, wrap the working yarn around the pole yarn before turning and continuing in the pattern.

color PLAY

When using the pole yarn method, be careful not to pull the pole yarn out by mistake; all your wraps will be lost, and your fabric will split apart at the join!

Managing Yarn Tails

Intarsia produces many, many yarn tails that must be woven in—two tails for each separate section of color. Although some knitters prefer to weave in the yarn tails at a project's completion, many knitters enjoy working them in as they go. I suggest that you do so, too, not just to save finishing time later but also to avoid mixing up the tails as you knit. (Trust me, you would not be the first knitter who's ever knitted with her tail!)

Weaving in Yarn Tails As You Knit

To prevent visible yarn tails, those from the start of a new color should be woven in during a subsequent row of that same color; tails resulting from the final use of a color, however, are best woven in during the first row of the next color. If the yarn tail is on the right side of the fabric, just bring it to the wrong side to weave it in later. Be sure it is interlocked before proceeding or else a tiny hole will form in the fabric. If it isn't interlocked, use a blunt-tip yarn needle to draw the tail through the interlock spot, twisting it with the other color, and then you can begin weaving it in as you knit (or purl).

The process for weaving in the yarn tails as you go is slightly different for Continental- and American-style knitting. For both types of knitting, the tail is held in the nonworking hand (the right hand if you're a Continental-style knitter or the left hand if you're an American-style thrower).

For American style: Bring the tail under the working yarn as you knit or purl the next stitch. For the subsequent stitch, bring the old yarn tail over the working yarn as you knit or purl the stitch. Continue this way, alternately bringing the tail over and under the working yarn on the wrong side of the fabric for approximately 2"/[5cm]. Snip the tail, leaving ½"[13mm].

For Continental style: Work the first stitch in the normal way. For the second stitch, insert the right-hand needle into the stitch as usual, then, before working the stitch, bring the yarn tail over the working yarn and around the right-hand needle tip counterclockwise; finally, wrap the working yarn around the needle as usual, then unwrap the tail back to its original position and complete the stitch the regular way by moving it to the right-hand needle. Continue in this manner for approximately 2"/[5cm], alternately working one stitch without wrapping the tail and another stitch wrapping the tail. Snip the tail, leaving ½"/[13mm].

NOTE: *If you have fewer than six or seven stitches of the proper color in which to work a yarn tail, try weaving the tail along the places where that color interlocks with another yarn on the wrong side—even diagonally, if necessary.*

As you weave in the tails, it's important to maintain the regular tension of your knitting. Check the public side of your fabric as you go to make sure that the stitches are not distorted. If you find that the woven strands are a bit tighter than the rest of

the fabric, tug gently widthwise to loosen the tails. Fabric that looks wonky on the needles will look just as wonky off the needles—no amount of blocking will cure it.

Weaving in Yarn Tails During Finishing

Some knitters actually enjoy the concentrated work of weaving in all the yarn tails once the knitting is completed. For them it's a way to avoid the "post-project depression" that can occur at the end of a large project. Refer to Color Knitting Fundamentals on page 15 for instructions on weaving in the tails after the fact.

Working Isolated Colors

For extremely small sections of a color, about four stitches or less, you might prefer to embroider the new color on top of stitches worked in another color to avoid carrying one more yarn across the row. Duplicate stitch embroidery (also called Swiss darning) mimics the look of a knitted stitch exactly and is easy to do. It's perfect for argyle patterns (as shown below), for adding a narrow stripe to a plaid, or for any other small details in a pattern. It's even good for covering up a stitch or two with the appropriate color if the wrong one was used during the actual knitting of a project!

Left: Tiny yellow diagonal lines, made using duplicate stitch, finish the Argyle Pattern in this swatch. **Right:** The back of the fabric stays nice and neat when using duplicate stitch. Used sparingly, the extra stitches will not dramatically affect the drape or weight of the garment.

FIXING A MISSED INTERLOCK

It's not uncommon to occasionally forget to interlock the yarns when knitting intarsia. It is easiest to fix a missing interlock while weaving in your yarn tails, so take the time to look over your fabric prior to finishing. If you discover a hole at the intersection of two yarns, don't worry. Simply draw the yarn tail through the interlock spot, twist it with the other color, and weave it in as usual.

Duplicate stitch can be worked in any direction. For example, the charts below show the Diamond Harlequin Pattern transformed into a classic Argyle Pattern. You would work this pattern using just two colors of yarn (red and orange), ignoring the yellow diagonal slashes. Then, after the project is complete, you would place your duplicate stitches according to the symbols in the chart. This little bit of yellow embroidery transforms the simple diamond design into a classic argyle one.

DIAMOND HARLEQUIN PATTERN

(mult 12 + 1 sts)

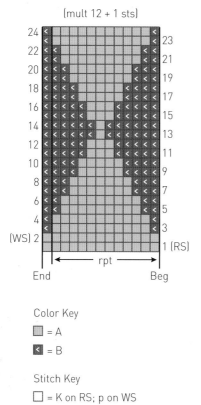

End Beg

Color Key

■ = A

◄ = B

Stitch Key

□ = K on RS; p on WS

ARGYLE PATTERN

(mult 12 + 1 sts)

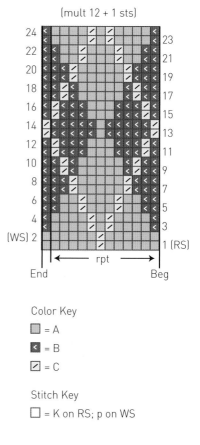

End Beg

Color Key

■ = A

◄ = B

◿ = C

Stitch Key

□ = K on RS; p on WS

To work duplicate stitch embroidery (horizontally, from right to left): Using a blunt-end yarn needle, bring the yarn up through the center of the stitch just below the one to be covered, then insert the needle from front to back to front, working from right to left, under both loops that make the "V" of the stitch in the row above. Then insert the needle back into the same spot in the stitch below (illustration 7). Bring the needle back up to the right side of the fabric through the center of the adjacent stitch.

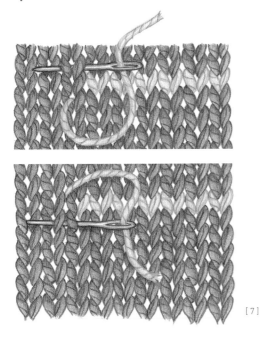

[7]

color PLAY

If you plan to add duplicate stitch to a piece of knitting, do the embroidery prior to seaming your pieces together. It'll be much easier to stitch.

To work duplicate stitch embroidery in a vertical line: Using a blunt-end yarn needle, bring the yarn up through the center of the stitch just below the bottommost stitch to be covered, then insert the needle from front to back to front, working from right to left, under both loops that make the "V" of the stitch in the row above. Then insert the needle back into the same spot in the stitch below (illustration 8, left). To start to cover the next stitch in the vertical column, bring the needle back up to the right side of the fabric through the center of the stitch just worked (illustration 8, right).

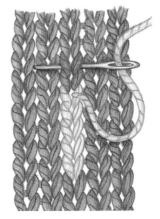
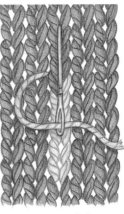

[8]

Designer's Workshop: Painting with Stitches

It's fun and easy to design your own original intarsia patterns! It's crucial to remember that since a knit stitch is not square in shape, regular graph paper won't work. Choose knitter's graph paper, which is proportioned correctly: Each block of the grid is rectangular, just like a knitted stitch. See page 173 for a sheet of knitter's graph paper that you can reproduce and use to draw your own charts. For a larger "canvas" on which to draw your designs, tape a few sheets together.

In addition, many websites offer free knitter's graph paper in various gauges. Check out www.tata-tatao.to/ knit/matrix/e-index.html for lots of great options. Even some spreadsheet and word processing computer programs can help you draw charts. You can use them to create a grid, being sure to carefully modify each cell to knitter's graph paper proportions (5:7), then select and fill them with colors for your chart. Inexpensive and easy! Or try Philippe Marquis's free downloadable software called Graph Paper Printer for creating graphs. Just plug in the dimensions you want and print out whatever you need! Of course, many software programs designed specifically for crafting are available on the market. Design-a-Knit by Softbyte is one of the best. It is user-friendly and has many handy features, including mirror imaging, tiling, and auto-constrained circles and squares; it even has the capability of displaying your charts as knitted fabrics. Other useful charting software include Stitch Painter, Stitch and Motif Maker, and Knit Visualizer.

Design Inspiration for Intarsia

You don't have to be an artist to develop intarsia charts. Here are some ideas to get you started:

CROSS-STITCH STAR PATTERN

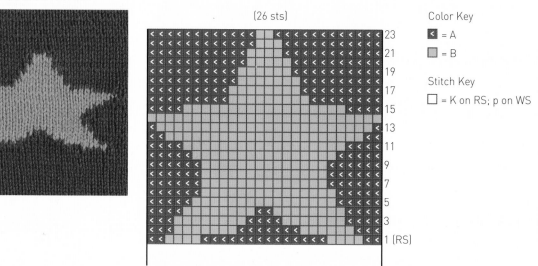

(26 sts)

23
21
19
17
15
13
11
9
7
5
3
1 (RS)

End

Beg

Color Key
◄ = A
▧ = B

Stitch Key
☐ = K on RS; p on WS

STAR PATTERN WITH EXTRA ROWS

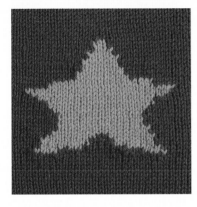

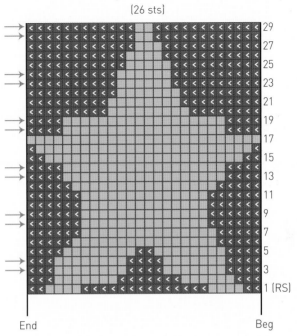

(26 sts)

End

Beg

Color Key

 = A

☐ = B

Stitch Key

☐ = K on RS; p on WS

• Instead of designing from scratch, modify a cross-stitch or needlepoint chart for intarsia knitting. This modification is important. Unlike those in knitting, stitches in cross-stitching are perfectly square, so their charts create a motif that, when knitted, looks slightly squat—unless you're doing stranded knitting (Chapter 2, page 21). For example, the cross-stitch chart on the left for a star motif looks perfectly fine—until it is knitted! When knitted in stockinette stitch, the star appears squished and sloppy.

To revise a cross-stitch chart for use in knitting, extra rows must be added to the chart. As a general rule, the easiest way to do this is to simply work every fourth row twice. The arrows on the left-hand edge of the

chart above show where rows have been repeated. Now the knitted star motif looks correctly proportioned.

• There are many websites that offer free conversion of JPEG files. Try www.microrevolt.org/knitPro to create a knittable chart from your own image. Choose Knit Portrait or Knit Landscape as your stitch option to proportion the chart for knitter's graph paper. Depending on the size of your original image, you might have to fiddle with the software a little to get a chart in a knittable size.

• It's fun (and easy) to mimic other textiles, especially those with geometric patterning such as Navaho rugs or quilts. And no master of fine arts degree is required! Rather than draw freehand, you can print knitter's graph paper onto a clear plastic

transparency sheet and then place it over an image you'd like to knit. Trace the image onto the transparency sheet and you're good to go!

• Intarsia offers the perfect opportunity to use up some of your yarn stash. Gather together yarn with similar gauge (or else double- or triple-strand some to make them work together), making sure that every yarn used within a project has the same laundering instructions. For items that will be washed, take the time to check for colorfastness, too.

• Do you want to add some complexity to your chart without any extra work? Try using a variegated or hand-dyed yarn as one of the colors. It'll add depth of color without increasing the number of yarn tails!

Pattern Treasury of Intarsia

Here's a collection of intarsia patterns for you to incorporate into your own knitting projects. Check page 13 for suggestions on how best to use this treasury. Each pattern includes a chart and sample swatch so that you can quickly find the perfect patterns for your projects. If you need a quick refresher course on chart reading, turn to page 10. Obviously, with so many different possibilities, no treasury of graphic motifs could ever be complete. I hope that this set will inspire you to develop your own original patterns!

Geometric Motifs

INTARSIA PATTERN 1

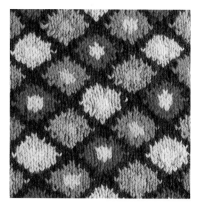

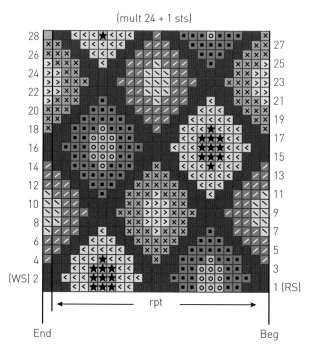

(mult 24 + 1 sts)

rpt

End — Beg

Color Key

■ = A

▪ = B

< = C

◪ = D

⊠ = E

◥ = F

▷ = G

★ = H

◉ = I

Stitch Key

☐ = K on RS; p on WS

INTARSIA PATTERN 2

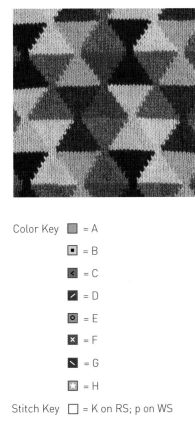

(mult 28 sts)

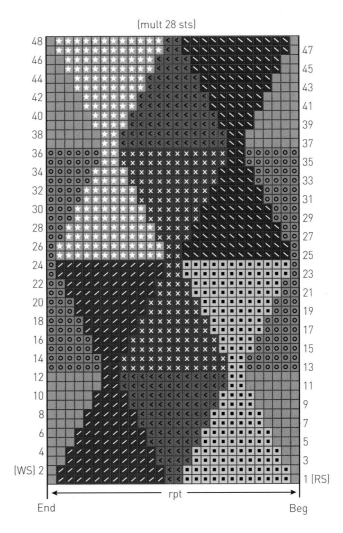

48 47
46 45
44 43
42 41
40 39
38 37
36 35
34 33
32 31
30 29
28 27
26 25
24 23
22 21
20 19
18 17
16 15
14 13
12 11
10 9
8 7
6 5
4 3
(WS) 2 1 (RS)

← rpt →

End Beg

Color Key = A

= B

= C

= D

= E

= F

= G

= H

Stitch Key □ = K on RS; p on WS

INTARSIA PATTERN 3

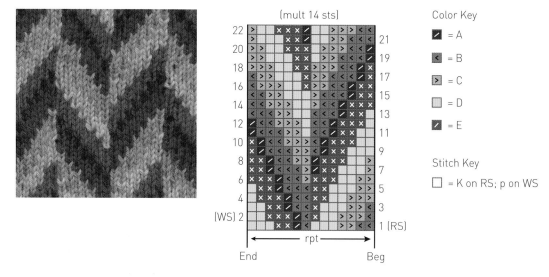

(mult 14 sts)

rpt

End Beg

Color Key

- ✎ = A
- ‹ = B
- › = C
- ☐ = D
- ✎ = E

Stitch Key

☐ = K on RS; p on WS

INTARSIA PATTERN 4

(mult 12 + 3 sts)

rpt

End Beg

Color Key

- ☐ = A
- ▦ = B
- ■ = C
- ☐ = D
- ▦ = E

Stitch Key

☐ = K on RS; p on WS

B = Bobble = K into (front, back, front) of next st, turn; p1, (p1, yo, p1) all into next st, p1, turn; k5, turn; p2tog, p1, p2tog, turn; slip 2 sts at once knitwise, k1, p2sso

INTARSIA PATTERN 5

Color Key

☐ = A

▨ = B

Stitch Key

☐ = K on RS; p on WS

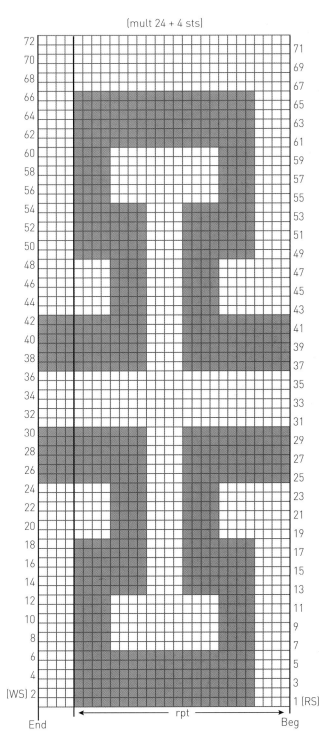

(mult 24 + 4 sts)

INTARSIA PATTERN 6

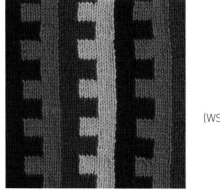

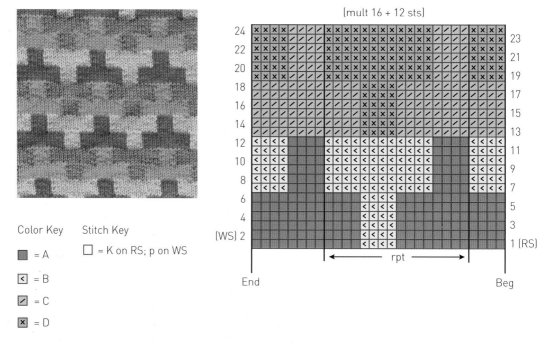

(mult 16 + 12 sts)

rpt

End Beg

Color Key

■ = A

< = B

/ = C

× = D

Stitch Key

□ = K on RS; p on WS

INTARSIA PATTERN 7

(mult 24 sts)

rpt

End Beg

Color Key

□ = A

× = B

< = C

/ = D

Stitch Key

□ = K on RS; p on WS

INTARSIA PATTERN 8

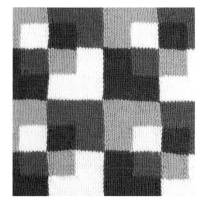

Color Key

■ = A

☒ = B

◪ = C

□ = D

Stitch Key

□ = K on RS; p on WS

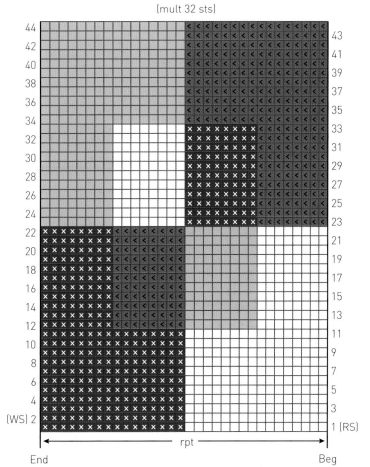

(mult 32 sts)

rpt

End Beg

INTARSIA PATTERN 9

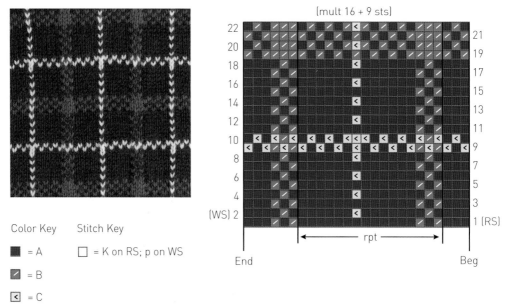

(mult 16 + 9 sts)

Color Key

■ = A

▨ = B

◧ = C

Stitch Key

□ = K on RS; p on WS

End Beg

INTARSIA PATTERN 10

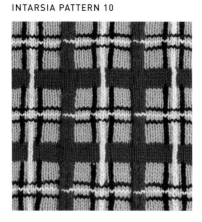

(mult 17 + 12 sts)

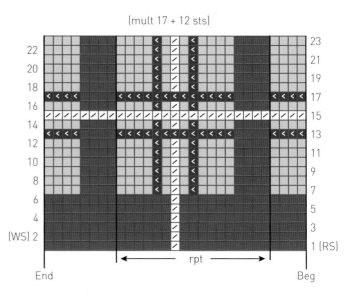

Color Key

■ = A

▧ = B

▢ = C

◧ = D

Stitch Key

□ = K on RS; p on WS

End Beg

Pictorial Motifs

INTARSIA PATTERN 11

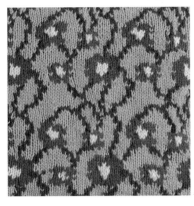

(mult 23 sts)

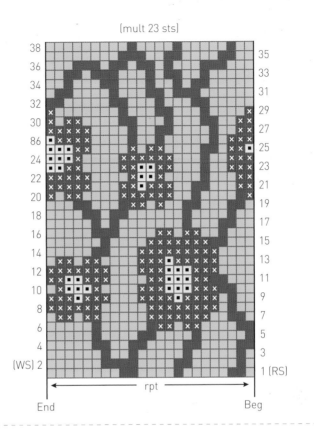

rpt

End

Beg

Color Key

■ = A

■ = B

☒ = C

▪ = D

Stitch Key

□ = K on RS; p on WS

INTARSIA PATTERN 12

(19 sts)

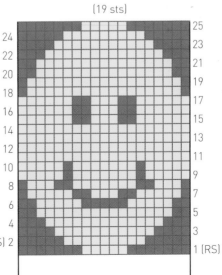

(WS) 2

1 (RS)

End

Beg

Color Key

■ = A

□ = B

Stitch Key

□ = K on RS; p on WS

INTARSIA PATTERN 13

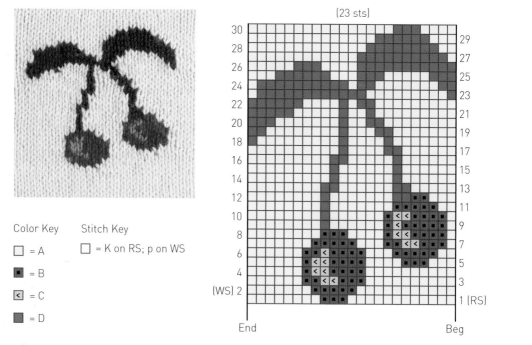

(23 sts)

Color Key

☐ = A

▪ = B

< = C

■ = D

Stitch Key

☐ = K on RS; p on WS

INTARSIA PATTERN 14

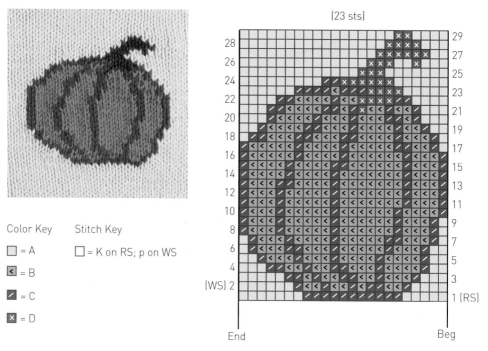

(23 sts)

Color Key

☐ = A

< = B

/ = C

✗ = D

Stitch Key

☐ = K on RS; p on WS

INTARSIA PATTERN 15

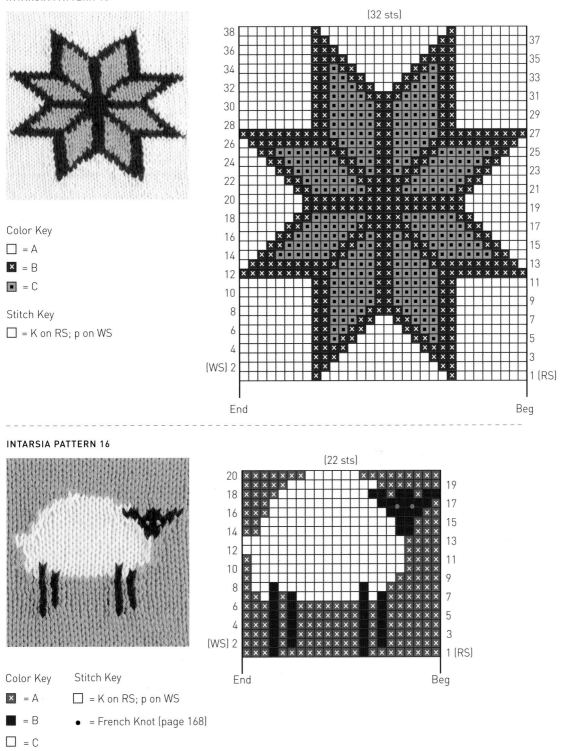

Color Key

☐ = A
☒ = B
▣ = C

Stitch Key

☐ = K on RS; p on WS

INTARSIA PATTERN 16

Color Key

☒ = A

■ = B

☐ = C

Stitch Key

☐ = K on RS; p on WS

● = French Knot (page 168)

INTARSIA PATTERN 17

Color Key

■ = A

□ = B

Stitch Key

□ = K on RS; p on WS

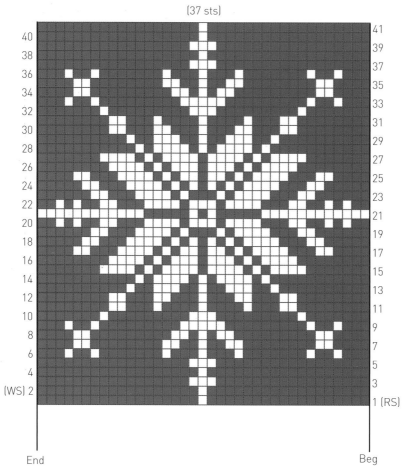

(37 sts)

End

Beg

INTARSIA PATTERN 18

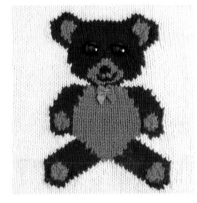

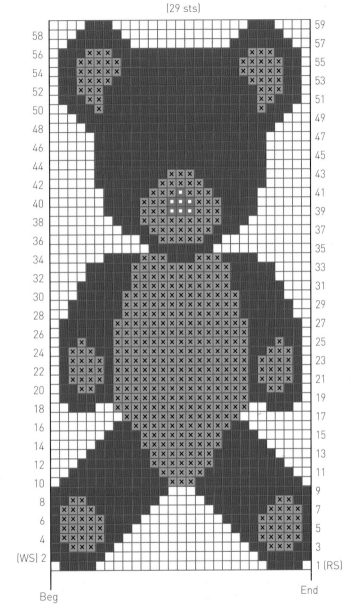

(29 sts)

Beg

End

(WS) 2

1 (RS)

Color Key

☐ = A

■ = B

☒ = C

▣ = D

Stitch Key

☐ = K on RS; p on WS

NOTE: Embroider mouth and tie ribbon bow at neck. Use two ⅝"/[16mm] buttons for eyes.

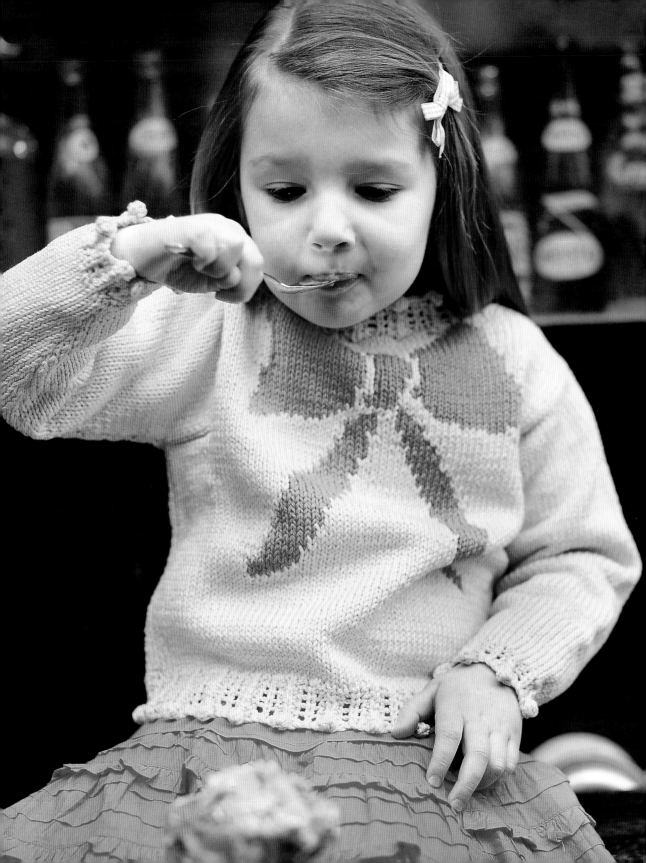

Gaylen's Dress-Up Sweater

Practicing basic intarsia techniques

A big, sumptuous bow makes any gift special, so why not knit one into a pretty sweater for your favorite little princess? Use the intarsia technique to place the motif front and center.

SKILL LEVEL

Intermediate

SIZES

Child's 2 (4, 6, 8). Instructions are for the smallest size, with changes for the other sizes noted in parentheses as necessary.

FINISHED MEASUREMENTS

Chest: 26 (29, 32, 35½)"/ [66 (74, 80, 90) cm]

Total length: 14 (15, 16, 17)"/ [35.5 (38, 42, 43)cm]

MATERIALS

Classic Elite Yarn's *Provence*: 3-light/DK weight; 100% mercerized cotton; each approximately 3½ oz/[100g] and 205 yd/ [187.5m]. 3 (3, 4, 4) hanks of Bermuda Sand #2689 (A) and 1 hank of Rosa Rugosa #2625 (B) **3**

Size 3 (3.25mm) knitting needles

Size 3 (3.25mm) 16"/[40cm] circular needle

Size 5 (3.75mm) knitting needles, or size needed to obtain gauge

Two stitch markers

Blunt-end yarn needle

GAUGE

22 stitches and 29 rows = 4"/[10cm] in Stockinette Stitch with the larger needles.

To save time, take time to check gauge.

(continued on next page)

NOTES

- For complete instructions on Make Bobble (MB), see page 164.

- To increase stitches, use M1-R and M1-L (page 165). For right-slanting decreases, use k2tog (page 165); for left-slanting decreases, use ssk (page 167).

- For sweater assembly, refer to the illustration for square-indented sleeve construction on page 169.

SUGGESTED ALTERNATE COLORWAYS

Alternate Colorway 1, left: Classic Elite Yarn's *Provence* in Zinnia Flower #2619 (A) and Sundrenched Yellow #2633 (B)

Alternate Colorway 2, right: Island Blue #2646 (A) and Bleach #2601 (B) **3**

STITCH PATTERNS

Border Rib Pattern
(multiple of 6 stitches + 1)
Row 1 (RS): *K1, yo, k1, s2kp2, k1, yo;
repeat from * to last stitch, k1.

Row 2: P2, *k1, p1, k1, p3; repeat from *
to the last 5 stitches, k1, p1, k1, p2.

Repeat Rows 1 and 2 for the pattern.

Stockinette Stitch
(any number of stitches)
Row 1 (RS): Knit across.

Row 2: Purl across.

Repeat Rows 1 and 2 for the pattern.

Bow Pattern (40 stitches)
See the chart (page 107).

Back

With the smaller needles and A, cast on 73 (79, 85, 97) stitches.

Row 1 (RS): K3, *MB, k5; repeat from * to the last 4 stitches, MB, k3.

Next Row: P2, *k1, p1, k1, p3; repeat from * to the last 5 stitches, k1, p1, k1, p2.

Work in the Border Rib Pattern until the piece measures approximately 1½"/(3.8cm), ending after a wrong-side row.

Next Row (RS): Change to the larger needles; begin working in Stockinette Stitch and decrease 1 (increase 1, increase 3, increase 1) evenly across the row—72 (80, 88, 98) stitches.

Work even in Stockinette Stitch until the piece measures approximately 7½ (8, 8½, 9)"/19 (20.5, 21.5, 23)cm], ending after a wrong-side row.

SHAPE ARMHOLES

Bind off 8 (10, 12, 14) stitches at the beginning of the next 2 rows—56 (60, 64, 70) stitches remain.

Work even until the armholes measure approximately 5 (5½, 6, 6½)"/[12.5 (14, 15, 16.5)cm], ending after a wrong-side row.

SHAPE NECK

Next Row (RS): K14 (16, 17, 20); join a 2nd ball of yarn and bind off the middle 28 (28, 30, 30) stitches, knit to the end of the row.

Decrease 1 stitch at each neck edge—13 (15, 16, 19) stitches remain on each side.

Work even until the armholes measure approximately 5½ (6, 6½, 7)"/[14 (15, 16.5, 18)cm], ending after a wrong-side row.

SHAPE SHOULDERS

Bind off 3 (4, 4, 5) stitches at the beginning of the next 6 rows, then bind off 4 (3, 4, 4) stitches at the beginning of the next 2 rows.

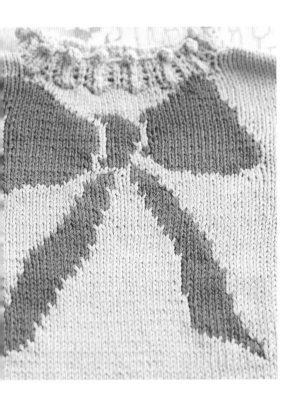

Front

Work the same as for the Back until the piece measures approximately 3½ (4½, 5½, 6½)"/ [9 (11.5, 14, 16.5)cm], ending after a wrong-side row.

Pattern Set-Up Row (RS): K16 (20, 24, 29), place a marker, work Row 1 of the Bow Pattern over the middle 40 stitches, place a marker, knit to the end of the row.

Work even in the established pattern until the piece measures approximately 7½ (8, 8½, 9)"/ [19 (20.5, 21.5, 23)cm], ending after a wrong-side row.

SHAPE ARMHOLES

Continuing established pattern, bind off 8 (10, 12, 14) stitches at the beginning of the next 2 rows—56 (60, 64, 70) stitches remain.

Work even until the armholes measure approximately 4½ (5, 5½, 6)"/[11.5 (12.5, 14, 15)cm], ending after a wrong-side row.

SHAPE NECK

Next Row (RS): K22 (24, 25, 28), join a 2nd ball of yarn and bind off the middle 12 (12, 14, 14) stitches, knit to the end of the row.

Working both sides at once with separate balls of yarn, complete the Bow Pattern, then continue with A only, and at the same time, bind off 6 stitches at each neck edge once, then bind off 2 stitches at each neck edge, then decrease 1 stitch at each neck edge once—13 (15, 16, 19) stitches remain on each side.

Work even until the armholes measure the same as the Back to the shoulders.

SHAPE SHOULDERS

Work the same as for the Back.

Sleeves (Make 2)

With the smaller needles and A, cast on 37 (37, 43, 43) stitches.

Row 1 (RS): K3, *MB, k5; repeat from * to the last 4 stitches, MB, k3.

Next Row: P2, *k1, p1, k1, p3; repeat from * to the last 5 stitches, k1, p1, k1, p2.

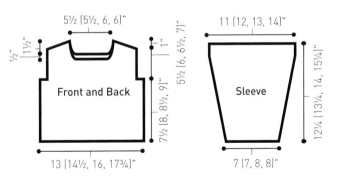

Work in the Border Rib Pattern until the piece measures approximately 1"/[2.5cm], ending after a wrong-side row.

Next Row (RS): Change to the larger needles; begin working in Stockinette Stitch and increase 2 stitches evenly across the row—39 (39, 45, 45) stitches.

Increase 1 stitch at each side every 4 rows 0 (5, 3, 6) times, every 6 rows 9 (9, 11, 10) times, then every 8 rows 2 (0, 0, 0) times as follows: K1, M1-R, knit to the last stitch, M1L, k1—61 (67, 73, 77) stitches when all shaping is complete.

Work even until the piece measures approximately 12¼ (13¼, 14, 15½)"/[31 (33.5, 35.5, 39.5) cm], ending after a wrong-side row.

Bind off.

Finishing
Weave in all remaining yarn tails.

Block all pieces to the finished measurements.

Sew the shoulder seams.

NECKBAND
With the right side facing, using the circular needle and A, pick up and knit 90 (90, 102, 102) stitches evenly spaced along the neckline; place a marker and join.

Round 1 (RS): *K1, yo, k1, s2kp2, k1, yo; repeat from * around.

Round 2 (RS): *K2, p1, k1, p1, k1; repeat from * around.

Repeat Rounds 1 and 2 until the neckband measures approximately 1"/[2.5cm], ending after Round 2.

Bobble Bind-Off: Bind off, placing bobbles above the double decreases as follows: Bind off 2 stitches, *MB, bind off 6 stitches (including the bobble); repeat from * around, ending the round with MB, then bind off the remaining stitches.

Set in the Sleeves.

Sew the Sleeve and side seams.

BOW PATTERN

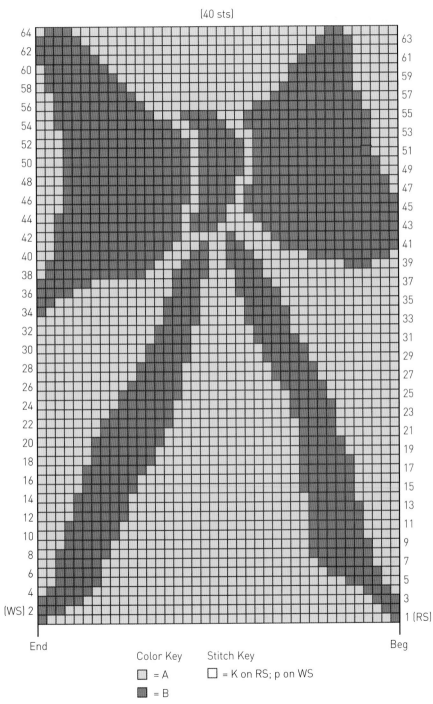

(40 sts)

End

Beg

Color Key

☐ = A

■ = B

Stitch Key

☐ = K on RS; p on WS

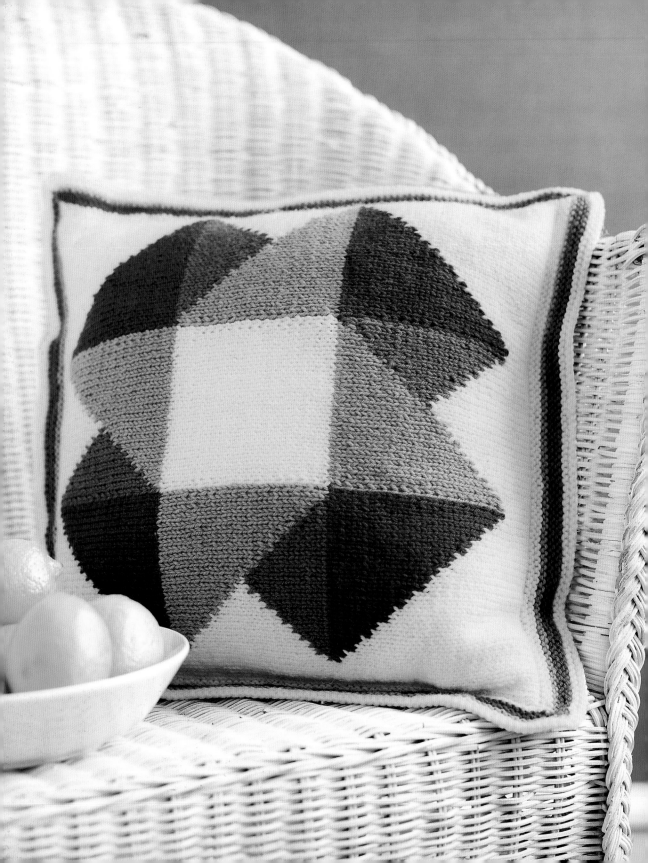

Country Quilt Block Pillow

Knitting a geometric intarsia motif

A traditional quilt block inspired the motif for this throw pillow. Use the intarsia technique to translate one needle art into another!

NOTE
• To increase stitches, use M1-R and M1-L (page 165).

SUGGESTED ALTERNATE COLORWAYS
Alternate Colorway 1, left: Aurora Yarns/Steinbach Wolle's *Super Sport* in Maize #55 (A), Brick #10(B), Persimmon #36 (C), and Squash #37 (D)

Alternate Colorway 2, right: Black #0 (A), Dark Charcoal #83 (B), Pearl Gray #80 (C), and Snow #1 (D) (**3**)

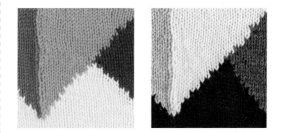

INTARSIA KNITS

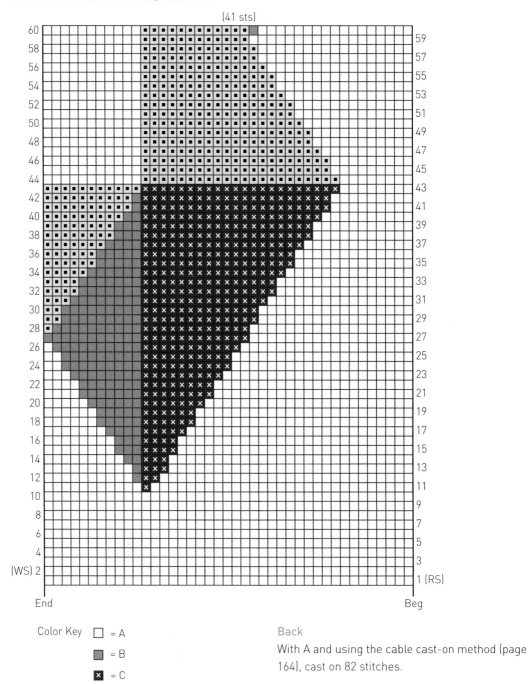

(41 sts)

End

Beg

Color Key □ = A

▨ = B

▣ = C

▣ = D

Stitch Key □ = K on RS; p on WS

Back

With A and using the cable cast-on method (page 164), cast on 82 stitches.

Set-Up Row (RS): Work Row 1 of the Right Side chart (Rows 1–60) across the first 41 stitches, place a marker, work Row 1 of the Left Side chart (Rows 1–60) across the last 41 stitches.

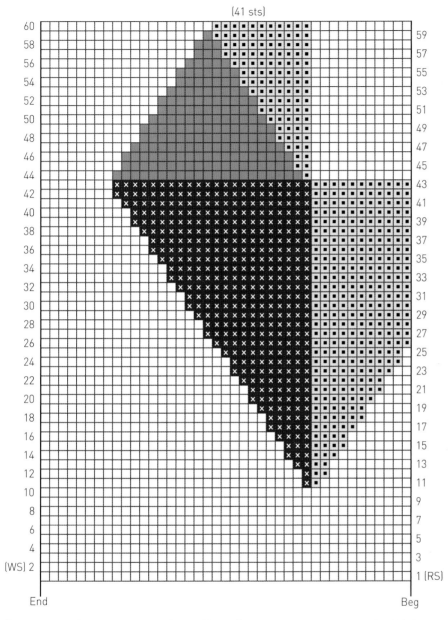

(41 sts)

End

Beg

Continue working both charts side by side until Row 120 is completed. See pages 112–113.

Bind off.

Front
Work the same as for the Back.

Finishing
Weave in all remaining yarn tails.

Block the pieces to the finished measurements.

With A, sew 3 of the side seams.

Insert the pillow form.

Sew the remaining side seam.

BORDER
With the right side facing and A, pick up and knit 82 stitches along one side of the pillow.

INTARSIA KNITS

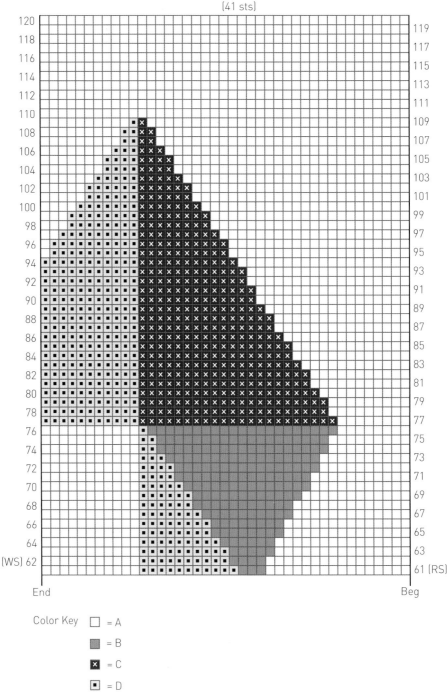

(41 sts)

End

Beg

Color Key □ = A

⬛ = B

☒ = C

⬛ = D

Stitch Key □ = K on RS; p on WS

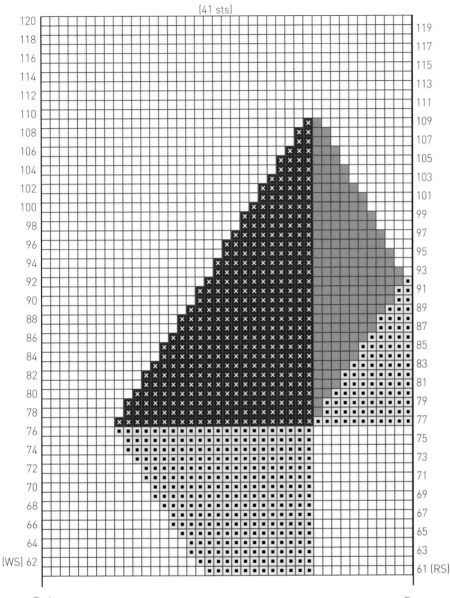

(41 sts)

End

Beg

Knit 3 rows with A, 2 rows with D, 4 rows with C, and 3 rows with A, and at the same time, increase 1 stitch at each side on every right-side row as follows: K1, M1-R, knit to the last stitch, M1-L, k1—94 stitches total when all increases are complete.

Next Row (WS): With A, bind off knitwise.

Repeat the border along each side of the pillow.

With the right side facing, sew the mitered corners of the border together.

SKILL LEVEL
Experienced

SIZES
S (M, L, 1X, 2X, 3X). Instructions are for the smallest size, with changes for other sizes noted in parentheses as necessary.

FINISHED MEASUREMENTS
Bust (buttoned): 36¼ (38¾, 42¼, 44¾, 48¼, 50¾)"/[92 (98.5, 107, 113.5, 122.5, 129)cm]

Hip (buttoned): 41¾ (44¾, 48¼, 50¾, 54¼, 56¾)"/[106 (113.5, 122.5, 129, 138, 144)cm]

Length: 35 (35½, 36, 36½, 36½, 37)"/ [89 (90, 91.5, 92.5, 92.5, 94)cm]

MATERIALS
Louet North America's *Brushed Mohair*: 4-medium/worsted weight; 78% mohair/13% wool/9% nylon; each approximately 1¾ oz/[50g] and 105 yd/[96m]. 5 (5, 6, 6, 6, 6) hanks of Mermaid #75 (A), 2 (2, 3, 3, 3, 3) hanks of Strawberry #23 (B), 3 (3, 4, 4, 4, 4) hanks *each* of Ruby Rose #89 (C) and Clementine #62 (D) 🧶

Size 8 (5mm) circular needle

Size 9 (5.5mm) circular needle, or size needed to obtain gauge

Two stitch holders

Stitch markers

Blunt-end yarn needle

Eight 1"/[2.5cm] buttons (JHB International's Moonshadow, Style #43144, were used on sample garment)

GAUGE
16 stitches and 22 rows = 4"/[10cm] in Stockinette Stitch with the larger needle.

To save time, take time to check gauge.

(continued on next page)

Traveling Triangles Jacket

Increasing and decreasing in intarsia

Don't let the allover colorwork on this jacket scare you. Once you get the geometric pattern set up, it's easily memorized. Take care to begin and end each section of color with nice, long yarn tails—and be sure to darn them in during idle moments while watching TV or else the finishing of the project might take longer than the knitting!

NOTES

• The instructions include one selvedge stitch on each side; these stitches are not reflected in the finished measurements.

• Work all decreases *inside* the selvedge stitches. To maintain the intarsia pattern, on right-side rows, work k2tog at the beginning of the row and ssk at the end of the row; on wrong-side rows, work ssp at the beginning of the row and ssp at the end of the row.

• Work all increases *inside* the selvedge stitches. Use M1-L or M1-R (page 165) in the color needed to maintain the intarsia pattern.

• When working the charts if only one or two stitches are worked in a separate color, do not use the separate color; instead, use the neighboring color for those one or two stitches.

• For sweater assembly, refer to the illustration for set-in sleeve construction on page 169.

Seed Stitch (even number of stitches)
Row 1 (RS): *K1, p1; repeat
from * across.

Row 2: *P1, k1; repeat from * across.

Repeat Rows 1 and 2 for the pattern.

*Stockinette Stitch
(any number of stitches)*
Row 1 (RS): Knit across.

Row 2: Purl across.

Repeat Rows 1 and 2 for the pattern.

Triangles Pattern for Back and Sleeves
See the chart (page 119).

Triangles Pattern for Left Front
See the chart (page 120).

Triangles Pattern for Right Front
See the chart (page 121).

Note: *Rather than working from
bobbins, cut several 120"/[305cm]
lengths of each color of yarn for each
section of color in the charts.*

SUGGESTED ALTERNATE COLORWAYS
Alternate Colorway 1, left: Louet North America's *Brushed Mohair*
in Buttercup #87 (A), Olive #41 (B), Clementine #62 (C), and
Pomegranate #74 (D)

Alternate Colorway 2, right: Auburn #46 (A), Cream #30 (B),
Desert #01 (C), Chestnut #53 (D) (**4**)

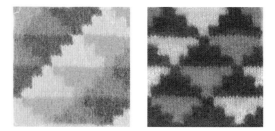

Back
With the smaller needle and A, cast on 84 (90, 96, 102, 108,
114) stitches.

Work in Seed Stitch until the piece measures approx-
imately 1½"/[3.8cm], ending after a wrong-side row,
increasing 1 stitch at the end of the last row—85 (91, 97,
103, 109, 115) stitches.

Change to the larger needle and Stockinette Stitch; work
the Intarsia Triangles Pattern for Back chart, beginning
and ending where indicated for your desired size, and
decrease 1 stitch at each side every 22 rows 5 (4, 3, 2, 2, 1)
time(s), then every 24 rows 1 (2, 3, 4, 4, 5) time(s)—73 (79,
85, 91, 97, 103) stitches remain.

Work even until the piece measures approximately 27"/
[68.5cm], ending after a wrong-side row.

SHAPE ARMHOLES
Bind off 3 (3, 4, 4, 5, 6) stitches at the beginning of the next
2 rows; bind off 2 (2, 2, 3, 3, 4) stitches at the beginning of
the next 2 rows—63 (69, 73, 77, 81, 83) stitches remain.

Decrease 1 stitch at each side every row 2 (3, 6, 5, 10, 8)
times, then every other row 4 (5, 4, 6, 3, 5) times—51 (53,
53, 55, 55, 57) stitches remain.

Work even until the armholes measure approximately 7
(7½, 8, 8½, 8½, 9)"/[18 (19, 20.5, 21.5, 21.5, 23)cm].

SHAPE SHOULDERS

Bind off 4 (4, 4, 5, 5, 5) stitches at the beginning of the next 4 rows, then bind off 4 (5, 5, 4, 4, 5) stitches at the beginning of the next 2 rows—27 stitches remain.

Bind off.

Pocket Linings (Make 2)

With the larger needle and A, cast on 21 stitches.

Work even in Stockinette Stitch until the piece measures approximately 6½"/[16.5cm], ending after a right-side row. Cut the yarn and place the stitches on a holder.

Left Front

With the smaller needle and A, cast on 46 (48, 52, 54, 58, 60) stitches.

Work in Seed Stitch until the piece measures approximately 1½"/[3.8cm], ending after a wrong-

side row and increasing 1 stitch at the end of the last row—47 (49, 53, 55, 59, 61) stitches.

Pattern Set-Up Row (RS): Change to the larger needle and Stockinette Stitch; beginning where indicated for your desired size, work Row 1 of the Intarsia Triangles Pattern for Left Front chart across the first 41 (43, 47, 49, 53, 55) stitches, place a marker; join A and work in Seed Stitch across the last 6 stitches for front band.

Working the patterns as established, decrease 1 stitch at the armhole edge every 22 rows 5 (4, 3, 2, 2, 1) times, then every 24 rows 1 (2, 3, 4, 4, 5) time(s); at the same time, when the piece measures approximately 11"/[28cm], ending after Row 4 of the charted pattern, **place the Pocket Lining** as follows:

Next Row (RS): Work 13 stitches, slip the next 21 stitches to a stitch holder for the pocket opening,

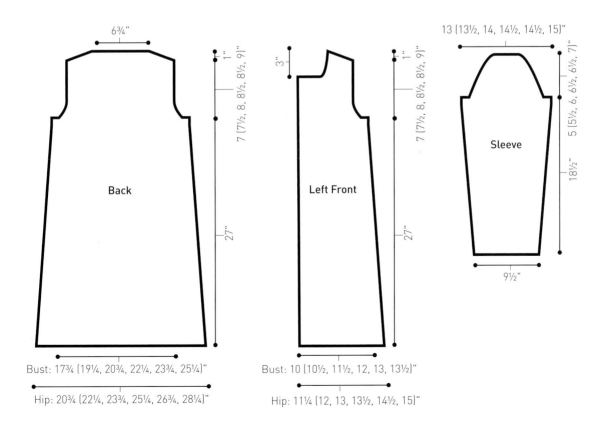

6¾"

1"

7 (7½, 8, 8½, 8½, 9)"

Back

27"

Bust: 17¾ (19¼, 20¾, 22¼, 23¾, 25¼)"

Hip: 20¾ (22¼, 23¾, 25¼, 26¾, 28¼)"

3"

1"

7 (7½, 8, 8½, 8½, 9)"

Left Front

27"

Bust: 10 (10½, 11½, 12, 13, 13½)"

Hip: 11¼ (12, 13, 13½, 14½, 15)"

13 (13½, 14, 14½, 14½, 15)"

5 (5½, 6, 6½, 6½, 7)"

Sleeve

18½"

9½"

continue in the established pattern across the 21 stitches from 1 Pocket Lining, work to the end of the row.

When the decreases are complete, work even on the remaining 41 (43, 47, 49, 53, 55) stitches until the piece measures approximately 27"/[68.5cm], ending after a wrong-side row.

SHAPE ARMHOLES

Bind off 3 (3, 4, 4, 5, 6) stitches at the armhole edge once, then bind off 2 (2, 2, 3, 3, 4) stitches at the armhole edge once—36 (38, 41, 42, 45, 45) stitches remain.

Decrease 1 stitch at the armhole edge every row 2 (3, 6, 5, 10, 8) times, then every other row 4 (5, 4, 6, 3, 5) times—30 (30, 31, 31, 32, 32) stitches remain.

Work even until the armhole measures approximately 5 (5½, 6, 6½, 6½, 7)"/[12.5 (14, 15, 16.5, 16.5, 18)cm], ending after a right-side row.

SHAPE NECK

Bind off 6 stitches at the neck edge once; bind off 4 stitches at the neck edge once; bind off 3 stitches at the neck edge twice—14 (14, 15, 15, 16, 16) stitches remain.

Decrease 1 stitch at the neck edge every row 2 (1, 2, 1, 2, 1) time(s)—12 (13, 13, 14, 14, 15) stitches remain.

Work even until the armhole measures approximately 6 (6½, 7, 7½, 7½, 8)"/[15 (16.5, 18, 19, 19, 20.5)cm].

SHAPE SHOULDERS

Bind off 4 (4, 4, 5, 5, 5) stitches at the armhole edge twice—4 (5, 5, 4, 4, 5) stitches remain.

Work 1 row even.

Bind off.

Place markers for 8 buttons along the Seed Stitch front band, placing the 1st marker ¼"/[6mm] from the top edge and the last marker 6"/[15cm] from the bottom edge.

Right Front

Work the same as for the Left Front except reverse all shaping, and make 8 buttonholes on the right-side rows opposite the marked button positions on the Left Front as follows:

Buttonhole Row (RS): K1, p1, bind off the next 2 stitches, work to the end of the row. On the following row, cast on 2 stitches over the bound-off stitches of the Buttonhole Row.

Sleeves (Make 2)

With the smaller needle and A, cast on 38 stitches.

Work even in Seed Stitch until the piece measures approximately 1½"/[3.8cm], ending after a wrong-side row and increasing 1 stitch at the end of the last row—39 stitches.

Change to the larger needle and Stockinette Stitch; begin working the Triangles Pattern for Sleeves where indicated in the chart.

Increase 1 stitch on each side every 8 rows 0 (0, 1, 6, 6, 11) time(s), every 10 rows 0 (4, 8, 4, 4, 0) times, every 12 rows 5 (4, 0, 0, 0, 0) times, then every 14 rows 2 (0, 0, 0, 0, 0) times, working new stitches into the charted pattern as they accumulate—53 (55, 57, 59, 59, 61) stitches.

Work even until the piece measures approximately 18½"/[47cm] from the beginning, ending after a wrong-side row.

SHAPE SLEEVE CAP

Bind off 3 (3, 4, 4, 5, 6) stitches at the beginning of the next 2 rows—47 (49, 49, 51, 49, 49) stitches remain.

Decrease 1 stitch at each side every other row 6 (7, 10, 12, 13, 16) times, then every row 9 (9, 6, 5, 3, 0) times—17 stitches remain.

Bind off 2 stitches at the beginning of the next 4 rows—9 stitches remain.

Bind off.

TRIANGLES PATTERN FOR BACK AND SLEEVES

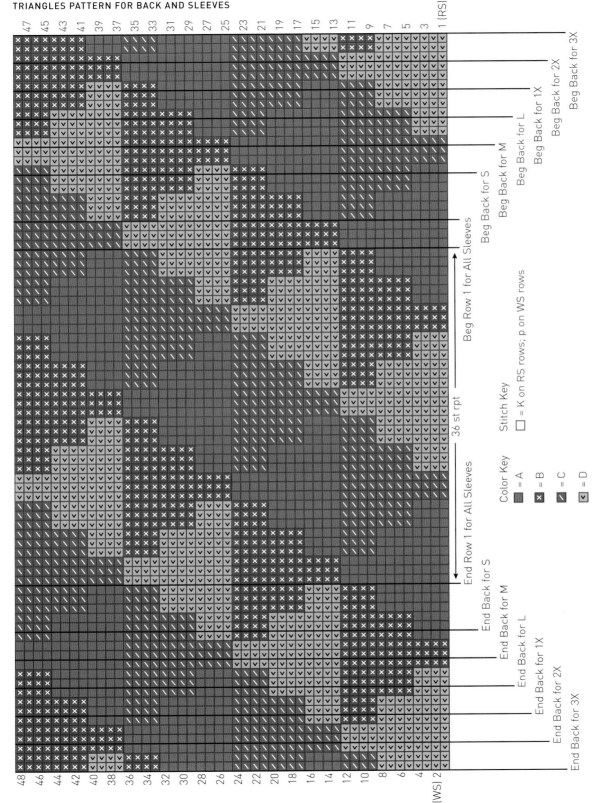

Beg Back for 3X
Beg Back for 2X
Beg Back for 1X
Beg Back for L
Beg Back for M
Beg Back for S

Beg Row 1 for All Sleeves

36 st rpt

End Row 1 for All Sleeves

End Back for S
End Back for M
End Back for L
End Back for 1X
End Back for 2X
End Back for 3X

Stitch Key

□ = K on RS rows; p on WS rows

Color Key

■ = A
☒ = B
◩ = C
☑ = D

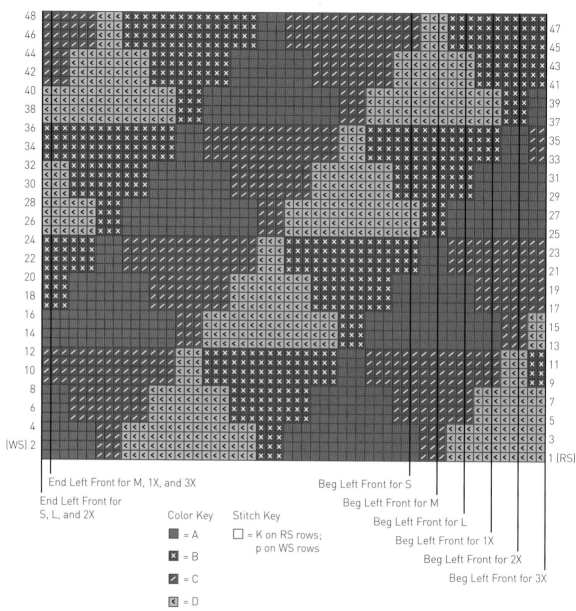

End Left Front for M, 1X, and 3X

End Left Front for
S, L, and 2X

Beg Left Front for S

Beg Left Front for M

Beg Left Front for L

Beg Left Front for 1X

Beg Left Front for 2X

Beg Left Front for 3X

Color Key

■ = A

☒ = B

◪ = C

◪ = D

Stitch Key

☐ = K on RS rows;
 p on WS rows

Finishing

Weave in all remaining yarn tails. Block the pieces to the finished measurements.

Sew the shoulder seams.

COLLAR

With the wrong side facing, using the smaller needle and A, pick up and knit 64 stitches along the neckline, beginning and ending ¾"/[2cm] in from the front edges.

Work in Seed Stitch until the collar measures approximately 2"/[5cm].

Increase 1 stitch at each side every other row 7 times, working the new stitches in Seed Stitch—78 stitches.

Change to the larger needle, and increase 1 stitch at each side every 4 rows twice, working new stitches in Seed Stitch—82 stitches.

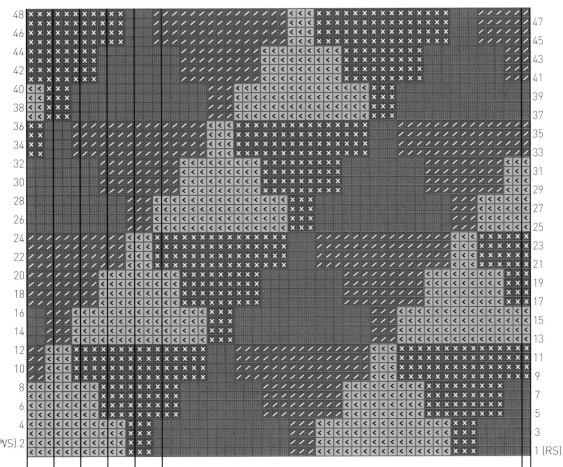

End Right Front for S

End Right Front for M

End Right Front for L

End Right Front for 1X

End Right Front for 2X

End Right Front for 3X

Beg Right Front for M, 1X, and 3X

Beg Right Front for S, L, and 2X

Bind off loosely.

POCKET EDGINGS

Slip the pocket stitches on hold from the stitch holder to the smaller needle.

With the right side facing and A, knit across.

Work in Seed Stitch for 1"/[2.5cm].

Bind off in pattern.

Sew the Pocket Linings to the wrong sides of the Right Front and the Left Front.

Sew the sides of the pocket edges to the right sides of the Right Front and the Left Front.

Set in Sleeves. Sew the Sleeve and side seams.

Sew on the buttons at the marked positions.

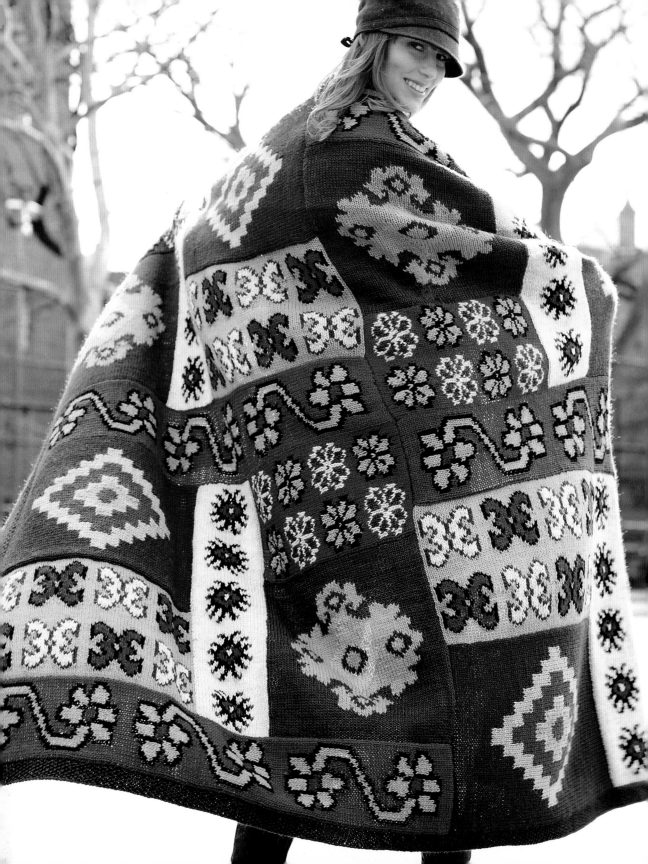

Kilim Sampler Throw

Combining colorwork techniques

Here's one of my favorite kinds of projects: Six patterned panels are combined to create a definite showstopper. Since each section is worked separately, it's perfect take-along knitting! Unlike most of the other projects in this book, no alternate colorways are presented for this throw—I like it best in the warm, earthy tones of traditional rugs.

NOTES

- For the colorwork, use a combination of intarsia (page 81), stranded (page 23), and duplicate stitch (page 85) techniques throughout.

- To increase stitches, M1-L or M1-R (page 165) in the color necessary to maintain the Seed Stitch pattern.

- Make 4 pieces of each panel.

- For assembly, refer to the illustration on page 127.

Panel 1 (Make 4)
Finished measurements: 5½" x 30"/[14cm x 76cm]

With the larger needles and A, cast on 25 stitches.

Work 6 rows in Stockinette Stitch.

Set-Up Row (RS): K3 with A, place a marker, work Row 1 of the Panel 1 chart across the middle 19 stitches, place a marker, k3 with A.

SKILL LEVEL
Intermediate

SIZE
One size

FINISHED MEASUREMENTS
Approximately 51" x 67½"/[129.5cm x 171.5cm] excluding 1½"/ [3.8cm] border

MATERIALS
Brown Sheep Company's *Lamb's Pride Worsted*: 4-worsted weight; 85% wool/15% mohair; each approximately 4 oz/113.5g and 190 yd/ 173.5m. 3 skeins *each* of Bittersweet #M193 (A), Oatmeal #M115 (D), and of Onyx #M05 (G); 4 skeins *each* of Pistachio #M184 (B) and Roasted Coffee #M89 (H); 5 skeins *each* of Sunburst Gold #M14 (C) and Oregano #M113 (E); 2 skeins of Spice #M145 (F) **4**

Size 8 (5mm) knitting needles, or size needed to obtain gauge

Size 7 (4.5mm) 36"/[91cm] circular needle

Four stitch markers

Blunt-end yarn needle

GAUGE
18 stitches and 24 rows = 4"/[10cm] in Stockinette Stitch with larger needles.

To save time, take time to check gauge.

(continued on next page)

STITCH PATTERNS

*Stockinette Stitch
(any number of stitches)*
Row 1 (RS): Knit across.

Row 2: Purl across.

Repeat Rows 1 and 2 for the pattern.

Panel 1 (19 stitches, 56 rows)
See the chart (opposite).

Panel 2 (33 stitches, 46 rows)
See the chart (opposite).

Panel 3 (52 stitches, 66 rows)
See the chart (page 126).

Panel 4 (13 stitches, 24 rows)
See the chart (page 128).

Panel 5 (41 stitches, 59 rows)
See the chart (page 128).

Panel 6 (28 stitches, 37 rows)
See the chart (page 129).

Seed Stitch (odd number of stitches)
Row 1 (WS): K1, *p1, k1;
repeat from * across.

Repeat Row 1 for the pattern.

Continuing to work the first and last 3 stitches with A in Stockinette Stitch, work the 56-row Panel 1 chart across the middle 19 stitches 3 times; remove the markers while working the last row of the chart.

With A, work 6 rows in Stockinette Stitch.

Bind off.

Panel 2 (Make 4)
Finished measurements: 16" x 9"/[40.5cm x 23cm]

With the larger needles and C, cast on 73 stitches.

Work 4 rows in Stockinette Stitch.

Set-Up Row (RS): K2 with C, place a marker, work Row 1 of Panel 2 across the next 33 stitches, place a marker, k3 with C, place a marker, work Row 1 of Panel 2 across the next 33 stitches, place a marker, k2 with C.

Work even in the established patterns until Row 46 of the Panel 2 chart is completed, removing the markers while working the last row of the chart.

With C, work 4 rows in Stockinette Stitch.

Bind off.

Panel 3 (Make 4)
Finished measurements: 11½" x 16"/[29cm x 40.5cm]

With the larger needles and B, cast on 52 stitches.

Work 16 rows in Stockinette Stitch.

Work Panel 3 until Row 66 is completed.

With B, work 16 rows in Stockinette Stitch.

Bind off.

Panel 4 (Make 4)
Finished measurements: 5½" x 20"/[14cm x 51cm]

With the larger needles and D, cast on 25 stitches.

Set-Up Row (RS): K6 with D, place a marker, work Row 1 of Panel 4 across the middle 13 stitches, place a marker, k6 with D.

PANEL 1

(19 sts)

PANEL 2

(33 sts)

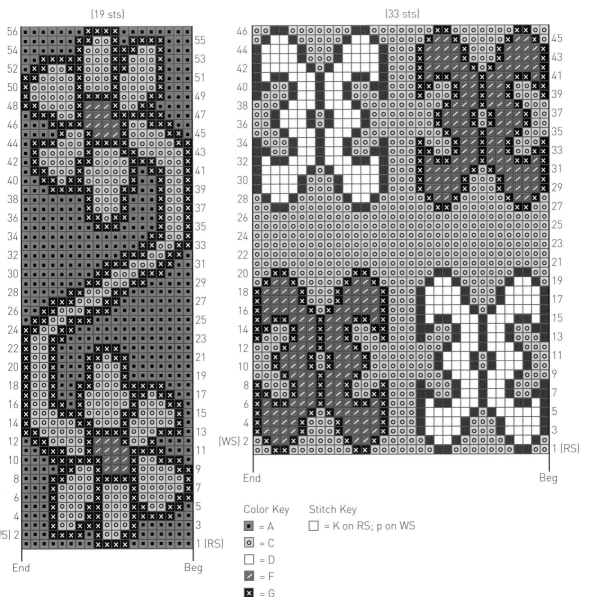

Color Key

- ■ = A
- ◉ = C
- □ = D
- ╱ = F
- ✕ = G
- ■ = H

Stitch Key

- □ = K on RS; p on WS

PANEL 3

(52 sts)

66
64
62
60
58
56
54
52
50
48
46
44
42
40
38
36
34
32
30
28
26
24
22
20
18
16
14
12
10
8
6
4
(WS) 2

End

65
63
61
59
57
55
53
51
49
47
45
43
41
39
37
35
33
31
29
27
25
23
21
19
17
15
13
11
9
7
5
3
1 (RS)

Beg

Continuing to work the first and last 6 stitches with D in Stockinette Stitch, work the 24-row Panel 4 chart across the middle 13 stitches 5 times.

Bind off.

Panel 5 (Make 4)
Finished measurements: 12¼" x 13"/[31cm x 33cm]

With the larger needles and B, cast on 55 stitches.

Work 10 rows in Stockinette Stitch.

Set-Up Row (RS): K7 with B, place a marker, work Row 1 of Panel 5 across the middle 41 stitches, place a marker, k7 with B.

Continuing to work the first and last 7 stitches with B in Stockinette Stitch, work the 59-row Panel 5 chart once, removing the markers while working the last row of the chart.

With B, work 10 rows in Stockinette Stitch.

Bind off.

Panel 6 (Make 4)
Finished measurements: 7" x 13¼"/[18cm x 33.5cm]

With the larger needles and F, cast on 32 stitches.

Work 2 rows in Stockinette Stitch.

Set-Up Row (RS): K2 with F, place a marker, work Row 1 of Panel 6 across the middle 28 stitches, place a marker, k2 with F.

Continuing to work the first and last 2 stitches with F in Stockinette Stitch, work the 37-row

ASSEMBLY ILLUSTRATION

NOTE: Arrows indicate the direction of knitting.

Panel 6 chart twice, removing markers while working the last row of the chart.

With F, work 2 rows in Stockinette Stitch.

Bind off.

Finishing
Weave in all remaining yarn tails.

Block the pieces to the finished measurements.

With right sides facing and using mattress stitch (page 168), sew the pieces together following the assembly illustration above.

Note: *It may be easiest to first sew together the pieces of each of the 4 quadrants, then sew the quadrants together.*

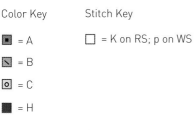

Color Key

■ = A

◩ = B

◉ = C

■ = H

Stitch Key

□ = K on RS; p on WS

PANEL 4

(13 sts)

PANEL 5

(41 sts)

BORDER

With the right side facing, using the circular knitting needle and E, pick up and knit 289 stitches along one long side of the throw.

Work in Seed Stitch and increase 1 stitch at each end of every right-side row 5 times, working the new stitches in Seed Stitch, as follows: K1, M1-L, work to the last stitch, M1-L, k1—299 stitches total.

Bind off in pattern.

Repeat along the other long side.

With the right side facing, using the circular knitting needle and E, pick up and knit 221 stitches along one short side of the throw.

Work in Seed Stitch and increase 1 stitch at each end of every right-side row 5 times, working the new stitches in Seed Stitch, as follows: K1, M1-L, work to the last stitch, M1-L, k1—231 stitches total.

Bind off in pattern.

Repeat along the other short side.

Use mattress stitch to sew the mitered corners together.

PANEL 6

(28 sts)

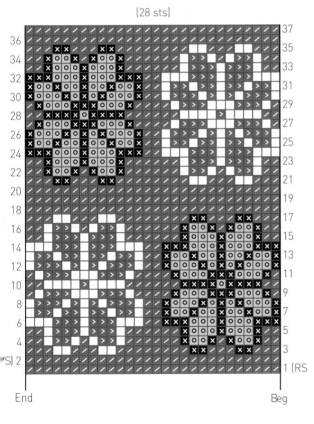

End · Beg

Color Key
◨ = B
◉ = C
☐ = D
▣ = E
◩ = F
✖ = G
■ = H

Stitch Key
☐ = K on RS p on WS

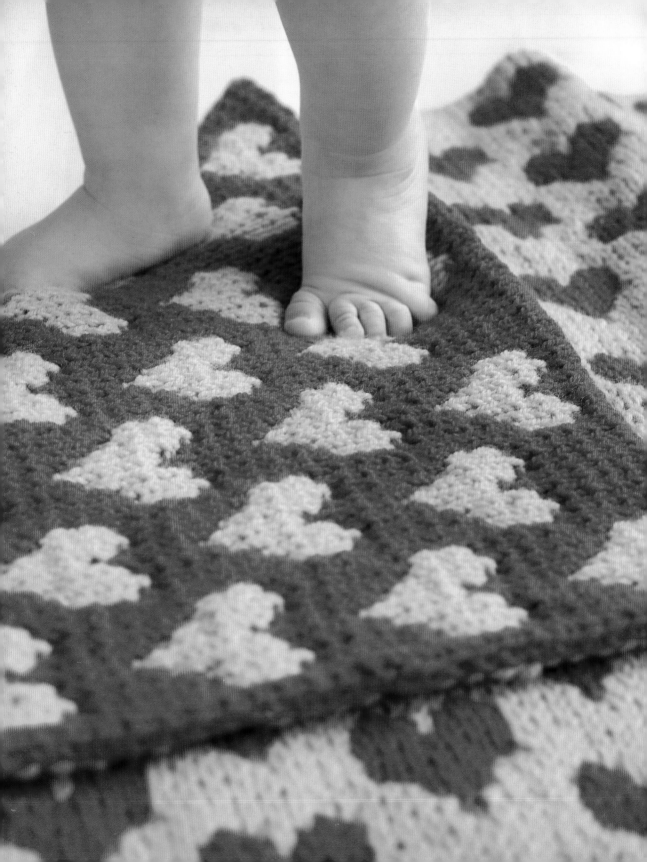

4 Reversible Two-Color Double Knitting:

Looking Good from Both Sides

Double knitting seems to do the impossible: It creates a fabric that looks like stockinette stitch on both sides—great for items such as scarves and blankets, or any garment you'd like to be reversible. Double-knit fabrics are two layers of fabric worked together: one layer of stockinette facing toward the knitter and another layer of stockinette facing away. Each "stitch" you work is actually made up of a pair of stitches, one that is knit and the other purled.

Double knitting shows off stockinette stitch on both the right and the wrong sides of the fabric. **Left:** One side of the swatch is green. **Right:** The other side is blue.

Double knitting gives you serious design freedom. Both sides of a fabric can be reversible (each side looks exactly alike), opposite reversible (the background and pattern colors are switched), or—and this gets really fun—unlike reversible (each side can look completely different from the other)! For example, in an opposite reversible pattern, a red polka dot on a blue background on one side of the fabric might become a blue polka dot on a red background on the other side. Or, in an unlike reversible pattern, vertical stripes on one side of the fabric might reverse to horizontal stripes on the other side, as in Double Knit Pattern 16 on page 150. Just keep in mind that a reversed motif appears in mirror image on the other layer of the fabric.

Casting On for Double Knitting In double knitting,

both layers of fabric are on the needle at once, so you must cast on enough stitches to work them both. In other words, if each layer is to be twenty-five stitches across, a total of fifty stitches must be cast on to start.

Nearly any cast-on technique can be used, but most of them result in both colors showing on both sides of the fabric. Obviously, this is not desirable for double knitting. For a smooth, clean, and highly elastic edge with only one color on each side of the fabric, use the two-color alternating cast-on described here. It's perfect for double knitting since it establishes pairs of knit and purl stitches from the very start. The knit stitches (color A) will begin one side of the fabric, and the purl stitches (color B) will begin the other side. The technique might feel awkward at first, but it'll become easier as you practice. At first it might be helpful to have

someone read the instructions out loud while you're doing the motions. You can promise your assistant a lovingly knit, handmade double-knit project once you become proficient with his or her help!

To cast on: With both colors held together, leave a 6"/[15cm] tail and make a slip knot on the right-hand needle. (The slip knot does not count as a stitch and will be dropped once the piece is finished.) Hold both yarns in your left hand, with color A (shown in blue in these illustrations) over your index finger and color B (shown in green) over your thumb.

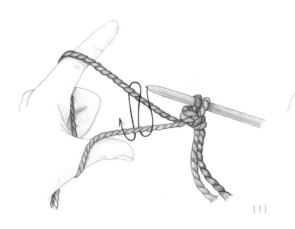

[1]

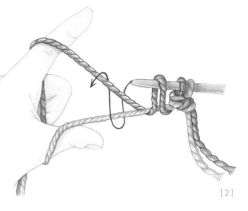

[2]

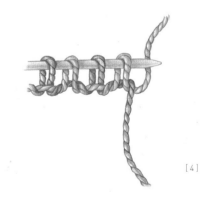

[3]

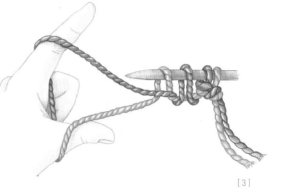

[4]

The first stitch cast on will be a knit stitch worked with blue (A): Swing the tip of the knitting needle in front of and under the strand of yarn that's over your thumb (B). Then swing the needle over and behind the strand that's over your index finger (A) (illustration 1). So far the technique is the same as for the long-tail cast-on, but hang on, because things are about to change!

The next stitch will be a purl stitch worked with green (B): From the back, bring the needle under both strands of yarn. Then bring the needle up and over to catch the green yarn (B) that's sitting on your thumb and bring it under and behind the blue (A) (illustration 2). So far two stitches have been cast on: one knit stitch made with blue (A) and one purl stitch made with green (B) (illustration 3).

Now alternate knit stitches cast on with color A with purl stitches cast on with color B until the required number of stitches has been cast on. And remember, stitches must be cast on for both layers of double-knit fabric!

Once all the stitches are cast on, twist color A over color B to prevent losing any stitches. Then turn your work, placing the needle in your left hand to knit the first row (illustration 4). Take care to safeguard that last stitch you cast on. It's easy for it to slip off. If you must put your knitting down before starting the first row, secure the stitches that have already been cast on by making an e-wrap cast-on stitch (page 32); be sure to undo it before beginning your first row.

color PLAY

Don't save this cast-on technique only for double knitting! When worked in one color, it's known as the invisible cast-on. Use it to start ribbed bands on sweaters and more for a beautiful, elegant edge.

Double-Knitting Techniques

When knitting double-knit fabrics, both sides of the fabric are worked at once, with all the stitches for the side of the fabric facing you (Side 1) to be knit and all the stitches for the side away from you (Side 2) to be alternately purled. Think of the stitches as being grouped in pairs: A knit stitch always is followed by a purl stitch.

Because both colors move back and forth with each stitch and share space on the needles, the stitches tend to spread and become larger than usual. Therefore, the gauge for double knitting is usually looser than the gauge for regular stockinette stitch—even when two identical swatches are knitted with the same yarn and needles.

When double-knit fabrics aren't knit tightly enough, a "grin through"—little blips of the color that show through from the layer beneath—may result. To counter this tendency, most knitters go down a needle size or two in order to get an attractive, tightly knit fabric. Of course, as in all knitting, use whatever size knitting needles you require to match the gauge called for in a pattern.

To create double-knit fabric: Start on Side 1 (Row 1) with both colors of yarn in back of your work. For the first stitch, knit a stitch with color A (illustration 5). Then bring both colors of yarn to the side facing you, and cross them over each other before working the second stitch of the pair. This will lock the sides together as you work. Purl a stitch with color B (illustration 6). Continue this way all across the row, alternately knitting one stitch with color A and purling one stitch with color B, then turn your work.

Side 2 (Row 2) is worked the same way as Side 1, but alternately knit the B stitches and purl the A stitches as follows (illustrations 7 and 8).

For Side 2: Begin with both colors of yarn in back of the work, and knit one stitch with color B. As before, bring both colors of yarn to the front, and cross them over each other before purling the second stitch with A. This will lock the sides together as you work. Continue this way all across the row.

Repeat these two rows: On Side 1 alternately knit one stitch worked with A and purl one stitch

[5]

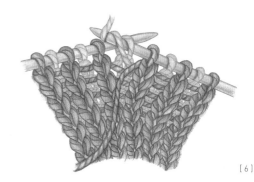

[6]

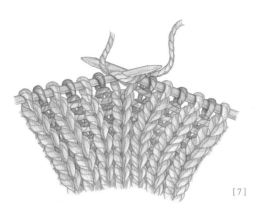

[7]

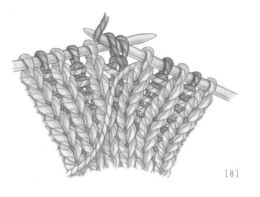

[8]

worked with B; on Side 2 alternately knit one stitch worked with B and purl one stitch worked with B.

NOTE: *Be sure to always bring both yarns between the needle tips to the front or back as you knit and purl. If you inadvertently separate the yarns when moving back and forth, the errant strand will show as a horizontal float on one of the layers.*

color PLAY

Crossing the two yarns after the first knit stitch of the row rather than at the beginning of the row prevents visible twists along the edge of the fabric. Plus, if you're making a project that will have seams (such as a reversible vest), your selvedge stitches will be less bulky, making seaming easier.

GIVING DOUBLE KNITS THE SLIP

For knitters with extra time on their hands (or for those who prefer to work with only one yarn at a time), there's another method of working double knitting: slip stitches. A knitter using the slip stitch method creates one layer of the fabric at a time while slipping the stitches for the other layer. On each row, you knit or purl the stitches that were slipped on the prior row and slip the stitches that were worked. With this method, it takes two passes on the needles to complete one row on both layers. A circular needle or double knitting needles must be used, since you must slide the stitches back to the beginning of the rows to work all the slipped stitches from the previous "pass" across the needle. Needless to say, it takes twice as long to knit. Guess which method I prefer?

To use the slip stitch method: For the first row, with Side 1 facing you, knit one stitch with color A,

then slip the next stitch purlwise (page 166) with the yarn in front. Continue to alternate knitting and slipping stitches according to your pattern until you reach the end of the row. Do not turn. Slide the stitches back to the opposite side of the needle to begin the second pass, and with Side 1 still facing you, alternately slip the knitted stitches (from the previous pass) purlwise with the yarn in back and purl the slipped stitches with color A until you reach the end of the row. Turn your work.

For the third and fourth rows, begin with Side 2 facing you. Alternately knit (or purl) and slip stitches using color A for Row 3, slipping stitches purlwise with the yarn in back, and color B for Row 4, slipping stitches purlwise with the yarn in front.

Repeat from the first row as necessary for your pattern.

Shaping in Double-Knit Fabrics

Stitches can be increased and decreased in double-knit fabrics, but take care to add and take away stitches from both sides of the fabric. For increases, work an increase into both paired stitches, and for decreases, slip the paired stitch to a cable needle so that you can knit (or purl) together stitches of the same side. *Voilà!* The increases and decreases are leaning in the same direction on their respective sides of the fabric.

Increasing Stitches

I like to use the M1 Increase to add stitches to double-knit fabrics because it is the most invisible method. As with all M1 Increases, the stitches can slant to the left or right for more refined shaping.

For an M1 Increase: With both yarns in back, scoop up the horizontal strand that is between the last knit stitch you worked and the next knit stitch from front to back. Knit into the back of this strand with the appropriate color, twisting it to prevent a hole. For the second increased stitch of the pair, bring both yarns to the front, insert the tip of your left-hand needle from back to front under the horizontal strand that is between the last purl stitch you made and the next purl stitch. Purl into the front of this strand with the appropriate color to create the new stitch.

NOTE: *This method makes an M1-R Increase on both sides of your double-knit fabric. To make an M1-L Increase (that slants to the left): For the first increased stitch of the pair, scoop up the horizontal strand from back to front and knit it into the front leg; for the second increased stitch of the pair, scoop up the strand from front to back and purl it through its back loop.*

Decreasing Stitches

Decreasing stitches on double-knit fabrics requires some preparation. The stitches must be set up so that two knit stitches and two purl stitches sit next to each other on the needle. Then common techniques such as k2tog and ssp for right-slanting decreases and ssk and p2tog for left-slanting decreases can be used.

To set up the stitches: Slip the knit stitch of the pair of stitches to be decreased purlwise from the left-hand needle to the right-hand needle. Slip the purl stitch of the pair to a cable needle purlwise and hold it to the back. Slip the next knit stitch purlwise to the right-hand needle. Slip the purl stitch from the cable needle back to the left-hand needle, taking care not to twist it. Slip the two knit stitches from the right-hand needle back to the left-hand needle.

Four stitches have now been rearranged, with two knit stitches next to two purl stitches. Decreases can now be worked slanting either to the left or to the right for both layers of the fabric as follows.

For a right-slanting decrease: For the first stitch of the pair, use a k2tog decrease. With both yarns in back, insert the tip of your right-hand needle into the two knit stitches knitwise and knit them together with the appropriate color yarn. To decrease the second stitch of the pair, use an ssp decrease. Move both yarns to the front, slip the two purl stitches knitwise, one at a time, to the

right-hand needle. Then slip them back to the left-hand needle, maintaining their twisted position. Insert the tip of the right-hand needle through the back loops of the two purl stitches (going into the second stitch first), and using the appropriate color yarn, purl them together.

For a left-slanting decrease: For the first stitch of the pair, use an ssk decrease. With both yarns in back, slip the two knit stitches knitwise, one at a time, to the right-hand needle. Then insert the tip of your left-hand needle into the stitches and knit them together from this position with the appropriate color yarn. To decrease the second stitch of the pair, use a p2tog decrease. Move both yarns to the front, insert the tip of the right-hand needle purlwise into the two stitches, and purl them together with the appropriate color.

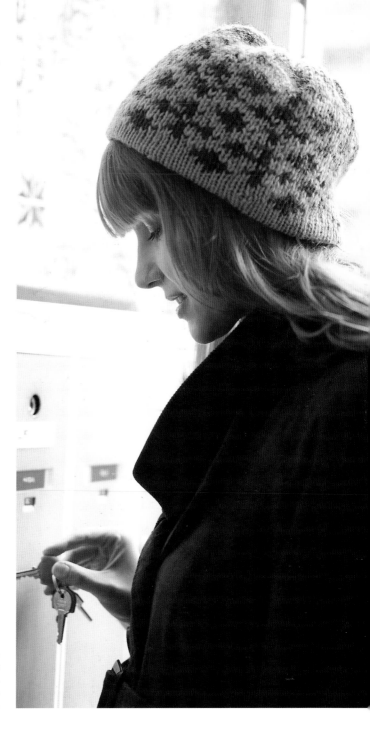

Right: Sometimes, you'll want to add shape to double-knit fabrics. The Memories-of-Vail Hat (page 158) uses decreases to shape the crown.

Binding Off

If you're like me, you like your bind-off edge to match your cast-on edge. If you've done the two-color alternating cast-on to start, the best way to end your piece of knitting is by grafting the two layers together using Kitchener stitch, as follows.

Begin by slipping all the knit stitches to one circular knitting needle and all the purl stitches to another one. (To do this, slip alternate stitches onto each needle.)

Align the needles so that the circular needle with the knit stitches is in the front and the needle with the purl stitches is in the back. Cut the working yarn, leaving a strand approximately three times the width of your bind-off edge. Thread the yarn onto a blunt-end yarn needle, and insert it purlwise (page 166) through the first stitch on the front

needle (illustration 9). Leave that first stitch on the needle. Then insert the yarn needle purlwise through the first stitch on the back needle, and slip that stitch off the back needle (illustration 10).

Now insert the yarn needle knitwise (page 165) through the next stitch on the back needle. Leave that stitch on the needle (illustration 11). Finally, insert the needle knitwise through the first stitch on the front needle again, and remove that stitch from the front needle (illustration 12).

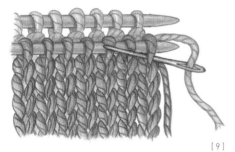

[9]

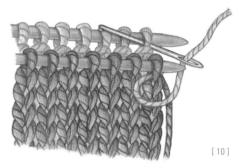

[10]

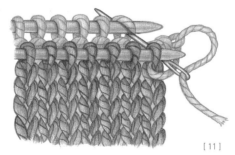

[11]

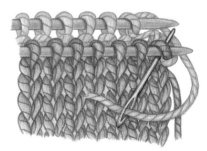

[12]

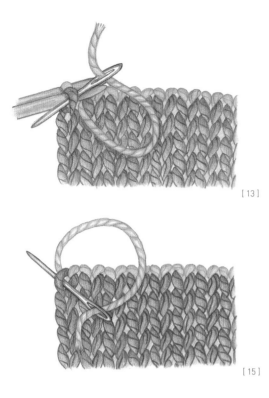

[13]

[14]

[15]

If your piece of fabric is narrow, the cables on your circular needles may curl, making the bind-off more difficult to do. Slip your stitches to two double-pointed needles instead. There's no sense dealing with curling cables when a short, straight double-pointed needle will do the trick!

Repeat the steps shown in illustrations 9–12 until only one stitch remains on each needle. Then follow illustrations 9, 10, and 12 once, omitting illustration 11 on this very last repeat.

To finish the last pair of stitches: Insert the yarn needle purlwise into the stitch on the front needle. Leave that stitch on the needle (illustration 13). Then insert the yarn needle purlwise into the stitch on the back needle and remove both stitches from the needles (illustration 14). Finally, insert the yarn needle knitwise into the very last stitch that had been on the front needle (illustration 15). Fasten off.

Hiding Yarn Tails

Since double-knit fabrics must look beautiful on both sides, one must be especially clever when hiding yarn tails. To ensure that the tails are secure and hidden, work duplicate stitch embroidery (page 85) on top of several stitches of the same color, then pull the tail so that it's between the sides of the fabric of a Row 1. Bring the tail back to the outside approximately 2"/[5cm] away from where it went between the sides, and cut the tail close to the fabric; stretch the fabric so that the tail disappears between the layers.

THE KITCHENER STITCH CHANT

It's helpful to have an instructional mantra to say to yourself as you perform this bind-off grafting technique. Just remember "purlwise, purlwise, knitwise, knitwise" and know that you remove a stitch from the needle only on the second "purlwise" or "knitwise." This way you won't lose track of where you are in the process!

Charts for Double Knitting

Charts for double knitting make the patterns easy and quick to read—just as they do for other types of knitting. However, since two layers of fabric are created at once, the charts for double knitting are slightly different than other charts. And the method changes depending on whether you are knitting flat in rows or are knitting in the round.

Flat Knitting Charts

When working back and forth in rows of double knitting, on odd-numbered rows, read the chart from right to left as you normally would. Side 1 will be facing you.

If the fabric is opposite reversible, with each side a reversed color image of the other, only one stitch of each two-stitch pair is shown. On odd-numbered rows, you're working on Side 1 of the fabric, and only the first stitch of each pair is given; with both colors of yarn in back, you knit with whatever color is shown in the chart. For the second stitch of the pair, you bring both colors of yarn to the front and purl with the other color—the one that is not shown in the chart. The second stitch of each pair is not actually drawn in the chart, but it is understood to be there. Continue in this way, knitting the stitches shown in the chart and purling the "silent" stitches, across the row.

color PLAY

You might find it useful to place a marker on Side 1 of your fabric. It'll give you a visual reminder that when you're on this side, the *knit* stitches are worked in the colors shown in the chart and on Side 2 the *purl* stitches are the ones shown in the chart.

On even-numbered rows, you're working on Side 2 of the fabric, and only the second stitch of each pair is shown. The first stitch of each pair is not included in the chart, but it is understood to be there. To work these even-numbered rows, read the chart from left to right as usual. However, you will begin with a "silent" stitch not shown in the chart. With both colors of yarn in back, knit the first stitch of each pair with the yarn color not shown in the chart, then bring both yarns to the front and purl the second stitch with the color shown in the chart. Continue across the chart, knitting the "silent" stitches and purling the stitches shown in the chart, from left to right in this fashion.

Completely reversible and unlike reversible patterns typically do not use charts in this way. They may use written instructions only, or there may be two charts—one for each side of the fabric.

Circular Knitting Charts

When working in the round, Side 1 of the fabric always faces you, so every round of the chart is read from right to left. This means that the chart shows only the first stitch of each pair of stitches. For every round, with both colors of yarn in back, you always knit the first stitch of the pair with the color shown in the chart. To work the second stitch of each pair, you bring both colors of yarn to the front and purl with the other color. These purled stitches are "silent" and do not appear in the chart.

Designer's Workshop: Designing for Double Knitting

It's quite interesting and fun to design original double-knit fabrics and even more exciting to watch them develop as they're knit! Play with some of the predesigned patterns in this book to get acquainted with the technique, and then let your imagination (and designer's mind) soar.

Inspiration

Use the following suggestions to jump-start your creativity with designing double-knit patterns.

• Rather than starting from scratch, you can use any traditional Fair Isle border chart for double knitting. See Double Knit Pattern 8 on page 146, for example.

• It's easy to place an isolated motif anywhere on a double-knit fabric. Try plopping one at both ends of a scarf or in alternating blocks for an afghan project!

• For an interesting effect, use two related patterns, putting one on each face of the fabric. Double Knit Pattern 16 on page 150, for instance, has vertical stripes on one side and horizontal stripes on the other. Cool!

Pattern Placement

Here are some basic guidelines for placing double knit patterns in a project:

• For opposite reversible pattern designs (colors are reversed on each side of the fabric) such as the Snuggle-Up Baby Blankie on page 162, simply chart out the color pattern for one layer. On odd-numbered rows, with both yarns in back, knit the first stitch of each pair of stitches with the color shown in your chart and with both yarns in front, then purl the second stitch of each pair with the other color; on even-numbered rows, just do the reverse.

• Keep in mind that not all patterns are suitable for reversible double knitting because images are not only reversed in color but are also mirror images. The musical note motif in Double Knit Pattern 19 on page 153, for example, would not be suitable as an opposite reversible pattern, as the musical notes on the other side of the fabric would be facing the wrong direction.

• For images that cannot be reversed, you may want a solid color on the opposing fabric layer. To knit these types of designs: On Side 1, with both yarns in back, work the knit stitch of each pair with the color shown in your chart and then, with both yarns in front, always work the purl stitch of the pair with the color you'd like to be solid on Side 2.

If you're working back and forth in rows, just do the reverse on Side 2: With both yarns in back, work the knit stitch of each pair with the color that's going to be solid on this side of the fabric and then, with both yarns in front, work the purl stitch of each pair with the color shown in the chart. If you're knitting in the round, just work the chart as if all rounds are on Side 1.

• You also can put different patterns on each layer of fabric. Work from two charts at once, and—to keep things as uncomplicated as possible—make sure that the charts have the same stitch and row repeats. Use one chart for the knit stitches on Side 1 and the other chart for the purl stitches on Side 1; for Side 2 (when working back and forth in rows), use the second chart for the knit stitches and the first chart for the purl stitches. You might find it useful to label the charts "Side 1" and "Side 2" and then put labels on your fabric so you know which side is which. For circular knitting, simply read the chart as if all rounds are on Side 1.

Pattern Treasury of Double Knitting

Some double-knit patterns in this treasury incorporate mirror images of the same design on both layers, some swap colors, and others—called unlike reversible patterns—look completely different on each side. Most patterns include a chart and sample swatch so that you can quickly find the perfect patterns for your projects, but the unlike reversible patterns use written instructions. With so many design options in double knitting, you're sure to have fun! Using the Pattern Treasuries on page 13 explains how best to incorporate individual patterns into your projects.

Reversible Patterns

DOUBLE KNIT PATTERN 1

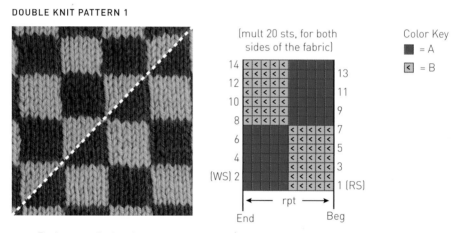

(mult 20 sts, for both sides of the fabric)

Color Key
■ = A
◁ = B

NOTE: Each square in the chart represents 2 sts (a knit stitch on the side of the fabric facing you and a purl st on the side away from you). Bring both yarns to the back or to the front as you knit and purl. On odd-numbered rows, knit the first st of the pair with the color shown in the chart and purl the second st with the other color (not shown); on even-numbered rows, knit the first st with the color not shown in the chart and purl the second st with the color shown in the chart.

DOUBLE KNIT PATTERN 2

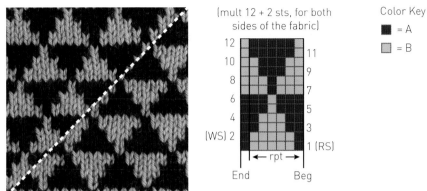

(mult 12 + 2 sts, for both sides of the fabric)

Color Key

■ = A

□ = B

NOTE: Each square in the chart represents 2 sts (a knit stitch on the side of the fabric facing you and a purl st on the side away from you). Bring both yarns to the back or to the front as you knit and purl. On odd-numbered rows, knit the first st of the pair with the color shown in the chart and purl the second st with the other color (not shown); on even-numbered rows, knit the first st with the color *not* shown in the chart and purl the second st with the color shown in the chart.

DOUBLE KNIT PATTERN 3

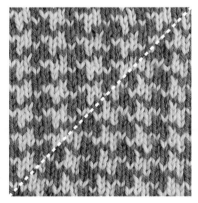

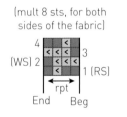

(mult 8 sts, for both sides of the fabric)

Color Key

■ = A

◰ = B

NOTE: Each square in the chart represents 2 sts (a knit stitch on the side of the fabric facing you and a purl st on the side away from you). Bring both yarns to the back or to the front as you knit and purl. On odd-numbered rows, knit the first st of the pair with the color shown in the chart and purl the second st with the other color (not shown); on even-numbered rows, knit the first st with the color *not* shown in the chart and purl the second st with the color shown in the chart.

Opposite Reversible Patterns

DOUBLE KNIT PATTERN 4

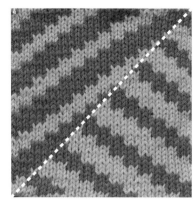

(mult 10 sts, for both sides of the fabric)

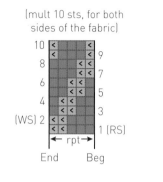

rpt

End Beg

Color Key

 = A

= B

NOTE: Each square in the chart represents 2 sts (a knit stitch on the side of the fabric facing you and a purl st on the side away from you). Bring both yarns to the back or to the front as you knit and purl. On odd-numbered rows, knit the first st of the pair with the color shown in the chart and purl the second st with the other color (not shown); on even-numbered rows, knit the first st with the color *not* shown in the chart and purl the second st with the color shown in the chart.

- -

DOUBLE KNIT PATTERN 5

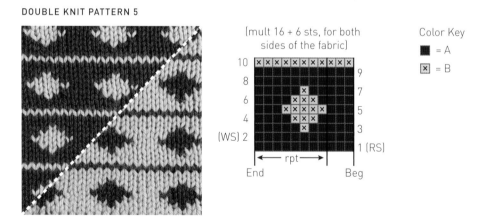

(mult 16 + 6 sts, for both sides of the fabric)

rpt

End Beg

Color Key

= A

= B

NOTE: Each square in the chart represents 2 sts (a knit stitch on the side of the fabric facing you and a purl st on the side away from you). Bring both yarns to the back or to the front as you knit and purl. On odd-numbered rows, knit the first st of the pair with the color shown in the chart and purl the second st with the other color (not shown); on even-numbered rows, knit the first st with the color *not* shown in the chart and purl the second st with the color shown in the chart.

DOUBLE KNIT PATTERN 6

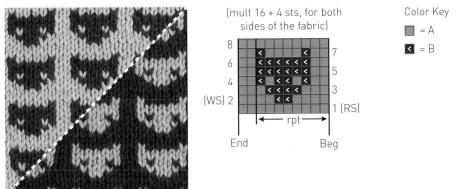

(mult 16 + 4 sts, for both sides of the fabric)

Color Key

◻ = A

◀ = B

NOTE: Each square in the chart represents 2 sts (a knit stitch on the side of the fabric facing you and a purl st on the side away from you). Bring both yarns to the back or to the front as you knit and purl. On odd-numbered rows, knit the first st of the pair with the color shown in the chart and purl the second st with the other color (not shown); on even-numbered rows, knit the first st with the color *not* shown in the chart and purl the second st with the color shown in the chart.

DOUBLE KNIT PATTERN 7

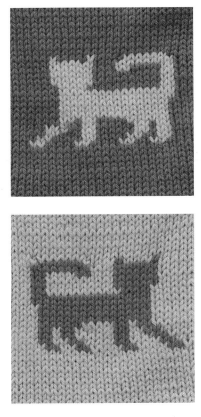

(40 sts, for both sides of the fabric)

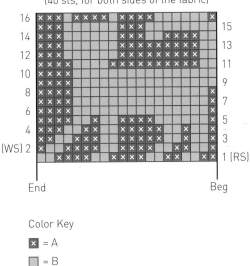

Color Key

☒ = A

◻ = B

NOTE: Each square in the chart represents 2 sts (a knit stitch on the side of the fabric facing you and a purl st on the side away from you). Bring both yarns to the back or to the front as you knit and purl. On odd-numbered rows, knit the first st of the pair with the color shown in the chart and purl the second st with the other color (not shown); on even-numbered rows, knit the first st with the color *not* shown in the chart and purl the second st with the color shown in the chart.

DOUBLE KNIT PATTERN 8

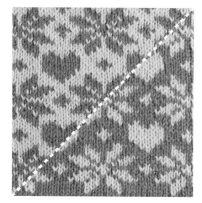

(mult 32 + 30 sts, for both sides of the fabric)

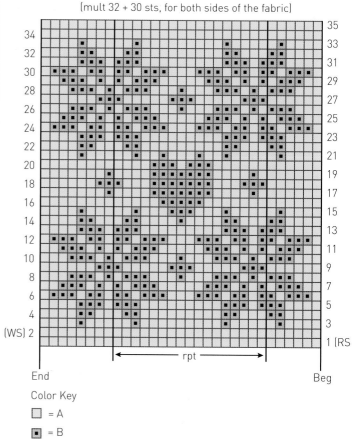

NOTE: Each square in the chart represents 2 sts (a knit stitch on the side of the fabric facing you and a purl st on the side away from you). Bring both yarns to the back or to the front as you knit and purl. On odd-numbered rows, knit the first st of the pair with the color shown in the chart and purl the second st with the other color (not shown); on even-numbered rows, knit the first st with the color *not* shown in the chart and purl the second st with the color shown in the chart.

Color Key

☐ = A

▣ = B

DOUBLE KNIT PATTERN 9

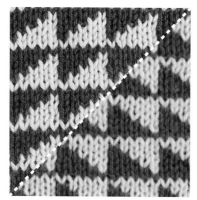

(mult 10 sts, for both sides of the fabric)

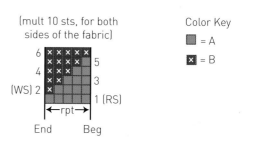

Color Key

▣ = A

☒ = B

NOTE: Each square in the chart represents 2 sts (a knit stitch on the side of the fabric facing you and a purl st on the side away from you). Bring both yarns to the back or to the front as you knit and purl. On odd-numbered rows, knit the first st of the pair with the color shown in the chart and purl the second st with the other color (not shown); on even-numbered rows, knit the first st with the color *not* shown in the chart and purl the second st with the color shown in the chart.

DOUBLE KNIT PATTERN 10

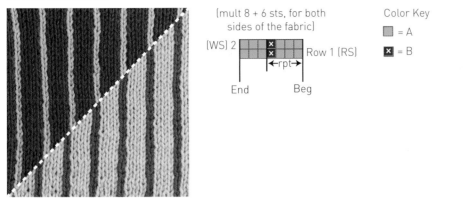

(mult 8 + 6 sts, for both sides of the fabric)

(WS) 2 ⟵rpt⟶ Row 1 (RS)

End Beg

Color Key

□ = A

☒ = B

NOTE: Each square in the chart represents 2 sts (a knit stitch on the side of the fabric facing you and a purl st on the side away from you). Bring both yarns to the back or to the front as you knit and purl. On odd-numbered rows, knit the first st of the pair with the color shown in the chart and purl the second st with the other color (not shown); on even-numbered rows, knit the first st with the color *not* shown in the chart and purl the second st with the color shown in the chart.

DOUBLE KNIT PATTERN 11

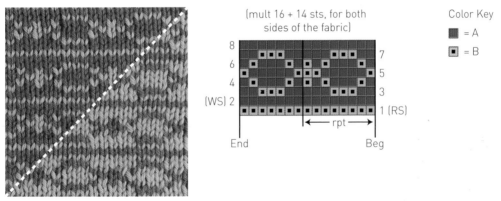

(mult 16 + 14 sts, for both sides of the fabric)

8
6 7
4 5
(WS) 2 3
 1 (RS)

⟵ rpt ⟶

End Beg

Color Key

■ = A

▣ = B

NOTE: Each square in the chart represents 2 sts (a knit stitch on the side of the fabric facing you and a purl st on the side away from you). Bring both yarns to the back or to the front as you knit and purl. On odd-numbered rows, knit the first st of the pair with the color shown in the chart and purl the second st with the other color (not shown); on even-numbered rows, knit the first st with the color *not* shown in the chart and purl the second st with the color shown in the chart.

DOUBLE KNIT PATTERN 12

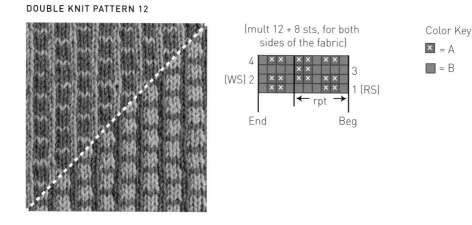

(mult 12 + 8 sts, for both sides of the fabric)

Color Key

☒ = A

⬛ = B

NOTE: Each square in the chart represents 2 sts (a knit stitch on the side of the fabric facing you and a purl st on the side away from you). Bring both yarns to the back or to the front as you knit and purl. On odd-numbered rows, knit the first st of the pair with the color shown in the chart and purl the second st with the other color (not shown); on even-numbered rows, knit the first st with the color *not* shown in the chart and purl the second st with the color shown in the chart.

DOUBLE KNIT PATTERN 13

(mult 2 sts, for both sides of the fabric)

Color Key

⬜ = A

◼ = B

NOTE: Each square in the chart represents 2 sts (a knit stitch on the side of the fabric facing you and a purl st on the side away from you). Bring both yarns to the back or to the front as you knit and purl. On odd-numbered rows, knit the first st of the pair with the color shown in the chart and purl the second st with the other color (not shown); on even-numbered rows, knit the first st with the color *not* shown in the chart and purl the second st with the color shown in the chart.

DOUBLE KNIT PATTERN 14

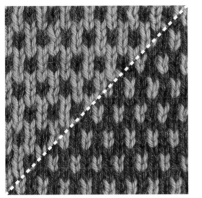

(mult 4 + 6 sts, for both sides of the fabric)

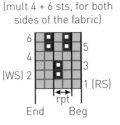

Color Key

☐ = A

▣ = B

NOTE: Each square in the chart represents 2 sts (a knit stitch on the side of the fabric facing you and a purl st on the side away from you). Bring both yarns to the back or to the front as you knit and purl. On odd-numbered rows, knit the first st of the pair with the color shown in the chart and purl the second st with the other color (not shown); on even-numbered rows, knit the first st with the color *not* shown in the chart and purl the second st with the color shown in the chart.

DOUBLE KNIT PATTERN 15

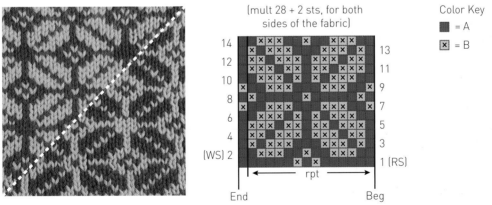

(mult 28 + 2 sts, for both sides of the fabric)

Color Key

■ = A

☒ = B

NOTE: Each square in the chart represents 2 sts (a knit stitch on the side of the fabric facing you and a purl st on the side away from you). Bring both yarns to the back or to the front as you knit and purl. On odd-numbered rows, knit the first st of the pair with the color shown in the chart and purl the second st with the other color (not shown); on even-numbered rows, knit the first st with the color *not* shown in the chart and purl the second st with the color shown in the chart.

Unlike Reversible Patterns

DOUBLE KNIT PATTERN 16

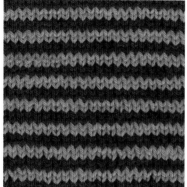
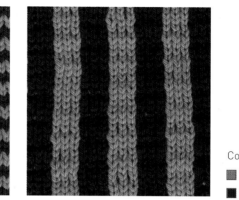

Color Key

■ = A
■ = B

(mult 12 sts)

Using the 2-color alternating cast-on (page 132), cast on a multiple of 12 sts, making the first stitch with color A.

Row 1 (RS): *(With both yarns in back, knit the next st with A, with both yarns in front, purl the next st with B) 3 times, (with both yarns in back, knit the next st with A, with both yarns in front purl the next st with A) 3 times. Repeat from * across.

Row 2: *(With both yarns in back, knit the next st with A, with both yarns in front, purl the next st with A) 3 times, (with both yarns in back, knit the next st with B, with both yarns in front, purl the next st with A) 3 times. Repeat from * across.

Row 3: *(With both yarns in back, knit the next st with B, with both yarns in front, purl the next st with B) 3 times, (with both yarns in back, knit the next st with B, with both yarns in front purl the next st with A) 3 times. Repeat from * across.

Row 4: *(With both yarns in back, knit the next st with A, with both yarns in front, purl the next st with B) 3 times, (with both yarns in back, knit the next st with B, with both yarns in front purl the next st with B) 3 times. Repeat from * across.

Repeat Rows 1–4 for the pattern.

Using A, graft the sts together using Kitchener stitch (page 138).

DOUBLE KNIT PATTERN 17

Color Key

■ = A

▨ = B

(mult 18 + 2 sts)

Using the 2-color alternating cast-on (page 132), cast on a multiple of 18 + 2 sts, making the first stitch with color B.

Row 1 (RS): *With both yarns in back, knit the next st with A, with both yarns in front, purl the next st with B, with both yarns in front, purl next st with B, (with both yarns in back, knit the next st with A, with both yarns in front, purl the next st with B) 6 times, with both yarns in back, knit the next st with B, with both yarns in front, purl the next st with B. Repeat from * across, ending the row with (both yarns in back, knit the next st with A, with both yarns in front, purl the next st with B).

Row 2: With both yarns in back, knit the next st with B, with both yarns in front, purl the next st with A, *(with both yarns in back, knit the next st with B, with both yarns in front, purl the next st with B) 6 times, with both yarns in back, knit the next st with B, with both yarns in front, purl the next st with A, with both yarns in back, knit the next st with B, with both yarns in front, purl the next st with A. Repeat from * across.

Row 3: *(With both yarns in back, knit the next st with A, with both yarns in front, purl the next st with B, with both yarns in back, knit the next st with B, with both yarns in front, purl the next st with B) twice, (with both yarns in back, knit the next st with A, with both yarns in front, purl the next st with B) 5 times. Repeat from * across, ending the row with (both yarns in back, knit the next st with A, with both yarns in front, purl the next st with B).

Row 4: Same as Row 2.

Row 5: Same as Row 1.

Row 6: With both yarns in back, knit the next st with B, with both yarns in front, purl the next st with A, *with both yarns in back, knit the next st with B, with both yarns in front, purl the next st with B, with both yarns in back, knit the next st with B, with both yarns in front, purl the next st with A, (with both yarns in back, knit the next st with B, with both yarns in front, purl the next st with B) 6 times, with both yarns in back, knit the next st with B, with both yarns in front, purl the next st with A. Repeat from * across.

Row 7: *(With both yarns in back, knit the next st with A, with both yarns in front, purl the next st with B) 6 times, with both yarns in back, knit the next st with B, with both yarns in front, purl the next st with B, with both yarns in back, knit the next st with A, with both yarns in front, purl the next st with B, with both yarns in back, knit the next st with B, with both yarns in front, purl the next st with B. Repeat from * across, ending the row with (both yarns in back, knit the next st with A, with both yarns in front, purl the next st with B).

Row 8: Same as Row 6.

Repeat Rows 1–8 for the pattern.

Using B, graft the stitches together using the Kitchener stitch (page 138).

DOUBLE KNIT PATTERN 18

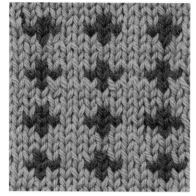 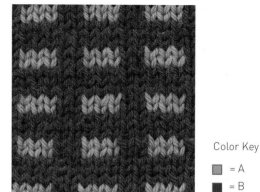

Color Key

■ = A
■ = B

(mult 10 + 4 sts)

Using the 2-color alternating cast-on (page 132), cast on a multiple of 10 + 4 sts, making the first stitch with color B.

Row 1 (RS): *(With both yarns in back, knit the next st with A, with both yarns in front, purl the next st with B) two times, (with both yarns in back, knit the next st with A, with both yarns in front, purl the next st with A) three times. Repeat from * across, ending row with (both yarns in back, knit the next st with A, with both yarns in front, purl the next st with B) twice.

Row 2: *(With both yarns in back, knit the next st with B, with both yarns in front, purl the next st with A) 3 times, with both yarns in back, knit the next st with B, with both yarns in front, purl the next st with B, with both yarns in back, knit the next st with B, with both yarns in front, purl the next st with A. Repeat from * across, ending row with (both yarns in back, knit the next st with B, with both yarns in front, purl the next st with A) twice.

Row 3: *(With both yarns in back, knit the next st with A, with both yarns in front, purl the next st with B) twice, (*with both yarns in back, knit the next st with B, with both yarns in front, purl the next st with B) 3 times. Repeat from * across, ending row with (both yarns in back, knit the next st with A, with both yarns in front, purl the next st with B) twice.

Row 4: Same as row 2.

Row 5: Same as row 1.

Row 6: *(With both yarns in back, knit the next st with B, with both yarns in front, purl the next st with A) twice, (with both yarns in back, knit the next st with A, with both yarns in front, purl the next st with A) 3 times. Repeat from * across, ending row with (both yarns in back, knit the next st with B, with both yarns in front, purl the next st with A) twice.

Row 7: *(With both yarns in back, knit the next st with A, with both yarns in front, purl the next st with B) 3 times, with both yarns in back, knit the next st with B, with both yarns in front, purl the next st with B, with both yarns in back, knit the next st with A, with both yarns in front, purl the next st with B. Repeat from * across, ending row with (both yarns in back, knit the next st with A, with both yarns in front, purl the next st with B) twice.

Row 8: *(With both yarns in back, knit the next st with B, with both yarns in front, purl the next st with A) twice, (with both yarns in back, knit the next st with B, with both yarns in front, purl the next st with B) 3 times. Repeat from * across, ending row with (both yarns in back, knit the next st with B, with both yarns in front, purl the next st with A) twice.

Row 9: Same as Row 7.

Row 10: Same as Row 6.

Repeat Rows 1–10 for the pattern.

Using B, graft the sts together using Kitchener stitch (page 138).

DOUBLE KNIT PATTERN 19

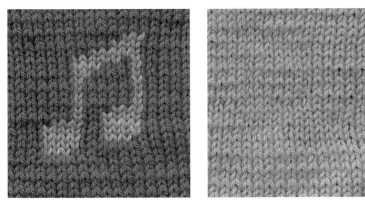

(52 sts, for both sides of the fabric)

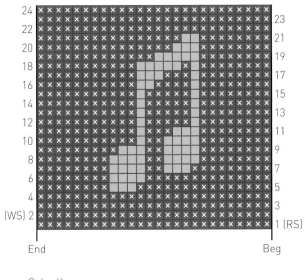

End Beg

NOTE: Each square in the chart represents 2 sts (a knit st on the side of the fabric facing you and a purl st on the side away from you). Bring both yarns to the back or to the front as you knit and purl. On odd-numbered rows, knit the first st of the pair with the color shown in the chart and purl the second st with the solid color (not shown); on even-numbered rows, knit the first st with the solid color and purl the second st with the color shown in the chart.

Color Key

 = A

☒ = B

SKILL LEVEL
Intermediate

SIZE
One size

FINISHED MEASUREMENTS
Approximately 7¼ x 68"/[18.5 x 172.5cm]

MATERIALS
Blue Sky Alpaca's *Sportweight:*
2-fine weight; 100% baby alpaca;
each approximately 1¾ oz/[50g] and
110 yds/[100.5m]. 4 hanks of Fuchsia
#530 (A) (2)

Blue Sky Alpaca's *Melange:*
2-fine weight; 100% baby alpaca;
each approximately 1¾ oz/[50g] and
110 yds/[100.5m]. 2 hanks of Licorice
#803 (B) (2)

Size 4 (3.5mm) knitting needles, or size
needed to obtain gauge

Two size 4 (3.5mm)
double-pointed needles

Blunt-end yarn needle

GAUGE
32 stitches and 28 rows = 4"/[10cm]
in the Stripe Pattern.

To save time, take time to check gauge.

STITCH PATTERN

Stripe Pattern (even number of stitches)
Row 1 (RS): *With both yarns in back, knit
the 1st st of the pair with A, with both
yarns in front, purl the 2nd st of the pair
with B; repeat from * across.

Row 2: With both yarns in back, knit
the 1st st of the pair with A, *with both
yarns in front, purl the 2nd st of the pair
with A; repeat from * across.

Repeat Rows 1 and 2 for the pattern.

Winter Warmer Scarf

Creating an unlike reversible fabric

This scarf is the perfect gift: It's colorful, luxurious, and wonderfully warm, thanks to the double-knit fabric. Choose sharply contrasting colors to ensure that the horizontal stripes pop!

NOTE
- At the beginning of each row, knit the first stitch with the indicated color, then bring both colors of yarn to the front, and cross them over each other before purling the second stitch with its correct color. This maneuver will close the sides as you work the two colors together.

SUGGESTED ALTERNATE COLORWAYS
Alternate colorway 1, left: Blue Sky Alpaca's *Sportweight* in Red #511 (A) and Melange in Tangerine #521 (B)

Alternate colorway 2, right: Sportweight in Dijon #807 (A) and Melange in Pesto #802 (B) (2)

Scarf

Using the two-color alternating cast-on (page 132), cast on 58 stitches, making the first stitch with color A.

Work even in the Stripe Pattern until the piece measures approximately 68"/[172.5cm], ending with Row 1.

Transfer all the stitches worked with A to one double-pointed needle and all the stitches worked with B to another double-pointed needle.

Using A, bind off by grafting the stitches together using Kitchener stitch (page 138).

Finishing

Weave in yarn tails using duplicate stitch embroidery (page 85).

Block the scarf to the finished measurements.

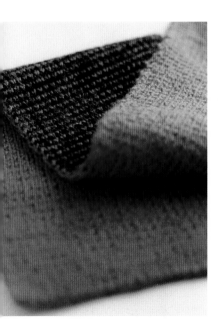

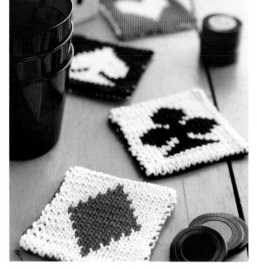

SKILL LEVEL
Intermediate

SIZE
One size

FINISHED MEASUREMENTS
Approximately 3½" x 3½"/[9cm x 9cm]

MATERIALS
JCA/Reynold's *Top Seed Cotton:* 3-DK
weight; 100% mercerized cotton; each
approximately 1¾ oz/[50g] and 105 yds/
[96m]. 1 hank *each* of White #260 (A),
Black #220 (B), and Red #971 (C) (**3**)

Three size 3 (3.25mm) double-pointed
needles, or size needed to obtain gauge

Blunt-end yarn needle

GAUGE
40 stitches and 30 rows = 4"/[10cm] in
the coaster chart patterns; one coaster
can serve as your gauge swatch.

To save time, take time to check gauge.

STITCH PATTERNS
Club Pattern (36 stitches, 26 rows)
See the chart (opposite).

Spade Pattern (36 stitches, 26 rows)
See the chart (opposite).

Heart Pattern (34 stitches, 26 rows)
See the chart (opposite).

Diamond Pattern (34 stitches, 26 rows)
See the chart (opposite).

Vegas-Style Coasters

Reading charts for flat double knitting

Who says knitting can't save your life—or at least your
furniture?! Knit these useful coasters while practicing
two-color double knitting. I chose the colors of traditional
playing cards, but you could choose any colorway you'd like.

NOTES
- To cast on, use two-color alternating cast-on (page 132), with
 the first stitch in color A.

- At the beginning of each row, knit the first stitch with the
 indicated color, then bring both colors of yarn to the front, and
 cross them over each other before purling the second stitch with
 its correct color. This maneuver will close the sides as you work
 the two colors together.

Coaster (make 4)
Cast on 36 stitches for the Club and Spade patterns and
34 stitches for the Heart and Diamond patterns.

Using the double-knitting technique, work the appro-
priate chart.

When the chart is complete, transfer all the stitches
worked with A to one double-pointed needle and all the
stitches worked with B to another double-pointed needle.

Using A, bind off by grafting the stitches together using
Kitchener stitch (page 138).

FINISHING
Weave in yarn tails using duplicate stitch embroidery
(page 85).

Block the pieces to the finished measurements.

CLUB PATTERN

(36 sts)

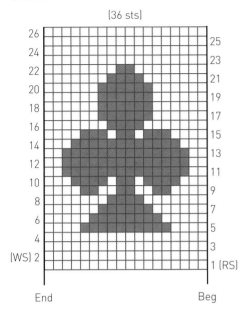

End Beg

SPADE PATTERN

(36 sts)

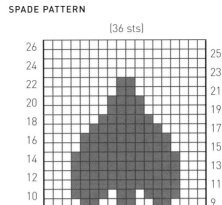

End Beg

HEART PATTERN

(34 sts)

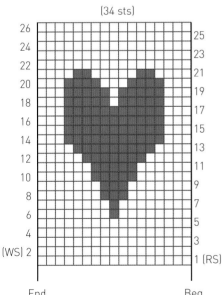

End Beg

DIAMOND PATTERN

(34 sts)

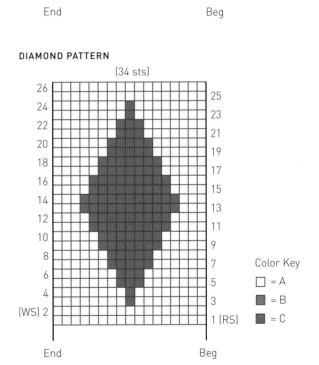

End Beg

Color Key

☐ = A

▨ = B

▓ = C

NOTE: Each square in the chart represents 2 sts (a knit st on the side of the fabric facing you and a purl st on the side away from you). Bring both yarns to the back or to the front as you knit and purl. On odd-numbered rows, knit the first st of the pair with the color shown in the chart and purl the second st with the other color (not shown); on even-numbered rows, knit the first st with the color *not* shown in the chart and purl the second st with the color shown in the chart.

Memories-of-Vail Hat

Making decreases in double knitting

This little hat is a blast to knit! It's opposite reversible, so you can wear it one way on Monday and the other way on Tuesday. And the hat's two layers make it extra warm. I've provided instructions for men's and women's versions, since everyone who's seen my hat wants one of his or her own . . .

SKILL LEVEL
Intermediate

SIZES
Woman's (Man's). Instructions are for the smaller size, with changes for the larger size noted in parentheses as necessary.

FINISHED MEASUREMENTS
Circumference: 19 (21)"/(48.5 (53.5)cm]

Length: 8¼ (8¾)"/(21 (22)cm]

MATERIALS
Louet Yarn's *Riverstone Light:* 4-medium/worsted weight; 100% wool; each approximately 3½ oz/[100g] and 193 yds/[176.5m]. 1 hank *each* of #24 Purple (A) and #55 Willow (B) 〔4〕

Size 5 (3.75mm) 16"/[40.5cm] circular knitting needle, or size needed to obtain gauge

Size 5 (3.75mm) double-pointed needles (2 sets of 4), or size needed to obtain gauge

Cable needle

Stitch marker

Blunt-end yarn needle

GAUGE
38 stitches and 26 rounds = 4"/[10cm] in the Vail Hat Pattern.

To save time, take time to check gauge.

STITCH PATTERN
Vail Hat Pattern (multiple of 20 stitches)
See the chart (page 160).

NOTES

- This hat is made in the round from the bottom up.

- When making the hat, change to double-pointed needles when there are too few stitches remaining to knit comfortably with the circular needle.

- When decreasing for the crown, decrease as follows in double knitting (this method decreases 1 stitch on each side of the fabric): Slip 1 stitch to the right-hand needle; slip 1 stitch to a cable needle; slip 1 more stitch to the right-hand needle; return the stitch from the cable needle back to the left-hand needle; slip the 2 slipped stitches from the right-hand needle back to the left-hand needle, then k2tog with A, p2tog with B.

SUGGESTED ALTERNATE COLORWAYS
Alternate Colorway 1, left: Louet Yarn's *Riverstone Light* in Caribou #53 (A) and Neptune #15 (B)

Alternate Colorway 2, right: Royal #60 (A) and Cream #30 (B) 〔4〕

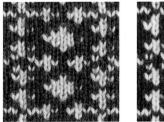

Hat

Using the two-color alternating cast-on (page 132), cast on 180 (200) stitches onto circular needles, making the first cast-on stitch with color A. Place a marker for the beginning of the round and join, being careful not to twist the stitches.

Work Rounds 1–45 in double knitting following the chart.

Work 0 (2) more rounds in colors as set.

DECREASE FOR CROWN

Next Round: *Decrease 1 stitch on each layer (Notes, page 159), [with both yarns in back, k1 with A; with both yarns in front, p1 with B] 3 times; repeat from * around—144 (160) stitches remain.

Work even for 1 (2) round(s), working all knit stitches with A and working all purl stitches with B.

Next Round: *Decrease 1 stitch on each side, [with both yarns in back, k1 with A; with both yarns in front, p1 with B] twice; repeat from * around—108 (120) stitches remain.

Work even for 1 round in colors as set.

Next Round: *Decrease 1 stitch on each side, with both yarns in back, k1 with A, with both yarns in front, p1 with B; repeat from * around—72 (80) stitches remain.

Work even for 1 round in colors as set.

Next Round: *Decrease 1 stitch on each side; repeat from * around—36 (40) stitches remain.

Next Round: Repeat the previous round—18 (20) stitches remain.

Do not bind off. Cut the yarns, leaving 12"/ [30.5cm] tails.

Finishing

Divide the stitches, placing the knit stitches of each pair onto one double-pointed needle and the purl stitches onto another.

With the darker side of the Hat facing and using a blunt-end yarn needle, thread the color A tail through the color A stitches; pull tight to close the top of the Hat.

Turn the Hat inside out and using the color B tail, close the top of the Hat as described above.

Weave in yarn tails using duplicate stitch embroidery (page 85).

VAIL HAT PATTERN

(mult 20 sts)

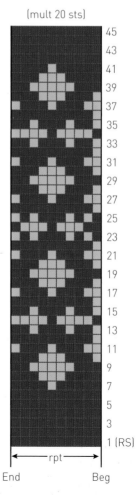

rpt

End Beg

Color Key

■ = A
▨ = B

NOTE: Each square in the chart represents 2 sts (a knit st on the side of the fabric facing you and a purl st on the side away from you). Bring both yarns to the back or to the front as you knit and purl. Because this hat is made in the round, always knit the 1st st of the pair with the color shown in the chart and purl the 2nd st with the other color.

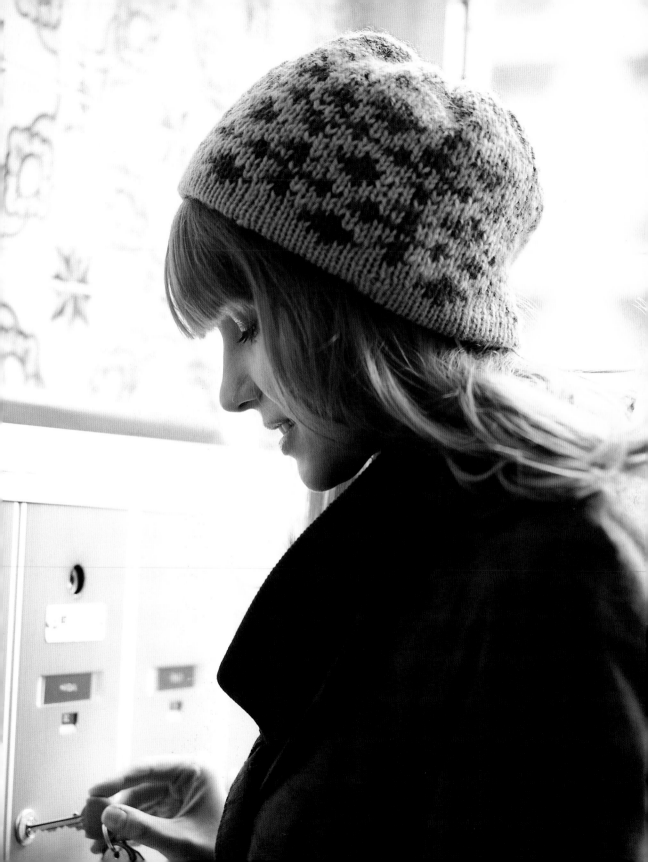

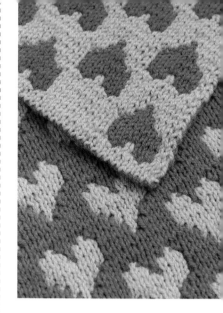

Snuggle-Up Baby Blankie

Creating an opposite reversible fabric

Every mother of a newborn would love to receive this baby blankie! Because it's double knit, it is nice and thick, and it looks great on both sides. Bonus: The wool and acrylic blend is machine-washable and soft.

NOTE

- At the beginning of each row, knit the first stitch with the indicated color, then bring both colors of yarn to the front, and cross them over each other before purling the second stitch with its correct color. This will close the sides as you work the two colors together.

SUGGESTED ALTERNATE COLORWAYS

Alternate Colorway 1, left: Plymouth Yarn's *Encore Worsted* Petal Pink #449 (A) and Skipper Blue #4045 (B)

Alternate Colorway 2, right: Light Butter #215 (A) and Spring Green #3335 (B) 🔲

SKILL LEVEL
Intermediate

SIZE
One size

FINISHED MEASUREMENTS
Approximately 34¾" x 34¾"/ [88cm x 88cm]

MATERIALS
Plymouth Yarn's *Encore Worsted:* 4-medium/worsted weight; 75% acrylic/25% wool; each approximately 1¾ oz/[50g] and 200 yds/[183m]. 5 balls *each* of #1385 Fuchsia (A) and #448 Orange Sherbet (B) 🔲

Two size 7 (4.5mm) 36"/[91cm] circular knitting needles, or size needed to obtain gauge

Blunt-end yarn needle

GAUGE
32 stitches and 21 rows = 4"/[10cm] in the Heart Pattern.

To save time, take time to check gauge.

STITCH PATTERN
Heart Pattern
(multiple of 16 stitches + 11)
See the chart (opposite).

Blanket

Using the two-color alternating cast-on (page 132), cast on 278 stitches, making the 1st stitch color A.

Begin working the Heart Pattern chart in double knitting, and work Rows 1–26 once.

Repeat Rows 11–26 ten more times, then work Rows 27–31 once.

Transfer all the stitches worked with A to one spare circular knitting needle and all the stitches worked with B to another spare circular knitting needle, using needles that are the same size or one or two sizes smaller than the working needle.

Using a 120"[305cm] length of B, bind off by grafting the stitches together using Kitchener stitch (page 138).

Finishing

Weave in yarn tails using duplicate stitch embroidery (page 85).

Block the blanket to the finished measurements.

HEART PATTERN

(mult 32 + 22 sts)

Rpt Rows 11–26 eleven times total

Color Key
■ = A
□ = B

End

Beg

NOTE: Each square in the chart represents 2 sts (a knit st on the side of the fabric facing you and a purl st on the side away from you). Bring both yarns to the back or to the front as you knit and purl. On odd-numbered rows, knit the 1st st of the pair with the color shown in the chart and purl the 2nd st with the other color (not shown); on even-numbered rows, knit the 1st st with the color *not* shown in the chart and purl the 2nd st with the color shown in the chart.

General Techniques

Following are some basic skills used in the projects in this book. Refer here whenever you'd like a refresher!

Knitting Techniques

Bobble (B)

Bobbles introduce surface texture to fabrics. Though time-consuming to knit, they add a bit of whimsy and are not at all difficult. To make a bobble, work several stitches into a single stitch, increasing the number of stitches in that area from 1 stitch to 3, 5, or more. Work several rows on these new stitches, turning the work after each successive row. Finally, decrease the stitches back to the original single stitch.

Cable

Cables are made when stitches exchange places with other stitches within a knitted row. One set of stitches is placed on a cable needle to keep the stitches out of the way while another set of stitches is worked. Several factors affect the final pattern: the number of stitches held, the direction in which they are held (to the front or to the back of the work), and whether the stitches are ultimately knitted or purled.

For a two-over-two right-crossed stockinette cable, slip 2 stitches to the cable needle and hold them in back of the work; knit 2 stitches from the left-hand needle, then knit 2 stitches from the cable needle.

For a two-over-two left-crossed stockinette cable, slip 2 stitches to the cable needle and hold them in front of work; knit 2 stitches from the left-hand needle, then knit 2 stitches from the cable needle.

Cable Cast-On

This particular cast-on is my favorite cast-on technique: It's beautiful, quick, and easy to do.

Plus, it's perfect when the first row worked is a right-side row.

Begin by making a slip knot on your knitting needle, then insert the tip of the right-hand needle knitwise into the loop that's sitting on the left-hand needle and knit a stitch (illustration 1) but don't remove the original stitch from the left-hand needle; instead, transfer the new stitch from the right-hand needle back to the left-hand one.

One new stitch has been cast on.

For each successive stitch to be cast on, insert the tip of the right-hand needle between the first 2 stitches on the left-hand needle to knit a stitch (illustration 2).

As before, do not remove the old stitch, but slip the new one back to the left-hand needle; repeat until you have cast on the required number of stitches.

[1]

[2]

Carrying Yarn

Basic technique (page 15)

For stranded knitting (page 25)

Circular Knitting

Basic technique (page 36)

For intarsia knitting (page 82)

Fasten Off

To finish a piece of fabric securely once the knitting is completed, cut the yarn leaving at least a 6"/ [15cm] tail, and fasten off by drawing the loose tail through the remaining stitch on the knitting needle. Later, this yarn tail can be used for seaming or else must be woven in (page 15).

K2tog Decrease

Here's the simplest kind of decrease, and the resulting stitch slants toward the right. Just insert your right-hand knitting needle into 2 stitches at once instead of 1 stitch and knit them together as 1 stitch (illustration 3).

NOTE: *For a K3tog, use the same method to combine 3 stitches into 1 stitch.*

[3]

Knit-On Cast-On

This cast-on technique is similar to the cable cast-on, previous page, except new stitches are created by working directly into stitches rather than in between them.

Knitwise

Instructions will sometimes tell you to insert your knitting needle into a stitch knitwise. To do this, simply insert the tip of your right-hand needle into the indicated stitch as if you were about to knit that stitch—in other words, from left to right and from front to back (illustration 4).

[4]

If you're told to slip a stitch knitwise, insert the tip of your right-hand needle into the indicated stitch as if you're about to knit it and slip that stitch off of the left-hand needle and onto the right-hand one, twisting the stitch (left leg in the front). Usually, stitches are slipped knitwise during a decrease.

Make One Increase (M1, M1-L, or M1-R)

This method of increasing is the most invisible and perhaps the most useful one to have in your knitting repertoire. It can be made to slant toward the left (abbreviated M1-L) or toward the right (abbreviated M1-R). *If the slanting direction is not specified, use the increase that slants left.* Used in combination, left- and right-slanting stitches can create beautiful, symmetrical sleeve increases.

To Make One slanting to the left (M1-L), use the left-hand needle to scoop up the horizontal strand between the needles from front to back and knit the strand through its back loop, twisting it to prevent a hole in your fabric (illustration 5, following page).

To Make One slanting to the right (M1-R), use your left-hand needle to scoop up the horizontal strand between the needles from back to front and knit the strand through its front loop, twisting it to prevent a hole in your fabric.

[5]

P2tog Decrease

This technique combines 2 purl stitches into 1 stitch, and it's usually worked on wrong-side rows; the resulting stitch slants toward the right on the right side of the fabric.

To do it, simply insert your right-hand knitting needle into 2 stitches at once and purl them together as 1 stitch (illustration 6).

NOTE: *For a p3tog, use the same method to combine 3 stitches into 1 stitch.*

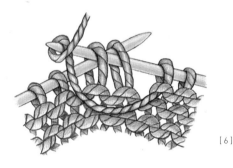

[6]

Purlwise

When instructed to insert your knitting needle into a stitch purlwise, simply insert the tip of your right-hand needle into the indicated stitch as if you were about to purl that stitch—in other words, from right to left and from back to front (illustration 7).

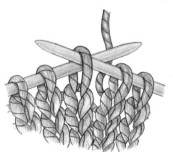

[7]

The convention in knitting is to *always slip stitches purlwise unless told otherwise.*

When told to slip a stitch purlwise, insert the tip of your right-hand needle into the indicated stitch as if you're about to purl it and slip that stitch off of the left-hand needle and onto the right-hand one, without twisting the stitch (right leg in the front).

S2KP2 Decrease

Here's a central double decrease that takes 3 stitches down to 1 stitch.

To do it, slip 2 stitches at once knitwise (illustration 8), knit the next stitch (illustration 9), then pass the 2 slipped stitches over the stitch you just knitted (illustration 10).

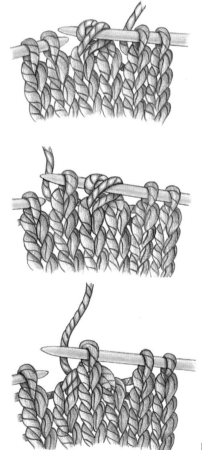

[8]

[9]

[10]

SSK Decrease

This decrease—known as "slip, slip, knit"—slants toward the left. It requires two steps to complete.

First slip 2 stitches knitwise, one at a time from the left-hand needle to the right-hand one (illustration 11). Then insert the tip of the left-hand needle into the fronts of these 2 stitches and knit them together from this position (illustration 12).

NOTE: *For an sssk decrease, use the same method, but slip 3 stitches and then knit them together into 1 stitch.*

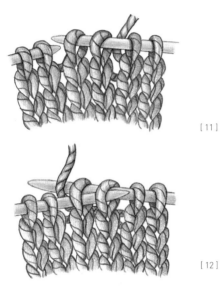

[11]

[12]

SSP Decrease

Here's a decrease that's most often used on wrong-side rows; the resulting stitch slants toward the left on the right side.

Slip the first and second stitches knitwise, one at a time, from the left-hand needle to the right-hand one. Then slip them back to the left-hand needle, keeping them twisted. Then insert the tip of the right-hand needle through the back loops of the 2 stitches (going into the second stitch first) and purl them together from this position (illustration 13).

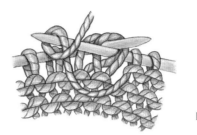

[13]

NOTE: *For an sssp decrease, use the same method, but slip 3 stitches and then purl them together into 1 stitch.*

Starting a New Yarn

Basic technique (page 14)

For stranded knitting (page 23)

Yarn Over Increase (yo)

This type of increase creates a decorative hole in knitted fabric and is most often used to make lace and other openwork patterns. It is done differently depending on whether the next stitch to be worked will be knitted or purled.

For a yarn over immediately before a knit stitch, bring the working yarn to the front, between the tips of the knitting needles. As you knit the next stitch, the yarn will go over the right-hand needle to create the extra stitch.

For a yarn over immediately before a purl stitch, the working yarn must be brought to the front, between the tips of the knitting needles, and then wrapped completely around the right-hand needle and back to the front.

Finishing Techniques

Applied I-Cord

This attractive border provides a firm, decorative edge. It's great to finish off a cardigan or afghan, and in this book, I've used it on the Stripes 'n' Dots Throw Pillow on page 56.

To do it, with the right side of the fabric facing you, use a circular needle to pick up stitches along the side on which you'll be putting the border. Then cast on 3 stitches onto the tip of the circular needle; these 3 stitches will form your I-cord. With a double-pointed needle in your right hand, *k2, ssk (joining the third I-cord stitch with 1 picked-up stitch on the pillow); do not turn; slip the 3 stitches from the double-pointed needle back to the circular needle; repeat from * along the edge (illustration 14).

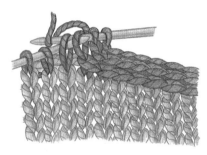

[14]

Blocking

Prior to seaming your knitted pieces, take the time to block them into shape. You'll be surprised at how this simple process can improve the appearance of your projects and can tame even the most unruly stitches! To do it, follow the laundering instructions on the yarn label, blot the excess water with a thick lint-free towel, then use rustless pins to shape the damp fabric to your desired measurements and allow it to dry. Or gently steam the pieces into shape by placing a damp cloth over them and then carefully wafting a hot steam iron just above the fabric. Don't actually touch the iron to the fabric or you'll risk flattening it.

Duplicate Stitch Embroidery (page 85)

French Knots

These little embroidered dots add color and texture to finished fabrics. To make them, thread the yarn into a pointy-end yarn needle. Bring the needle up from the wrong side, twist the yarn once (or sometimes two or three times for a larger knot), then, holding the yarn and needle firmly, insert it back into the fabric immediately next to the spot where it last emerged (illustration 15).

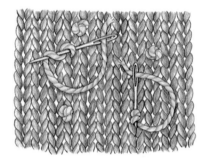

[15]

Hiding Yarn Tails

To make finishing your projects easier—and to make yourself a happier knitter—use the techniques discussed on page 84 to weave in the tails as you go as often as possible. This technique is especially time-saving when knitting intarsia. For double knitting, refer to page 139, and for basic instruction on hiding yarn tails that remain at the end of a project, refer to page 15.

Mattress Stitch Seams

Here's the neatest seam imaginable for stockinette stitch and most knitted fabrics. Nearly invisible, it can be worked vertically or horizontally.

For a vertical seam: Lay your pieces flat, with the right sides of the fabric facing you, matching patterns, if applicable.

Thread a blunt-end yarn needle with your sewing yarn, then bring the needle up from back to front through the left-hand piece of fabric, 1 stitch from the edge, leaving a 6"/[15cm] tail.

Bring the yarn up and through the corresponding spot on the right-hand piece to secure the lower edges.

Insert the needle from front to back into the same stitch on the left-hand piece and bring it up through the stitch in the row above.

Insert the needle from front to back into the same stitch on the right-hand piece and bring it up through the stitch in the row above.

Repeat the last two steps until you've sewn approximately 2"/[5cm], then pull firmly on the sewing yarn to bring the pieces of the fabric together, allowing the 2 stitches on the edges of each piece to roll to the wrong side.

Continue this way until your seam is complete (illustration 16).

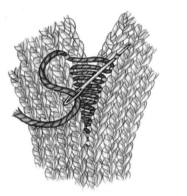

[16]

For a horizontal seam: Lay your pieces flat with the right sides of the fabric facing you and with the bound-off edges of the pieces together. Bring the needle up through the center of a stitch just below the bound-off edge on the lower piece of fabric, then insert it from front to back and from right to left around both legs of the corresponding stitch on the other piece of fabric. Bring the needle tip back down through the center of the same stitch where it first emerged.

Continue this way until your seam is complete (illustration 17).

[17]

Sweater Assembly

Sweater pieces fit together like a jigsaw puzzle, with the type of armhole determining how the Front, Back, and Sleeves interlock. Refer to the illustrations below when assembling sweaters.

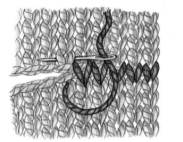

Square Indented

Set In

Abbreviations and Symbols

Abbreviations List

Following is a list of abbreviations used in the charts of this book. Many of the techniques are discussed in the Knitting Techniques section (page 164).

cm	centimeter(s)
cn	cable needle
g	gram(s)
k	knit
k2tog	knit the next 2 stitches together; this is a right-slanting decrease
LH	left-hand
M1	Make 1 (increase)
M1-L	Make 1 slanting to the left (increase)
M1-R	Make 1 slanting to the right (increase)
MB	Make bobble: Knit into the (front, back, front) of the next stitch, turn; p1, (p1, yo, p1) all into the next stitch, p1, turn; k5, turn; p2tog, p1, p2tog, turn; s2kp2.
mm	millimeter(s)
mult	multiple
oz	ounce(s)
p	purl
p2tog	purl the next 2 stitches together; a right-slanting decrease
patt(s)	pattern(s)
rem	remain(ing)
RH	right-hand
rib	ribbing
rnd(s)	round(s)
rpt	repeat
RS	right side (of work)
s2kp2	slip 2 stitches together knitwise, k1, pass the 2 slipped stitches over (centered double decrease)

sl	slip 1 stitch from the left-hand needle to the right-hand needle; the convention is to do so purlwise unless otherwise instructed in the pattern
ssk	slip the next 2 stitches knitwise, one at a time from the left-hand needle to the right-hand one, insert the left-hand needle tip into the fronts of both slipped stitches to knit them together from this position (left-slanting decrease)
ssp	slip the next 2 stitches knitwise, one at a time from the left-hand needle to the right-hand one, return both stitches to the left-hand needle and insert the right-hand needle into them from left to right and from back to front to purl them together through their back loops (left-slanting decrease)
st(s)	stitch(es)
tog	together
WS	wrong side (of work)
yd(s)	yard(s)
yo	yarn over
*	repeat instructions after asterisk or between asterisks across row or for as many times as instructed
()	alternate measurements and/or instructions for different sizes; also, repeat instructions within the parentheses for as many times as instructed
[]	repeat instructions within the brackets for as many times as instructed; these brackets also indicate the separation between empirical and metric measurements in the pattern text

Symbol Key

Every chart has a stitch key near it; but for handy reference, here's a list of the symbols used in the charts in this book.

☐ = K on RS; p on WS

• = P on RS; k on WS

B = Bobble = K into (front, back, front) of next st, turn; p1, (p1, yo, p1) all into next st, p1, turn; k5, turn; p2tog, p1, p2tog, turn; s2kp2

● = French Knot

Yarn Choice and Substitution

Each project in this book was designed for a specific yarn. Different yarns possess their own characteristics, which will affect the way they appear and behave when knitted. To duplicate the projects exactly as photographed, I suggest that you use the designated yarns. Even so, you'll find that the nature of any handmade garment assures subtle differences and variances.

However, if you would like to make a yarn substitution, be sure to choose one of weight similar to the one called for in the pattern. Yarn sizes and weights are usually located on the label; but for an accurate test, knit a swatch of Stockinette Stitch using the recommended needle size, making it at least 4"/[10cm] square. Count the number of stitches in this 4"/[10cm] swatch and refer to the table below to determine the yarn's weight.

Craft Yarn Council of America	1	2	3	4	5
Yarn Weight	Lace, Fingering, Sock	Sport	DK, Light Worsted	Worsted, Aran	Chunky
Avg. Knitted Gauge over 4" (10cm)	27–32 sts	23–26 sts	21–24 sts	16–20 sts	12–15 sts
Recommended Needle in US Size Range	1–3	3–5	5–7	7–9	9–11
Recommended Needle in Metric Size Range	2.25–3.25mm	3.25–3.75mm	3.75–4.5mm	4.5–5.5mm	5.5–8mm

Resources

Material Resources

I always recommend purchasing supplies at your local yarn shop. If there isn't one in your area, contact the appropriate wholesaler for more information.

Aurora Yarns
PO Box 3068
Moss Beach, CA 94038-3068
(650) 728-2730
www.aurorayarns.net

Blue Sky Alpacas
PO Box 88
Cedar, MN 55011-0088
(763) 753-5815 /
(888) 460-8862
www.blueskyalpacas.com

Brown Sheep Company, Inc.
100662 County Road 16
Mitchell, NE 69357-2136
(800) 826-9136
www.brownsheep.com

Cascade Yarns
1224 Andover Park East
Tukwila, WA 98188-3905
(206) 574-0440
www.cascadeyarns.com

Classic Elite Yarns
122 Western Avenue
Lowell, MA 01851-1434
(978) 453-2837
www.classiceliteyarns.com

Jamieson's
(see Simply Shetland)

JCA, Inc.
35 Scales Lane
Townsend, MA 01469-1094
(978) 597-8794
www.jcacrafts.com

JHB International, Inc.
1955 South Quince Street
Denver, CO 80231-3206
(303) 751-8100 /
(800) 525-9007
www.buttons.com

Knitcraft
215 North Main
Independence, MO 64050-3023
(816) 461-1248
www.knitcraft.com

Louet North America
3425 Hands Road
Prescott, ON, Canada K0E 1T0
(613) 925-4502 /
(800) 897-6444
www.louet.com

Plymouth Yarn Company, Inc.
500 Lafayette Street
Bristol, PA 19007-0028
(215) 788-0459
www.plymouthyarn.com

Reynolds Yarn
(see JCA, Inc.)

Simply Shetland
18375 Olympic Avenue South
Seattle, WA 98188
(877) 743-8526 /
(425) 981-1228
simplyshetland.net

Steinbach Wolle
(see Aurora Yarns)

The Knitting Community

To meet other knitters and to learn more about the craft, contact the following. I currently sit on their Advisory Board and can attest to the educational value—and the pure, knitterly fun—of this group:

The Knitting Guild Association
1100-H Brandywine Boulevard
Zanesville, OH 43701-7303
(740) 452-4541
E-mail: TKGA@TKGA.com
www.tkga.com

To meet other knitters online, visit:
www.ravelry.com

Knitter's Graph Paper

Use this knitter's graph paper to draw your own designs. The rectangular shape of the boxes mimic the shape of stitches. To design stranded patterns, use traditional square graph paper, available wherever office supplies are sold.

Acknowledgments

Many thanks go to the following knitters for expertly knitting samples for this book: Toni Blye, Didi Bottini, Carol Buchholz, Jen Chin, Corrina Ferguson, Lynn Gates, Nancy Hand, Erica Hernandez, Tom Jensen, Cheryl Keeley, Laura Leone, Joan Murphy, Holly Neiding, Veronica Ory, Dawn Penny, Kathy Redman, Marina Salume, Judy Seip, Norma Jean Sternschein, Jody Strine, Angie Tzoumakas, Vanessa Vine, Lauren Waterfield, and Judie Wise.

I am grateful to Jocelyn Grayson for assisting me with so many persnickety details during the production of this book. Thank you for everything. Especially your friendship!

Once again Cascade Yarns Company provided an unbelievably generous amount of its spectacular Cascade 220 yarn for the pattern treasuries in the book. This beautiful yarn is delightful to work with and is well priced, with lots of yardage per hank. Best of all, its huge color range makes it a color-knitting-book author's absolute dream! Thank you, Jean and Shannon.

Thank you, Peggy Wells and Brown Sheep Yarn Company, for sending yarn to construct the color wheels shown in Chapter 1. Brown Sheep Yarn Company's Naturespun Yarn comes in enough brilliant colors to show off every color of the spectrum. I am grateful for your generosity.

This book has benefited from the expertise of two very talented (and patient!) individuals within the yarn/knitting industry: my fantastic technical editor, Charlotte Quiggle, and my technical illustrator, Joni Coniglio. Thank you for working with me on this project!

Once again I've been fortunate to work with my fantastic editor at Random House, Rebecca Behan. Your insight and input have contributed greatly to this book. Here's to our next one.

Index

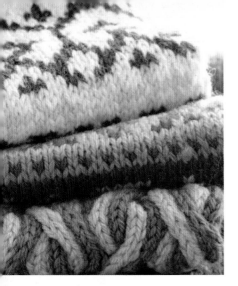

Index, continued

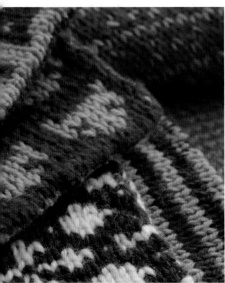

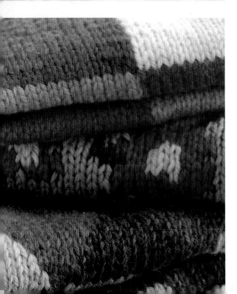